MW01063016

Foundations of Russian Culture

Protopresbyter Alexander Schmemann

Translated from the Russian by Nathan K. Williams

HOLY TRINITY PUBLICATIONS
Holy Trinity Seminary Press
Holy Trinity Monastery
Jordanville, New York

2023

Printed with the blessing of His Grace,
Bishop Luke of Syracuse
and Abbot of Holy Trinity Monastery

Foundations of Russian Culture
© 2023 Holy Trinity Monastery

HOLY TRINITY
SEMINARY PRESS

An imprint of

HOLY TRINITY PUBLICATIONS
Holy Trinity Monastery
Jordanville, New York 13361-0036
www.holytrinitypublications.com

ISBN: 978-1-942699-55-2 (hardback) Limited Edition
ISBN: 978 1 942699-50-7 (paperback)
ISBN: 978-1-942699-54-5 (ePub)

Library of Congress Control Number: 2023938475

Cover Art: Photo, "Hagia Sophia." Source: istockphoto.com, ID 670401080,
Tolga_TEZCAN; Sketch, "The Ship" by Ivan Bilibin. Source: wikimedia.org;
Engraving, "Peter the Great Czar of Russia." Source: iStockPhoto.com,
ID157442669, duncan1890; Painting, "Jaune Rouge Bleu"
by Wassily Kandinsky. Source: wikimedia.org.

Contents

Fr Alexander Schmemann

Foreword

I am most beholden to Holy Trinity Orthodox Seminary and Dean Nicolas Schidlovsky for publishing an English translation of these broadcasts my father Protopresbyter Alexander Schmemann made to Russia over Radio Liberty in the 1970s. Apart from the contribution they make to the history and understanding of Russian culture, and I'm told by Russian friends that it is considerable, the essays also reveal an intellectual side to Father Alexander Schmemann that may be less familiar than his work in the Church, but critical in his life.

From his earliest years, Father Alexander was enthralled by literature, which is the focus of these broadcasts. He was of that unique generation of Russian émigrés born already outside Russia, but whose lives were still shaped to a large degree by their lost motherland—by its Orthodox Church, its traditions, its creative arts, and the haunting memories of lost lands, loyalties, and loves. From his earliest years, my father and his twin brother Andrei served as altar boys at the Cathedral of St Alexander Nevsky on rue Daru in Paris. The church in those years was the heart of Paris's Russian diaspora, packed with grand dukes, war veterans, former ministers, and relatives. His first school was the Corps of Cadets, a Russian military school

for boys, whose mission was to prepare them for a return to Mother Russia.

It was in that church and in that school that my father found his life's course and vocation. The diaries he kept in his teenage years describe early struggles with powerful religious feelings, especially after a bout with a serious illness. And in the *Journals* he kept in his last years, he recalled how the director of the school, General Vladimir Rimsky-Korsakov, recognized young Sasha's talents and intellect and privately gave him hand-copied poems to read, thus opening his mind to Russian literature. It would become a lifelong passion.

As Father Alexander moved on to a French lycée and then the St Sergius Orthodox Theological Institute, and then, in 1951, America and St Vladimir's Seminary, his literary world accordingly expanded to include French and then English literature. Our modest home in a New York suburb overflowed with books and journals in three languages. Father Alexander's circle of friends in New York included writers like Vladimir Varshavsky and Roman Gul, and his trips into the city always included a stop at a French bookstore on Rockefeller Center. Blessed with a remarkable memory, he could quote prodigiously not just from Pushkin, Blok, or Brodsky, but also from André Gide or E.E. Cummings, among many, many other poets and writers. I remember him telling me once that had he not entered the priesthood, he might have become a literary critic.

It is not for me to critique Father Alexander's thoughts on Russian culture. I am a journalist and have spent my life writing

about world affairs; in the sphere of literature, my father was, and remains, my authority and my teacher—quite literally, as I took his course on "Religious Themes in Russian Literature" at Columbia University. What I learned from him was that literature, true literature, is not separate from faith; that poetry is also revelation and truth. The reading list for the course consisted basically of analyzing works he loved: I most vividly remember his lecture on the opening scene of Gogol's *Dead Souls*, that immortal conversation between two muzhiks looking over the wheel of a carriage that has just rolled into a provincial city, idly wondering whether the wheel would survive a trip to Moscow (yes) or to Kazan (probably not). It was a wonderful analysis and a wonderful course, and I remember a student once asking Father Alexander, "But where are the religious themes?" He was incredulous: "These are works of genius. That is a gift of God!"

That is what literature, and especially poetry, was to Father Alexander. It was not "about" religion, it was what religion is all about. There is an entry in his *Journals* in which he describes his thoughts on reading a poem by E.E. Cummings, "Wherelings Whenlings": "This is precisely about 'life,'" he noted. "And it seems to me immeasurably closer to what faith and religion are about than the theology books that my desk is covered with."

Sharing his thoughts about the wellspring of Russia's extraordinary culture with his captive nation was a natural extension of the broadcasts he made over Radio Liberty for almost three decades. The talks were a major part of Father

Alexander's life's labors—a weekly "conversation," as they were titled, recorded in a smoke-filled studio in New York, with very little information about whether anyone in Russia was listening through the Soviet jamming. My father lived to learn that they were, most poignantly in a letter Alexander Solzhenitsyn wrote to a friend: "For a long time, with spiritual delight I have been listening on Sunday evenings, whenever possible, to the sermons of 'Father Alexander' (his surname was never given) over Radio Liberty ... Never a note of falsehood, not an iota of rhetoric, without empty recourse to obligatory form and ritual which causes a listener discomfort and embarrassment for the preacher or for himself. Always a deep thought and profound feeling "

I heard many such comments when I arrived in the Soviet Union as a *New York Times* correspondent in 1980. My father longed to visit us and finally see the land that was such a great part of his life, but he fell ill and died before he could. Yet that conversation with Russia, with Russians, about the things that were most important to him was an integral part of his life. "Each one of us, Russian Christians, carries a duty," Father Alexander said in a speech in 1977 on the spiritual fate of Russia, "to ensure, as best as we can, whether here or over there, whether in large degree or small, that Russia can have a spiritual fate."

These words have a sadly renewed relevance today, when Russia's leaders once again invoke a perverted version of Russian history, religion, and culture that has brought the nation to the present fratricide. The message that gave Russians succor

and hope fifty years ago is as important today as it was then: "Russian culture is a remarkable symphony, in which melodies filled with melancholy are transformed in the end into praise of goodness, truth and beauty."

Serge Schmemann

A Simple Yet Complex Script

The edition history of *Foundations of Russian Culture* is one of no little complexity.[1] The text here published was pieced together like a puzzle from fragments over a number of years. Today the radio series of the renowned church figure and theologian Protopresbyter Alexander Schmemann is presented to the reader in its complete form—from the first talk to the last.

It all began in 2011, when yet another piece of the vast archive of the prominent émigré prosaist and publicist Vladimir Sergeyevich Varshavsky arrived at the Alexander Solzhenitsyn House of Russia Abroad. These materials were received over the course of several years (2007–2019) in large and small shipments from the city of Ferney-Voltaire on the French-Swiss border, from the writer's widow, Tatiana Georgievna Varshavskaya (1923–2019).[2] In one of the shipments delivered from Moscow, an authorized typewritten copy was found (with corrections and marginal notes) under the collective title of *Foundations of Russian Culture*—a fragment of a series of talks by Father Alexander Schmemann, compiled according to Radio Liberty script standards. At that time, in 2011, of the entire corpus of *Foundations* only thirteen isolated

lectures (or talks, as Schmemann customarily termed his radio broadcasts) were discovered—Talks 2 through 12 (1970) and Talks 29 and 30 (1971). Judging by the dates on the title pages, Schmemann introduced the new project in June 1970 and continued to work on it the following year. Once a week he would record the broadcasts at the radio station's New York division in Manhattan, and the following week (generally on Wednesday or Thursday) they would go on the air via the Russian office in Munich.

That the typewritten copy was in the possession of Vladimir Marshavsky is easily explained. Both Varshavsky and Schmemann worked together at the New York division of Radio Liberty,[3] but they were chiefly united by lively conversation, which over time grew into a friendship that lasted many years. Tikhon Igorevich Troyanov,[4] a colleague of theirs at the radio station, later recalled these conversations "on the same wavelength" (about democracy, the Russian émigré community, Henri Bergson, Teilhard de Chardin, the USSR, and more). What was puzzling was rather the fragmentation of the archived series: on what principle had Varshavsky removed individual scripts from the complete corpus? Was this deliberate selectivity, or had a number of the talks from the writer's personal collection been accidentally lost?

From the archived scripts it proved possible to reconstruct the overall concept of the radio series as a whole: it was apparent that from one broadcast to the next Father Alexander had successively created a panorama of Russian culture, encompassing a vast expanse of history—from the era of the Christianization

of Kievan Rus' to the twentieth century. The particular char-
acteristics of the radio broadcast (the invariable flashbacks
to previous broadcasts and thematic previews of those to fol-
low) also aided in the reconstruction of the overall concept.
The fragment discovered spurred further archival searches;
the very fact that the scripts were a duplicated document gave
grounds for hope. The House for the Russian Diaspora applied
to Sergey Alexandrovich Schmemann, son of Father Alexan-
der, as well as to Radio Liberty. Neither the family archives nor
the archive of the radio station contained a manuscript under
that name.[5] Yet the value of the fragment's content appeared
so significant that it was decided to prepare a publication with
extensive commentary, which was published in 2012 in the
scholarly periodical of the House for the Russian Diaspora.[6]
To be sure, we cherished the hope that one day the rest of the
typewritten copy would surface, but everything suggested that
the story of the publication of *Foundations* had come to a close.

The situation changed in 2016 when, in the archives
of poetess Nina Bodrova (1946–2015) in Munich, Andrey
Andreyevich Nikitin-Perensky (creator of the ImWerden elec-
tronic library and the Vtoraya Literatura electronic archive)
discovered a folder of scripts. It was the complete corpus of the
radio series, from which only the first talk was missing. Andrey
Andreyevich immediately notified the Moscow publishers
of his find. On the basis of this "Munich corpus," in 2017 the
publishing arm of PSTGU prepared and released *Foundations
of Russian Culture*, making up for the absence of the first talk
with a valuable addendum of radio talks and lectures given

by Father Alexander at various times on Russian literature.[7] The book was well received in Russia and was released in Europe in Serbian and French translations.[8]

Finally, in 2018, *Foundations* were fully restored. While sorting through yet another shipment of the archive of Vladimir Varshavsky, delivered to Moscow from Ferney-Voltaire, the missing part of the radio series was discovered, including the first talk.[9] The scripts delivered to the House for the Russian Diaspora differed somewhat from the typewritten copy from the archive of Nina Bodrova. Upon comparison it was found that in a number of the talks from the "Munich version" the last pages had been lost. The complete text of the radio talks became the basis for a revised and annotated edition.

Each book has its own story. The story of how *Foundations of Russian Culture* came to be published fully reflects the complex path of the return of the archives of the Russian émigré community to their homeland. But there is something highly symbolic in the complicated history of this publication; in how Schmemann's essay gradually unfolds before the Russian reader; in the ethical imperative of the "common cause" that attended the work of the publishers, researchers, and archivists; in the engrossing process of reconstructing the text of *Foundations* and the context in which their author worked on the manuscript.

Foundations of Russian Culture holds a special place in the legacy of Schmemann. The ideas of Father Alexander are invariably passed through Christian metaphysics, but this *a priori* circumstance does not change the fact that before us

we have a *secular* composition by an outstanding theologian, the fruit of his cultural and philosophical constructs. It is not just a nominal list of the milestones in Russian culture, but an attempt to analyze the multifaceted junctures and irreconcilable antonyms that irreversibly led to the tectonic social disruptions in the early twentieth century, to "revolution as the rupture of personal and national history"[10] for several generations at once, to the disappearance of prerevolutionary Russia as a cultural civilization, and to the tragedy of the Russian exodus, which included Alexander Schmemann himself, who was born in emigration but identified as "indisputably Russian."[11]

"The paradox of Russian cultural development,"[12] according to Schmemann, took the form of two polar opposite phenomena: on the one hand, the extraordinary cultural heyday that reached its zenith in the nineteenth century, and on the other, the tragedy of Russian culture. Like many other thinkers of the Russian émigré community, Schmemann held that the distinguishing feature of the inevitable conflict was the impassable demarcation line between the highly educated portion of Russian society and the masses at large. The radio series names many factors in the occurrence of this watershed: the church schism; the Petrine reforms; the twilight of Russian culture in the period of the *raznochintsy* [predecessors of the intelligentsia], when the utilitarian approach to art reached its zenith; and so on. In dispassionately listing the chief milestones of cultural delimitation, Father Alexander logically arrives at the greatest and most catastrophic watershed for Russian culture and for the country as a whole—between the intellectual elite and the

people. The questions Schmemann raises are so fundamental that they have lost none of their relevance in our own time; in the 1970s his talks on Radio Liberty were all the more acutely pertinent.

The year when work upon *Foundations* began was a pivotal one for Father Alexander himself. In 1970, after prolonged negotiations with the Moscow Patriarchate, the Metropolia of North America received its independence and began to be called the Orthodox Church in America, thereby adding to the number of local Orthodox churches.[13] This autocephaly, which fortified the spiritual authority of Orthodoxy in the United States, was made possible in large part by the pro- active position and writings of the rector of St Vladimir's Orthodox Theological Seminary, Archpriest Alexander Schmemann. That same year he was elevated to the rank of protopresbyter.

In that landmark year for Father Alexander he introduced an original culturological project at Radio Liberty, which he began with a discourse on "*a new debate regarding culture.*" For the Soviet intelligentsia, which found itself in a post-Khrush- chev reality—or (in Schmemann's words) "*a reality of ideolog- ical vacancy*"—this discourse was long overdue. In the history of Russian culture, the 1970s were a decade of growing disso- nance: the heyday of Soviet theater and cinema, together with new names in literature and representational art, stood in stark contrast to the "Era of Stagnation." The sensational events of the preceding decade and the reaction to them of global soci- ety—the arrest of Joseph Brodsky (1964), the affair of Andrey

Sinyavsky and Yuly Daniel (1965), the pamphlet by academi-
cian Andrey Sakharov entitled "Progress, Peaceful Coexist-
ence, and Intellectual Freedom" (1968), the rise of the dissident
human rights movement, the advent of the Initiative Group for
the Defense of Human Rights (1969), and the Committee on
Human Rights (1970)—being in equal measure political and
cultural phenomena, proved a part of the fateful "*new debate*."
Finally, in the "red-letter year" for the USSR of 1970 (100
years from the birth of Lenin), Alexander Solzhenitsyn was
declared the winner of the Nobel Prize. To this historic event
Alexander Schmemann responded with his keynote article
"On Solzhenitsyn."[14] It is worthy of note that the *Vestnik of the
RSCM* in which the article appeared made a significant con-
tribution in the 1970s to the discussion of Russian culture. At
the crux of two decades, this prominent émigré religious and
philosophical magazine introduced a number of new columns,
including the polemical column "Fates and Fortunes of Russia"
(beginning in 1969, № 91/92), participants in which included
authors from "across the border" and representatives of the
Russian émigré community. Among the latter was the deputy
chairman of the Russian Student Christian Movement, Arch-
priest Alexander Schmemann.[15] In 1973 Schmemann observed
a common denominator, which he recorded in his diary: "The
seventies: the beginning of a sixth decade—that is, in essence,
of old age or, at least, merely of aging. Russia once more:
Solzhenitsyn, dissidents, the *Vestnik*. Perhaps the beginning
of a certain internal 'synthesis,' of some 'vision' through which
everything is now falling into place."[16]

Foundations of Russian Culture was part of the large-scale *"debate about what is most important, on which the future of both Russia and the world also depends."* Furthermore, this work holds a special place in the history of Radio Liberty. It is commonly known that the radio station, as one of the largest anti-Soviet centers in the Cold War era, was an energetic initiator of and participant in the discussion of the fates and fortunes of Russia. But it was the 1970s that saw the dramatic period of pointed differences in opinion, which first and foremost affected the Russian office.[17] In the strained atmosphere of internal conflict, the question of how to regard Russian cultural assets and the Orthodox faith was one of the most important. The new generation that was supplanting the old guard viewed the traditions of the first wave as excessively archaic and unsuitable for purposes of liberal propaganda. By the mid-1970s the crisis had come to a head and resulted in the retirement of a whole series of prominent collaborators, the majority of whom were members of the old Russian emigration.[18] The upshot of the workplace politics at Radio Liberty was a palpable change in the mental climate, which Alexander Solzhenitsyn outlined as follows in a letter to the management of the radio station:

> "The majority of broadcasts engendered in the bowels of your station … perpetually hyperfocus on the latest fleeting events and are not permeated with a sense of the long-term historical process, the long-term history of Russia, and an analysis of its past century, which has been particularly blanketed with lies

and stripped of the objective coverage that is so vital to listeners in the RSFSR."[19]

Father Alexander's talks lay in precisely this paradigm of "a sense of the long-term history of Russia and an analysis of its past century" for which Solzhenitsyn called. In 1970, when the ideological and generational conflict had only just emerged, Schmemann's new project had a certain symbolical significance and found support among the most senior collaborators. One prominent member of the Russian émigré community, Ludmila Sergeyevna Obolenskaya-Flam, described the situation on the eve of the release of *Foundations* (with the caveat that she was an indirect witness to the events):

> "My husband,[20] who served as program director at Liberty in New York, had high praise for Fr. Alexander's broadcasts and defended him when they were criticized for being 'too Orthodox' ('What else are they supposed to be?!'). But I don't recall exactly who criticized him. What matters is that the broadcasts stayed—and not only that, his second, parallel series on Russian culture was launched."[21]

In the early 1970s *Foundations of Russian Culture* brought significant balance to the politics of the radio station, lending depth and fundamentality to its strategy. In his new project Schmemann convincingly synthesized innovation (the *"new debate regarding culture"*) and the extraordinarily rich tradition created by the Russian emigration in the context of Radio Liberty and beyond—within the context of the cultural legacy

of the Russian émigré community. This educational mission of the radio series deserves special attention.

Speaking on the radio is a particular genre, one of which Father Alexander had a superb command. As the priest's son Sergey Schmemann notes, "His words were literally those of a conversation with a Russian person who was starving for spiritual food and, at the same time, conversations with himself. He spoke of eternal questions and great truths. . . . He spoke in words comprehensible to all, for he believed what he said."[22] Incidentally, the airtime of broadcasts in the radio war era was sometimes tightly restricted. "Father Alexander was known as an unsurpassed lecturer," recalled his pupil Alexander Dvorkin. " … Employees at the Radio Liberty station where he recorded his broadcasts related that he had a perfect sense of timing: he would speak for precisely the time allotted and could arrange his entire talk to fit it: introduction, main body, and conclusions."[23] Each program in *Foundations* lasted around ten minutes (6.5–7 typewritten one and a half-spaced pages). But in his laconic talks Schmemann could create a multi-tier discourse, combining concise thoughts and simplicity of delivery, a lofty instructional pathos, and simultaneously a hidden exhortation not to be content with the radio broadcast's popularization agenda, but to go further, back to the sources. Due to the brief airtime allotted, Father Alexander was not always able to cite those sources. By slowly reading the scripts discovered, it is now possible to recognize the hidden quotes and implied references, and to correlate the profound erudition of the author of *Foundations* with the legacy of Russian

thought, including that of the "golden age of emigration,"[24] as in his diary Schmemann defined the interwar years of the Russian émigré community.

The same diary serves in part as a bibliographical guide: "In the evening, in bed, I would leaf through old, old issues of *Sovremennye Zapiski*," Schmemann would write on November 7, 1981. "Poems by Poplavsky. Reviews by Khodasevich, Adamovich, Bitsilli. Russian Paris in the brief moment of its heyday. … And how glad I am that, albeit in the twilight of my youth, though I understood but little, I 'tasted' of that inimitable moment."[25] Schmemann's preferences as a reader shed considerable light upon his conceptual development—for example, the key theme of the tragedy of Russian culture, as well as the miracle of its heyday in the post-Petrine era, harking back to the article of humanitarian and encyclopedist Pyotr Bitsilli, "The Tragedy of Russian Culture."[26] Or his musings on the legacy of the founding father of Slavophilism, Aleksey Khomyakov, for whom the works of Nikolai Berdyaev served as the foundation. Or the underlying theme of "*Pushkin's 'Mystery,' its exclusive, singular place in Russian culture*," rooted in the tradition of the "Pushkiniana" of the emigration. These are but a few isolated examples. In this edition, the ideological focuses of *Foundations* became a subject of comment, including apocryphal stories which, although formally "inaccuracies," are also the legacy of the Russian émigré community and its "golden age," and have their authors and preservers. One such example is a theme that at one time was very much in vogue in literature on Blok, concerning the poet's dying wish that all copies

of his poem "The Twelve" be burned—a theme introduced by
Georgy Ivanov (*Petersburg Winters*, 1928), but which remains
undocumented.

Alexander Schmemann's *Foundations of Russian Culture* is a
script at once simple and complex. It is simple in that it is a
series of radio broadcasts, addressed to a very broad audience.
The scripts are grounded in speech that was intended to be
received orally, without the possibility of replaying or rereading
it. In accordance with the laws of the genre, each talk contains
a single key idea: this idea must be repeated so that the lis-
tener is sure to retain it, lest it go unnoticed if, for example, his
attention should wander for a moment. It is this that produces
the complexities of the text—first and foremost, the complex-
ity of brevity.

Foundations is not so much the beginning of a new conver-
sation as it is a finale—one of the last texts that mark the close
of the great tradition of descriptions of Russian culture, lay-
ing its structure bare. What is presented in the descriptions of
Belinsky or Gertsen, Milyukov or Plekhanov as a subject of con-
flict and dissonance now sounds familiar—as a thing already
read many times over, even if you know with certainty that you
are reading it for the first time. Schmemann's text repeats the
words of others, and these sound unlike the rest of his words.

In this the contrast with *The Diaries* is obvious and pain-
ful—specifically because in *Foundations* the author's words
are presented as a universal position—but that position is

clearly biased, and in no way does it problematize itself. Where Schmemann's private conversations with himself are filled with constant doubts, self-questioning, and clarification, step by step, in the scripts of *Foundations* there is no dissonance: all is harmonious.

And this "unpleasant lack of dissonance," as one reader put it, this harmony, acts in two different ways, depending on what the reader is anticipating. One who prefers flowing journalistic texts is satisfied, since "everything comes together": Schmemann presents a simple, intelligible schematic of Russian culture, asking simple questions of no one in particular—or rather, of everyone—concerning the future of Russian culture, responsibility, etc. The text seems to flow without difficulty; there are no snags to impede it.

Conversely, the reader for whom a text that "flows" presents difficulties attempts to find in Schmemann's text something that goes beyond the bounds of the familiar, the self-contained—to a place where the unique, singular voice of the author can be heard.

Foundations do not so much discuss Russian culture as present a schematic of it. Schmemann, it seems, deliberately avoids any paradoxical judgments, basing his observations on "generalities" and conceptualizing them. The very framework of the culture is presented as significant, consisting of simple elements and their relative positions, rather than their content.

This selection of elements and their transformation into a construct deserves separate attention. Essentially, it is here that irregularities surface in which one may observe a problem far

removed from the rhetorical exhortation to understand the foundations as such.

The first "irregularity" emerges in the use of the key concepts selected by Schmemann. It is noteworthy that nowhere does he elucidate them at all overtly, thereby increasing the complexity, which heightens as the text progresses.

First and foremost, this "*culture*" is something external to the "intelligentsia": it is something that the latter can renounce, for example, or which it is capable of neglecting. It is something that interacts with "the government" and at the same time with "politics." In the context of this narrative, culture is something that, if not wholly synonymous with literature, is so closely associated as to be practically indiscernible from it. It is also defined—in Talk 24, on virtually the sole occasion when the author attempts to clarify the concepts he employs—as the "*rational and creative aspect of the life of the national organism.*" It may however immediately be seen that this refers not in the least to empirical multiplicity, not to the vast multitude of artifacts created at a given point in time, but to pinnacles and what is dubbed the life of the "*national organism.*" In other words, we have before us a quite recognizable construct—with deliberate selectivity and a concept of "pinnacles"—which however is far from arbitrary, inasmuch as both the time distance and preservation in a current, ongoing conversation determines names and texts that are inevitable.

Here, "culture" is not solely and not so much a "legacy" as it is something that is coexistent, preserved, and continued. At the same time it is stripped of unambiguity, inasmuch as this

also refers to that which in the "legacy" has gone unheard or must be revisited—to texts that are read, but that have not been read thoroughly.

The word *"foundations,"* also present in the heading, is likewise multilayered. The first meaning is foundations as something "elemental"—the blocks with which any assembly process begins. These are followed by "foundations" as a thing historical, determining and forming succession—foundations in the far reaches of time and, at the same time, that on which the present rests or should rest, and by which the future ought to be determined. But it also harks back to another meaning: that of the "foundations" upon which Russian culture is built, that which defines its "essence."

It is the multiple layers of the concept of "foundations" that determine the unique structure of the text. Its first part, the main body after the introductory talks, is devoted to a historical account—to the delineation of key milestones and trends in Russian culture in its development in time. Talk 23 serves as a watershed, a transition from the historical narrative to modern times, to a conceptualization in which "here and now" the foundations of Russian culture are sought (1) in the past and the sense of tradition, (2) in the West, (3) in science and technology, (4) in the social problem, and (5) in the religious agenda.

The third most frequently mentioned word in the text is a word connected with past and present, and also, first and foremost, with the future: *synthesis*. It is understood as something that is sought in the future, which makes it possible to attain

pan-unity, passing through the contradictions and impasses inherent in Russian culture—and at the same time illumined by a gleam of embodiment, of unexpected harmony: Pushkin. The concept of synthesis reveals the pathos of Schmemann, which goes beyond the bounds of the problem of "culture and religion" that occupied minds and, to some degree, souls in the first half of the twentieth century.

This pathos lies in the impossibility of localizing Christianity or Orthodoxy—of equating it with any historical, cultural form—and, at the same time, in the impossibility of envisioning it outside all form. In this sense culture proves an imprecise, inadequate tool—but one that strives for precision, for approximation, for the discovery of a precise word or image to express Christianity. And this same pathos is the pathos of acknowledgment of inevitable failure, while preserving the effort and the essential miracle of approximation.

In Schmemann's understanding, Russian culture is produced by gravitation toward the universal—by aspiration to Christianity, which is acquired in "the West" (hence also the longing for culture, which is likewise acquired there). But this aspiration immediately is found to be encumbered by contradictions. On the one hand, in adopting Christianity, Rus' or Russia adopts it not as something Greek, immersed in a thick layer of culture, but as something external and contrasted to culture. At the same time, she strives for the universal at a time when the last visage of that universal is disappearing. In this sense, the longing for "the West" in Russian culture proves to be constantly at odds with the actual West: it simultaneously

aspires toward it as a visible image of the universal, ready to sacrifice all it possesses as meaningless compared to what is acquired—Chaadayev's pathos of renunciation—and repulses it as something actually far from universal, but rather limited, concrete, and partial.

Consequently, in the profound interpretation of Schmemann, both the contradictions and the impasses of Russian culture prove no longer to be a narrative of the concrete, but a contradiction lying at the very foundation of "Christian culture," an eternal search and eternal discontent—and, simultaneously, a possibility of sudden epiphanies, which attest that an impulse or an aspiration is not solely an illusion or an empty dream, but rather a hope.

Maria Vasilyeva, Andrey Teslya

Note to the Reader

Italics are used to indicate words the author underscored in his radio script.

Fragments or sentences in the typewritten radio script that were struck-through and therefore not broadcast have been included as footnotes.

Conjectures, comments, and text added by the editors of the Russian language edition are enclosed in square brackets.

 TALK 1

THE CULTURAL DEBATE IN THE USSR: A PROTEST

Today we are beginning a new series of broadcasts that we have titled "Foundations of Russian Culture." In these broadcasts, of necessity significant space will be allotted to the history of Russian culture and the particularities of various trends within it, often contradictory and even mutually exclusive, and the disputes amid the conflict between them, which are reflected in our own time. This alone is sufficient reason for these broadcasts to be devoted less to history than to our own modernity, in which Russian culture has found itself in so grave and critical a state—one which to a very large extent explains the generally diseased state of modern public life.

Many, many people are convinced that this disease is chiefly political in nature; that is, that it comes down to the foundations of the system of government, to a lack of freedoms, of law and order, of civil rights, and so on. But there are also people who hold that problems of a political nature are only part of a deeper and more complex *problem of culture*,

that politics are not only inseparable from culture, but also that they are the fruit of culture, its derivative in the sphere of state and public affairs. In other words, in our era of the seemingly universal supremacy of politics in life, this latter view affirms the primacy of culture, while relegating politics to a secondary, subordinate position.

For the moment we will not give preference to either of these views. We will however emphasize that by culture we mean not only the sum total of the cultural assets amassed by any given nation—its literature, art, science, and philosophy—but also a certain image of man that unites all people, of which they are often not even fully aware; how he experiences history, life, and his vocation, which is what ultimately defines the public image and endeavors of a given nation. In our age this general concept has a truly singular significance for Russia—because for over half a century her political life, methods, and actions have been in the control of men with very specific ideas that renounce culture completely, transforming it into a mere handmaid of politics.

The politics of this group of people are overtly and deliberately divorced from cultural succession, and for this reason it effectually cannot be susceptible to the influence of culture. In this instance, politics and culture share no common language, though both appear to employ the same words, terms, and concepts. Furthermore, the authorities have their own specific policy regarding culture—but this policy has objectives that are foreign to culture, that are estranged from it, and that ignore it, nor do they even know or understand it.

We may put it this way: as a result of the revolution of 1917, politics in Russia were seized by strangers to culture, who were formed under the influence of ideas and aspirations that destroy culture and comprise a peculiar sphere of anti-culture. The chief hallmark and inspiration of this anti-culture is in fact the complete autonomy of politics from culture—the declaration that politics are, so to speak, fully self-sufficient, having no need whatsoever of any dependence on culture. In the talks that follow we will be investigating where exactly this strange phenomenon of anti-culture originated and what it comprises. For the present we need only note that as long as the political path of the Soviet Union is controlled by people of this ilk, the country may experience political changes, but a *change in policy* is hardly possible.

A change in policy or in the political climate is only possible if the interplay between politics and culture is reestablished, where the link between them is restored, without which politics, whoever may control them, inevitably becomes a deformed, diseased, and terrible phenomenon. For this reason the awakening in present-day Russia of a cultural identity, the advent in her of a highly singular and new *debate on culture,* must be considered an event of extraordinarily important, primary significance.

This should not be understood to mean that culture in Russia vanished and must now be regenerated anew. No, it continued to exist—but it was silenced. Crushed, subjected to political downshouting and duress, limited in its manifestations, Russian culture was doomed to a covert existence,

estranged from effectual, active involvement in the political life of the country.

Over the last ten to twelve years the situation has gradually begun to change. An increasing number of people hold that the matter is not one of political struggle alone, and that first and foremost a certain spiritual mobilization is needed, which would then render it possible to carry on the fight for men's souls. And that a human personality is defined not only by external rules, but by its *content*, its spiritual load—that is, specifically by culture.

The increase in the number of people who understand this must unavoidably lead to a lively discussion of the question of culture—essentially, a debate on the topic—because the nascent new sense of responsibility for the *content* of human life in its aspiration toward the future, at least at the outset, cannot be unified. A protest against the prevailing but pointless and inhuman politics does not yet signify the internal unity of this new cultural identity. And as has happened repeatedly in Russian history, this awakening consciousness is beginning with polarization, with a debate over the essence of Russian culture and, ultimately, the fate of Russia.

What is to be contraposed to these obsolete, inwardly desolate politics that have lost all meaning? Here debate, discussion, and deliberation are inevitable.[i, ii] To attempt to deepen this

i Fragments or sentences in the typewritten radio script that were struck-through and therefore not broadcast have been included hereafter as footnotes.

ii Here debate, discussion, and deliberation are inevitable, albeit initially clandestine, prohibited, and persecuted.

debate, to examine its content in the light of Russian spiritual development, to try to grasp its chief focus—this is the objective of the talks at hand.

Upon this debate and the ever-expanding and deepening quest revolving around its pivotal theme a great deal may depend: the fate of our motherland, its future, and in a sense, perhaps, the fate of the whole world. For the whole world is currently experiencing a crisis of politics and culture, a crisis of a form that has ceased to suit its content, and everywhere this crisis gives rise to disquiet, discussions, and debates. These are occasioned by many phenomena quite unlike like those existing in Russia, but at their very core one also finds the same causes, emphasizing the unity of our world and its destiny.

The role of Russian culture in the global crisis is unique. This is already explained by the fact that in its greatest achievements Russian culture has always been defined by a profound disquiet concerning man and his integrity— and this significantly and advantageously set it apart from the cultures of other nations. On the other hand—and in this lay its great tragedy—throughout the course of its development, as in our own time, Russian culture has always been a culture of the minority, divorced from "the masses," from society at large, and to a considerable degree even foreign to it. For this reason in particular, political endeavors in Russia have at times been concentrated in the hands of anti-cultural forces, engulfed by various simplified and inwardly barren ideologies.

Even in days of yore many people in Russia thought that in order to be "with the people" one had to renounce

culture, while in order to be "with culture" one needed to distance oneself from the people. It is this that lent a particular urgency to the cultural question in Russia. In England, for instance, no one ever suggested renouncing Shakespeare, or Corneille and Racine in France. Nor did anyone ever demand that they be thrown overboard from "the ship of modernity."[27] But in Russia a certain part of the intelligentsia proposed, and even demanded, that culture be renounced in the name of the people—even the preeminent writer Tolstoy with a kind of obsession looked to bast shoes and long braids for the salvation of humanity. And this despite a great, refined, splendid culture, which was created and dawned forth [in] a mere 150 years.

There is an undeniable and tragic pattern in the fact that this state of affairs ultimately led to the accession of "anti-culture" and the complete elimination of culture from politics. It took a grueling, agonizing half a century to produce a renewed awareness of the need for a shift in position—an awareness that politics must be subordinated to culture.

The discussion of culture that is regaining momentum, albeit conducted for the present in hushed undertones, may be characterized as a protest against the hapless subjection of all of life to politics—and also as an awareness of the primary significance of assets, of content, of "in the name of what" and to what public and private life must submit. This protest is no longer against particularities, against any given outrage, lawless act, or crime, nor is it the struggle of one political agenda against another. It is first and foremost a protest against a

politics divorced from any cultural corrective, any assessment from the perspective of independent human values—the foundations of culture. It is a protest against politics as an end in itself, declared to be self-sufficient and self-contained. It is no longer a mere demand for greater cultural freedom or autonomy—no, it is a demand that culture be the criterion of politics.[iii]

Solzhenitsyn's novel *In the First Circle*[28] depicts Russian culture as behind bars, wholly subjected to political authority and cynically used at the Gulag's *sharashka* secret research office specifically to further the agenda of "politics." The fate of culture is a tragic one. But the novel also shows that inwardly culture does not capitulate to politics; that it not only resists, but even gains the moral victory over politics. Likewise depicted is the ongoing dispute amid this culture—a dispute over politics and over the essence of culture itself—and this dispute ultimately comprises the central focus of the novel.

Over twenty years have passed since the time described in that novel. In those years many of Solzhenitsyn's characters have perished—but the ideas they scattered remain, and

iii In order for this demand not only to be heard, but also to be comprehended, for it to become maximally effectual and rousing, simultaneously the very concept of culture must be further developed and recognized; the integrity of cultural identity must be restored. This requires discussion, a conversation regarding the question of culture, which has already begun and which, it is to be hoped, can no longer be broken off.

are taken up by other people. The dispute and the discussion continue, and will continue, because it is a dispute over what is most important, upon which hangs the future of Russia and of the world.

TALK 2
THE DISPUTE OVER CULTURE IN THE SOVIET UNION

In our first talk we already touched on this topic: we said that the dispute and the quest that have commenced are not abstract or academic. For the subject at hand is not essentially that of culture as such, but of culture as a factor determining the social and political life of the country itself, the spiritual climate in which it lives. Here the starting point is the tragic fact that in our country the influence of culture on politics was forcibly terminated, and politics fell into the hands of forces that embody what we have termed "anti-culture." Hence, the new disputes, discussions, and quests in the sphere of culture are both public and even political phenomena. It is the quest of a country and a people for their own soul, the quest for that hierarchy of values without which life becomes meaningless and arbitrary.

We shall attempt to analyze this still-new phenomenon, to examine it, and first and foremost to determine where it originated and why, and what it comprises.

Here, perhaps, the most obvious line of thinking is as follows: the Stalinist years uprooted—apparently leaving no trace—all that once comprised the "revolutionary faith." This revolutionary faith should be understood, firstly, as the uncritical and frequently ecstatic acceptance of a particular ideology, of an entire worldview, the mystical core of which comprises the ultimate, revolutionary transfiguration of the whole world and all of life. Secondly, it means the adoption of a political structure based upon a partisan dictatorship, by means of which this worldview was to come to life, becoming a reality.

But then this faith, along with the adoption of a particular revolutionary ideology, came to an end; this faith crumbled. And the ideology turned into scholastic dogma, whose terminology is banally employed to express any idea—[dogma] which it is considered obligatory to invoke, and which must be forcibly pounded into the consciousness of people who regard it with indifference.

They are indifferent because this ideology is in a state of complete sclerosis and even of degeneration. And this is a tremendously important point. For whatever the case may be, over the course of fully half a century the revolutionary faith, although imposed upon the country, was nevertheless the self-evident way of life for this country, its sole unifying principle—and its loss of this significance first and foremost creates a yawning void that demands to be filled. Here no attempt to return to the old ways of recent experience can suffice, for this void was created by the death of the old ways, by their obsolescence.

Consequently, the first reality of the post-Stalinist, now post-Khrushchev era is the reality of ideological *vacuum.* For some this created the possibility and the exigent necessity of filling it, which gives rise to disputes and quests. Others were driven by this vacuum to cynicism, to the adoption of the purely egoistical principle of "every man for himself." And even if we have no interest in this second reaction to the spiritual void that has formed, we cannot help but recall that attempts at spiritual and cultural renewal, all creative exploration, and the entire dispute over culture are as though suspended over a terrible abyss of disillusionment, desolation, and cynicism. Hence the strenuous nature of the quests and disputes, the awareness that little time remains to extract the toxins poisoning the body. And if we recall the continual persecution by a government incapable of inspiring one to any achievement, but still quite able to "drag people off and not let them in,"[29] we will understand the conditions in which the quests and disputes are taking place.

What then are the well-meaning, forward-thinking people, scattered across the country and as yet isolated from each other, attempting to contrapose to the vacuum that has formed? What new "cultural identity" is discerned in the written and oral testimonies that reach us? To this it must first be stated that these testimonies bespeak not some unified, integral front with a well-thought-out cultural and ideological program, but rather various voices and opinions that represent a variety of quests and aspirations. As has repeatedly occurred in our history, the Russian people have substantiated and derived

and continue to derive their opposition to the current state of affairs, their opposition to those who have shown their incapacity for creativity, from various sources.

In the nineteenth century we had the Westernists and the Slavophiles; in the eighteenth century we had supporters of rationalist "popular enlightenment," and supporters of German idealism and mysticism. Still earlier, in the seventeenth century, there were supporters of the Slavo-Grecian or Latin-Western cultural tradition. Some looked toward the West, others toward the East; some called for a sort of isolation from both East and West; some saw salvation in assimilating technical civilization, others in furthering spiritual, religious principles. And this naturally by no means signified, nor does it signify today, the insolvency of Russian consciousness and its dependence on the outside world: it signifies only that in its best manifestations our culture has always been a synthesis of many cultural traditions. So it is today: amid spiritual ruins, almost devoid of oxygen, alone, the country's creative powers strive first and foremost to open the windows to air out the room, to expel the stale air, to look out upon the world. For some, this may be a window into the past; for others it may be the same old window into Europe, which, however they chop away at it, time and again proves boarded shut; for still others it is a window into a world of spiritual, supertemporal realities. This pluralism, which in actuality only appears chaotic, should be no cause for perturbation: there is no culture without unrest, without dispute, without laborious and creative choices. Furthermore, the country has lived too long

under the duress of anti-cultural dogma, which denies the very principle of unrest and choice. Small wonder, then, that the period of ideological exploration is once again beginning at a certain psychological crossroads …

Outwardly this crossroads was described as follows by one eyewitness of the ideological unrest in the Soviet Union: The "elite revolution," having shaken the monolith built by Stalin, likewise made possible a certain movement in society, and a new force, one independent of the government, began to materialize. For our purposes it may be called the "culture of the opposition." Some writers, who had heretofore adhered to the official line or simply kept silent, changed their tune, and a part of their works was published or distributed in manuscripts. Many young poets, artists, and musicians emerged, typewritten magazines began circulating, semi-legal art expositions began to open, and youth ensembles formed.

"This movement was directed not against the political regime as such, but only against its culture, which the regime itself nevertheless viewed as a composite part of itself. . . . In the meantime, from the bowels of the 'cultural opposition' there emerged a new power that opposed itself not only to the official culture, but also to many aspects of the ideology and practice of the regime."[30]

Within this movement, several primary schools may be discerned. On one flank, which may very loosely be called "the left," are groups that still continue to draw inspiration in one way or another from *Marxism*. In their opinion, the regime has betrayed authentic Marxism, and a return to its pure principles

is necessary. Since this "pure," shall we say "ideal Marxism," which renounces totalitarianism, suppression of freedom, and the suffocation of culture also inspires part of the intellectual class in the West, between this group and corresponding schools in the West there is an undeniable spiritual kinship.

On the other flank are those who may with some reservations be called *neo-Slavophiles*. These emphasize, on the one hand, Christianity and its spiritual values and, on the other hand, faith in Russia's unique mission, her own unique vocation, in resolving the agonizing problems that mankind faces today.

Between these two extreme ideological positions there is also a school that is most easily characterized as "liberal-democratic," founded on the idea of law and order, human rights, and formal freedoms in general.

It should however be emphasized that here we are speaking not merely of political views or political conflict. With good reason all these tendencies are rooted, one way or another, in a "culture of opposition"—and this means that they emerged not from narrow political premises, but from broad cultural terms of reference. For this reason they are inspired first and foremost by literature, poetry, and art—that is, by a broad understanding of the design for private, public, and historical life. Whatever the differences in the artistic or social relevancy of works such as Pasternak's *Doctor Zhivago*,[31] Dudintsev's *Not by Bread Alone*,[32] and Solzhenitsyn's *In the First Circle*, all of them were in a sense stages, not only in the cultural but also in the public and political history of the last decade and a half.

As before, in the nineteenth century culture found itself at the center of political exploration. And the authorities, in their own way, are well aware of this, as all authorities in every place and time have been aware of it. They recognize that the artificial and compulsory subjugation of culture to politics that survived for half a century is slowly but surely coming to an end. They also see how it is becoming increasingly difficult to pass off as culture their own "anti-culture," which they have inculcated to maintain the myth that they are preserving and developing ostensibly authentic culture. A country in which *Doctor Zhivago* and *In the First Circle* could not be printed, such a country is abysmally and terribly diseased, no matter how monolithic it may have seemed to the superficial gaze of many.

Today the first victory may even be said to have been won: "anti-culture" has been unreservedly discredited, and a merging of culture not only with political exploration, but also with these same hopes has already begun or is at least impending.

It is in this atmosphere that the question of the meaning and content of culture, of its mission in human society, is emerging with particular acuteness. And, as we stated in our first talk, the living creative forces are now once again returning to the same age-old question that faced Russian consciousness no less acutely one hundred years ago: the question of culture and how it relates to "liberation"—the liberation of man, society, and nation. To this question and how it has always stood in Russian self-identity we will proceed in our next talk.

TALK 3
"Culture" in Russian Self-identity

I n our first talk we said that for Russian self-identity, at nearly every stage of its development, a unique contraposition of "politics" to "culture" is typical. And any attempt to analyze the modern dispute over culture and how this dispute pertains to the political tragedy in which we are living should begin specifically with this very unique and very Russian phenomenon. Naturally, everyone remembers the famous assertion of one of the great leaders of the Russian revolutionary intelligentsia of the nineteenth century: "Boots are superior to Shakespeare."[33] Everyone remembers the passionate, ecstatic discreditation and repudiation of culture by our preeminent writer Leo Tolstoy in his article, "What is Art?"[34] Yet the same was said, albeit somewhat differently, by Count Benkendorf, minister of Nicholas I, regarding Pushkin: "Writing poetry," he stated, "is not the same as pursuing a useful occupation."[35]

Gogol burned the manuscript of *Dead Souls*[36]; in his *Diary of a Writer*[37] Dostoevsky wanted more to be a politician and an ideologist than a writer. Turgenev had dreams of being forgiven

by the intelligentsia for his "art for art's sake" if he wrote a "topical" novel. But the simple peasant had never even heard these names: Pushkin, Gogol, Turgenev, Dostoevsky, Tolstoy. He would likely have agreed with Smerdyakov that poetry and writing in general is a frivolous, pointless affair.[38]

The history of Russian culture has always been tragic. In the 150–170 years of its staggering florescence it was never truly accepted by the nation that created it. When the great French poet Paul Valéry described nineteenth-century Russian literature as the eighth wonder of the world,[39] not more than 10 percent of the Russian people were familiar with this literature. Such is the tragedy, such is the paradox of Russian culture, and this naturally explains much in both the political and the spiritual history of the Russian people.

In speaking of Russian culture we must first determine the scope and content of this concept. Here it should be said that Russian culture can hardly be treated as some organic magnitude. In actuality, in Russia there were—and to some degree remain—not one, but essentially *three* cultures, three cultural traditions. A link between them naturally exists, but it differs profoundly from the continuity that links, for example, the medieval English poet Chaucer[40] and modern English writers, or the poets of the sixteenth-century French *Pléiade*—Pierre de Ronsard, Joachim du Bellay, and Clément Marot[41]—with the poets of the romantic period. The reason for this is apparently that the development of Russian culture must be considered not "organic," but rather "revolutionary." The first cultural revolution was brought about by Peter the Great. He sharply

differentiated between Old Russian culture—that of Moscow and Kiev—and the new culture borrowed from the West and almost forcibly transplanted into Russian soil.

Thus, here we have two cultures: one, which is customarily termed "Old Russian," and another, which with such singular luster and inimitable depth emerged from the Petrine *assemblée*[42] and only a few decades later produced Derzhavin, Pushkin, and all that we were given after Pushkin.

But we have also a third "culture," one likewise originating from the Petrine revolution, but which should not be confused with the culture of Derzhavin, Pushkin, and Gogol. This third culture may be called technical or pragmatic culture. In his spiritual constitution, Peter the Great himself was specifically a technicist and a pragmatist. He wholeheartedly loved technicians, mechanics, and professionals.[i] Due to this love of Peter's, Russia, that backward agrarian country, found itself so to speak "psychologically" integrated into the dispositions, interests, and endeavors born in the West out of the industrial revolution that was beginning in Europe.

It is however extremely important to note the following: these three "cultures," born of different sources and isolated from each other by seemingly nearly impenetrable psychological and existential barriers, practically *coexisted* side by side

i He wholeheartedly loved technicians, mechanics, and professionals, who had fascinated him even as a child in Moscow's suburban German Quarter, and he retained this love for technical-pragmatic culture for the rest of his life.

in Russia. They did not follow or derive from one another in succession, albeit a revolutionary succession, or in accordance with historical continuity, but continued to exist, creating different strata, different "consciousnesses," one might almost say—"different worlds" within the very body of the people.

First and foremost, nearly all of peasant Russia, about 80 percent of the country's entire population, found itself outside the Petrine "cultural revolution"—which in turn means outside the culture of Derzhavin and Pushkin, as well as outside the pragmatic-technical culture. But did these masses remain outside culture altogether? No, for its culture remained the first, old culture that was almost wholly defined by Christianity and church life. If this were not so, if the Russian peasantry or, as enlightened Russia later came to call them, *the people* uninvolved in the Petrine "enlightenment" had turned out to be mere rude, primitive savages, what could explain the mysterious, incessant pull that "the people" exercised upon enlightened Russia, who turned to the people in search of wisdom, mysterious truth, healing, linguistic purity, and so on? Whereas Pushkin learned the Russian language at the prosphora bakeries of Moscow,[43] Dostoevsky ascribed his epiphany to the people—the benighted people of his imprisonment and exile, at that—and Tolstoy with characteristic directness compelled himself to emulate these people, to become like them himself.[ii]

ii No one in any place but Russia has ever "gone to the people"—and this fact cannot fail to be of tremendous cultural significance.[Going to the People (Хождение в народ) was a diffuse Populist movement in the

Later on we will speak more of the content, meaning, and fate of this "culture of the people" in the development of Russian cultural identity. For the present we will proceed to the third, technical-pragmatic type of culture. In the Petersburg-Petrine period of our history, a considerable percentage of "enlightened" Russia, no longer "of the people," pertained to this cultural type. Here culture was understood first and foremost specifically as "enlightenment," as the acquisition of a certain quantity of official, useful "knowledge." Already in the Petrine era there appeared a type of person that was obsessed with "usefulness," a person spiritually born in the West in the "Age of Enlightenment" with its limitless faith in encyclopedias and diagrams and its equation of culture with knowledge— or, more precisely, its equation of it with exact knowledge. It was among people of this type that the word *science* gradually underwent a semantic rebirth, becoming narrowed to the confines of "natural science" alone. This, as has been stated, is the technical and practical culture.

Knowledge and usefulness—knowledge intended to be immediately, directly useful. But this type of people included not only the intelligentsia that was gradually emerging in Russia, but also, strange as it may seem, the empire's entire enormous bureaucratic administrative and military apparatus. The officials and officers—who were very numerous

Russian Empire in the second half of the 1860s–1870s that advocated a social revolution. —Trans]

indeed—essentially lived by an awareness of the absolute conviction that they were being "useful" to the fatherland. Consequently, their entire understanding of culture, their knowledge, and their training for their profession or vocation was wholly permeated with this idea of usefulness, and was reduced almost exclusively to it. For this vast stratum of people there was no further "quest" for or "refinement" of culture.

Individual groups within the technical-pragmatic culture could be mortal enemies of one another. For example, the military class and the intelligentsia disdained each other; nevertheless, both these groups belonged to the same "cultural" type. They could also differ completely in their understanding of "usefulness," yet both still lived by the same concept of usefulness. Most importantly, of course, the psychological limitations of their spiritual outlook grounded in this pragmatic "usefulness" frequently rendered them practically impermeable to assimilating and understanding our *second*[44] culture—the one that may most appropriately be linked, first and foremost, with the names of the great Russian writers, but naturally not with them alone.

As fate would have it, and for the reasons just mentioned, in our country this second culture proved the culture of a minority—one might even say of an insignificant minority. Incomprehensible to "the people," it also proved foreign to those of the technical-pragmatic culture. And yet, in one way or another, all three of these cultures were obsessed with Russia, its fate, and its mission; all of them were in this sense "of the people," and all of them—at their core—supplied some authentic, vital need.

Neither Pushkin, nor Suvorov, nor Chernyshevsky, nor Sera-
phim of Sarov can be struck not only from Russian history, but
also from Russian "culture." But while they cannot be struck,
it is no easy thing to "unite" them, to see them all from some
common perspective, to transform them into a kind of unified
"synthesis."

For this reason when we Russians speak of culture, in
actuality and most often even subconsciously we customarily
choose our own culture—the one with which we feel a spiritual
connection. But what renders the modern dispute over culture
particularly important is that now, perhaps for the first time, we
must necessarily raise the question not of choice, but specifi-
cally of *synthesis.* For this tragedy in which we have now lived
out so many years, this primarily political tragedy—is it not in
fact rooted in this cultural "crossroads," in the absence of coher-
ence in Russian cultural identity? And to overcome and heal
this tragedy—does this not mean first and foremost to restore
the unity that was lost so long ago?

In order to answer this question we must take a closer look
at the true essence of our three cultural types and attempt to
understand their inner dynamics. This we shall undertake to
do in the talks that follow.

PARADOXES OF RUSSIAN CULTURAL DEVELOPMENT: MAXIMALISM

Culture is linked with a sense of moderation, an awareness of limits. The ancient Greeks, creators of one of the greatest cultures in the world and, in a sense, the mothers of our modern global culture, made central to the understanding of culture the concept of *metros*—an adjective signifying moderation, harmony, and consequently the natural *limitedness* of any perfection. Moderation presupposes order, framework, structure, form, conformity of form to content, completeness, and closure. The creators of this cultural tradition apparently understood that the most difficult thing in creative work is in fact self-restriction, recognizing limits and, in a sense, humbling oneself before them.

Incidentally, one of the paradoxes of Russian culture lies in the fact that from the very beginning one of its principal constituent traits has actually been a sort of renunciation of this very "metros," a sort of pathos of maximalism, which aspires to eliminate both moderation and limits. The paradoxicality of this trait lies in that the pathos of maximalism

is specifically inherent in Russian culture itself. On previous occasions, and not only in Russia, maximalism, fanaticism, and renunciation of culture had quite often led to the destruction of cultural assets in the name of various other values—but this was clearly an extra-cultural or anti-cultural phenomenon. In our country—and in this lies the paradox—this sense, this impulse was inherent to the vehicles and creators of culture themselves. And this introduced and introduces a particular polarization within culture itself, making it fragile and often controversial, even seemingly spectral.

The sources of this maximalism should be sought in Old Rus's adoption of Byzantine Christianity. Hundreds of books have been written on the meaning and significance of this fundamental event in Russian history; in one way or another it has always been at the center of Russian debates and quests—and yet its particular significance for the fate of Russian culture compels us to return to it time and again.

We will pause only on one aspect of this phenomenon, which will help us to explain the constant tension in Russian cultural identity, its constant association with a certain truly explosive maximalism. Many Russian historians note that Rus' adopted Christianity in its Byzantine visage with comparative ease. But far more rarely has it been observed that this adoption process by no means assimilated all that constitutes the concept of "Christian Byzantinism." The pivotal difference here came down to the fact that Christian Byzantium was heir to the vastly rich and profound culture of Greece.

Kievan Rus' had no such cultural heritage. For the Byzantine, Christianity was the crown to a long, complex, and infinitely rich history, the "churching" of an entire world of beauty, thought, and culture. Old Rus' could have no such cultural memory, no such sense of "crowning" and completion. It is therefore natural that Byzantium, on the one hand, and Rus', on the other, had a different perception of the "maximalism" inherent in Christianity.

That Christianity is maximalistic need not be debated. The entire Gospel in built upon the maximalistic call: "Seek first the kingdom of God," upon the invitation to abandon all, to renounce all, to sacrifice all—in the name of the Kingdom of God which is to come at the end of time. Nor can it be said that Christian Byzantium in any way "minimalized" this call or mitigated its categorical nature. But in the complex system of Christian dogma that Byzantium developed, its maximalism was presented as a certain "hierarchy of values," in which the values of this world—first and foremost the values of culture—found their place and were thereby justified in one way or another. The whole world was as though sheltered beneath the majestic dome of Hagia Sophia, Divine Wisdom, which poured forth its light and its blessing upon all of human life and culture. But the dome of *Kiev*'s Hagia Sophia, patterned after and inspired by that of Byzantium, essentially had nothing to shelter or bless: Old Kievan Rus', practically still in its infancy, had no "hierarchy of values" to be reconciled with the maximalism of the Gospel. In Rus' there was essentially no place and no background for the complex yet symmetrical correlation

between culture and Christian maximalism that comprises the essence of Christian Byzantium, for one of the composite parts of this correlation was lacking: namely, an old, rich, profound culture.

Old Rus' did not have to undergo the long, complex, often-agonizing process of reconciling culture with Christianity, the Christianization of Hellenism and the Hellinization of Christianity—a process that marked five to six centuries of Byzantine history[i]; it hardly even had a history. But this means that Byzantine Christianity was adopted by Rus' simultaneously as faith and as culture, and consequently the *maximalism* inherent in the Christian faith also proved in practice to be one of the chief foundations of the new culture.

In adopting Byzantine Christianity, Rus' took no interest in Plato or Aristotle, or in the entire Hellenist tradition that for Christian Byzantium remained a living and vital reality. Old Rus' surrendered not a modicum of its soul, its attention, or its interest to Byzantine "culture." Historians emphasize that, despite its abundant ecclesiastical and political connections with Constantinople, Rus' was wholeheartedly drawn not toward it, but toward Jerusalem and Athos—toward Jerusalem as the place of Christ's real history, His abasement and suffering, and toward Athos, the monastic mountain, as a place of real Christian asceticism. More than all the subtleties of

i —a process that marked five to six centuries of Byzantine history: as yet, Old Rus' had nothing to reconcile, it hardly even had a history.

Byzantine dogma and all the splendor of the Byzantine ecclesiastical and cultural world, it was the image of the crucified and abased Christ of the Gospel, as well as the heroic figure of the ascetic monk, that permeated the self-identity of Rus'. Russian Christianity remarkably began without a school or a scholastic tradition, and Russian culture somehow immediately found itself concentrated in the temple and in worship.

Naturally, a Russian Christian culture also began to take shape. But it is one thing when a church is built in the middle of an ancient Greek city that is saturated with culture, in which one purpose of the church is to unite the culture with Christianity, to "Christianize" it—and quite another when that same church becomes *everything*—both faith and culture. This is what happened in Rus'. Its culture, its true culture, became concentrated in the temple, in which its essence became, so to speak, "self-conviction," a call to maximalism that demanded a rejection of "the world." All that was authentic, beautiful, and great in Old Russian culture is at the same time a call to *abandon*, to reject, to *renounce*—and if not to abandon, then to devote one's efforts to building an ultimate, perfect "kingdom," wholly inclined toward heaven and living by it, in which all without reservation is subjected to "the one thing needful."[45]

So it was that maximalism became the destiny of Russian culture and of Russian cultural identity. Culture as "moderation," culture as the "limit" and "form," was what least inspired it both in the past and in the time that followed, when the direct link between Christianity and culture was severed. In

a sense it may even be said that our Russia never formed the very concept of culture as an aggregate of knowledge, assets, historical treasures, and ideas—an aggregate handed down from generation to generation to be preserved and increased, and simultaneously as the measure of creativity. Because Christian culture, which found expression in the temple, in worship, and in daily life, by its very nature proved foreign to the idea of development and creativity, and became sacrosanct and static, excluding the possibility of doubt or exploration. We simply had no other culture.

Consequently, all creativity, all exploration, all change was perceived as mutiny, nearly as sacrilege and anarchy, and consequently the essence of culture as creative continuity was not established.[ii]

Such are the sources of maximalism in the sense of a renunciation of moderation and limits that is so often encountered in the complex dialectic of Russian cultural identity. And this maximalism could not be eradicated even by the Petrine cultural reform that so abruptly initiated Russia into the Western cultural tradition. Here a telling paradox may be observed: one product of this initiation into Western culture, the great Russian literature of the nineteenth century, manifested for the West as something that explodes from within the very "moderation" and "limits" of Western culture, introducing into

ii Every creator by definition also found himself a revolutionary: he could only create or establish something fundamentally new on the ruins of knowledge that did not admit of any development or revision.

it the explosive matter of quests, epiphanies, and tensions that erode its sedate, symmetrical edifice.

There is profound truth in the famous words about the Russian boy who, when shown a map of the star-studded heavens, returned it half an hour later corrected.[46] The Russians after Peter proved to be astonishing students. All the technical resources of Western culture were assimilated by Russia in under a century. But the students, once they had learned, naturally and almost unconsciously returned to what had been instilled in them from the very beginning—namely, to the maximalism that in the West had been almost wholly "neutralized" by centuries of intellectual and social discipline.

This also pertains, albeit in different ways, to all three layers of Russian culture of which we spoke in our previous talk. In the culture of the people, the culture which we have termed technical-pragmatic, and finally the culture of Derzhavin, Pushkin, and Gogol—everywhere we see a gradual accumulation of explosive maximalism, as well as a sense of the impossibility of being satisfied *solely* by culture, perhaps because it lacks the skills and methods needed to resolve the questions that man encounters. This in turn brings us to the second paradox of Russian cultural identity: the *minimalism* instilled in it, which is contraposed to the maximalism of which we have spoken today.

 TALK 5

Paradoxes of Russian Cultural Development: Minimalism

In the previous talk on the foundations of Russian culture we spoke of maximalism as one of the characteristic properties or even paradoxes of Russian cultural development. We link this maximalism to the Byzantine Christian roots of Russian culture, which imparted to it an aspiration to achieve moral and religious perfection, while relegating to the margins, somewhere off in the background, all awareness of the need for everyday, routine, always inevitably limited cultural "work." But as is well known, maximalism almost always coexists fairly easily with minimalism. If anyone wishes for too much, for *everything*, for what is *unfeasible*, when this "everything" proves unattainable he comparatively easily reconciles himself to "nothing." "A little" or "at least something" seems to him unnecessary, neither here nor there, not worth his interest or effort.[i]

i To a certain degree this is what occurred in Russian cultural development: this trait of "all or nothing" in our national visage is frequently

Absolutes in assertions lead to absolutes in negations: this polarization may be traced throughout the entire development of our national identity. For example, the history of the governmental and cultural formation of Muscovite Rus' corresponds to and is countered by the history of its constant "erosion" from within by renunciation, abandonment, and rejection. When in the second half of the fifteenth century the governmental and national identity of Moscow was formed, it immediately assumed the extreme maximalist ideology of the Third Rome, the sole, ultimate, purely Orthodox Kingdom, after which "there will be no fourth."[47]

But this maximalist self-assertion and self-aggrandizement were accompanied more or less simultaneously by a sort of cultural nihilism. From this perspective the so-called heresy of the Judaizers,[48] which then held sway over practically all the highest ranks of Muscovite society, was quite typical. An astounding feature of this infatuation was the ease of the break with native tradition, the insistent, almost-passionate desire to cut ties with all the customary criteria of faith, thought, and culture, and to be reincarnated as something wholly opposite. The protopopes of Novgorod and Moscow, the crown and bulwark of the educated class of the time, secretly changed their Russian names to Hebrew names from the Bible, as though thereby renouncing their very personalities. This was effectively an unprecedented, enigmatic phenomenon,

pointed out by historians and critics of Russian culture, and it has often served as a theme in fiction.

but it is explained with comparative ease by a peculiar feature of Russian culture: it contains a recurring aspiration to break free from history, from "endeavors," or at any rate to reduce its endeavors to a minimum for the sake of some otherworldly ideal, which in history, in our earthly life, in our "endeavors" cannot be realized regardless. Minimalism in Russian cultural development manifests predominantly in a stubborn opposition to any changes whatsoever, to the very idea of reform, improvement, or development. A peculiar anarchism, anti-historicism, and quietism flavor the writings of Nilus of Sora, who headed the movement of the "Non-possessors"—a movement that protested not only the "possessiveness" of the church, the monasteries, and the clergy, but even the very idea of any historical responsibility whatsoever, of any involvement in history.[49]

The same sixteenth century saw the striking and telling tragic fate of Maximus the Greek, who came to Rus' by official invitation to offer his creative criticism of Muscovite culture.[50] In Moscow he encountered almost cataclysmic opposition and hostility on the part of the clergy, and practically his entire life there was spent in spiritual confinement. Also noted in history is the passivity of an immense part of the population in the critical years of the Time of Trouble—its apparent "self-recusal" from responsibility for the fate of the nation.

"The people are silent." This closing note in Pushkin's *Boris Gudinov* pertains not only to the fact that in those years the people were incapable of breaking their silence, but also to the fact that they had no desire to do so.[51] The fate of Russia and its culture has almost always been decided at the upper

levels, by a small group of earnest political leaders and activ-
ists, whose efforts often ran up not so much even against hos-
tility as against the indifference of the masses. Furthermore,
the sympathies of the masses often ended up being not with
the builders and reformists, but with the deniers, skeptics, and
those who were historical and cultural minimalists of a sort.
For example, the leaders of the seventeenth-century schism
headed by Protopope Avvakum were not benighted, ignorant
people: they belonged to the cream of Muscovite society, to
those who were the vehicles of its self-identity. Their resist-
ance, nevertheless, was directed not against the excesses of
the Nikonian reforms: they rejected the reforms as such. "Let
that which was instituted before us so remain forever"—this
phrase was not an expression of traditionalism or conserva-
tism, but a renunciation of history and historical endeavors.[52]

Religious maximalism often transforms into historical and
cultural minimalism. And it must be acknowledged that the
vehicle of Russian culture, the Church, in pre-Petrine society
was also the primary factor in cultural minimalism. But it did
not disappear even after the Petrine revolution, which almost
violently imposed upon Russia the cultural tradition and cul-
tural experience of Western Europe. To be sure, the superhu-
man efforts of Peter the Great in Russia produced a cultural
stratum that in a very short time created a great and illustri-
ous culture in its turn. But as early as Pushkin each person
who contemplated the fate of this culture could not help but
acknowledge the paradoxical nature of its existing seemingly
in spite of the environment, the society, and the country for
which it was created.

The peculiar cultural minimalism in Russia spread not only to the government but to society itself, which gradually and increasingly contraposed itself to that government. Pushkin noted, "In other lands writers write either for the crowd or for a select few. In our country the latter is impossible: people must write for themselves."[53]

Characteristically, in the lengthy and passionate musings and debates over our country, its meaning in history, the goals of its existence—in disputes that have marked all of Russian intellectual life—somehow hardly anyone equated Russia with the established Russian culture that already exists. Chaadayev, who launched this dispute in the nineteenth century, called Russia "a blank sheet of paper" upon which nothing is written[54]—yet he wrote his *Philosophical Letters* at a time when the majority of the works of Pushkin, Baratynsky, Zhukovsky, and Derzhavin before them had already been written. Chaadayev seemed not to notice this, and for him Russia remained merely something anticipated, belonging to the future—a future "possibility."

Khomyakov and the Slavophiles saw the essence of Russia either in the past or else in the people who were uninvolved in culture. Even Dostoevsky, in his renowned "Pushkin Speech," said that Pushkin is "our everything,"[55] and praised him not so much for his labors in building culture as for a sort of mysterious gift for "universal sensitivity,"[56] viewing him primarily as the prophet of a certain future messianic era substantiated by Russia.

What besides an odd indifference to culture as such, to its tradition, to its quality, could explain the fact that *after* Pushkin,

after Lermontov and Tyutchev, an entire generation could be enraptured with the poetry of Nadson?[57] Pushkin himself, musing on the indifference of the Russian public to dramatic art, quite aptly wrote: "A significant part of our society is too occupied with the fate of Europe and the fatherland … too introspective, too important … to take any part whatsoever in the dignity of dramatic art, and Russian art at that."[58] He could have written, "of art in general."

Let us reiterate: these phenomena by no means resulted from a lack of education or culture, but from a strange maximalism of hopes and expectations—a maximalism that made it hard to link these hopes with ongoing cultural efforts and to make every effort to aid them. But naturally this cultural maximalism reached its greatest extremity and expression after the Russian intelligentsia was definitively formed into a sort of emancipatory revolutionary "order," with the simultaneous formulation of "security forces" opposed to it. Both here and there authentic culture was, in a sense, simply ejected from the hierarchy of values. In the circles of the intelligentsia, Gorky's "Stormy Petrel" was contrasted to the poetry of C.R.—the great prince Konstantin Konstantinovich, who was studying in the cadet corps.[59] Usefulness, enlightenment, and emancipation were, on the one hand, the glory of the fatherland, yet on the other, in equal measure, they excluded culture as a component and the foundation of both enlightenment and glory.

All this suggests conclusions that are important when attempting to understand the disputes and quests of today, as well. In Russian cultural identity the concepts of "Russia"

and "Russian culture" essentially never acquired content that was universally accepted, indisputable, and not subject to reassessment. No synthesis occurred—and for this reason, on the one hand, the perpetually ongoing debate over these concepts continued. On the other hand, one's attention is drawn to the passionate nature of this dispute, so characteristic of it at its every stage—to its polarization, its extremes. For some, Gertsen, Belinsky, and Chaadayev do not belong in the concepts of "Russia" and "Russian culture," while for others the same is true of Khomyakov, Soloviev, and Leontiev. The Slavophiles in each new reincarnation lash out at the Westernists; the Westernists are still incapable of hearing and understanding the Slavophiles. And this is because "maximalism," still integral to Russian self-identity, continues to accept as dogma the primacy of "politics" over "culture"—and effectually proves incapable of culture—that is, of taking the sum total of the quests and achievements, the spiritual world created by each nation, and seeing in them the only possible criterion, as well as the content, of "politics."

If Russian culture did not exist as a long-since substantiated and actual world, there would be no need to speak of any of this. But it *does* exist, and it is this culture that comprises the core, the finest and indestructible essence of Russia. This is why, without overcoming both her cultural maximalism and minimalism, she is intrinsically incapable of moving forward.

Paradoxes of Russian Cultural Development: Utopianism

In our previous talks devoted to the foundations of Russian culture we spoke of two paradoxes of our cultural development, of its contradictory and paradoxical manifestation of a peculiar maximalism and a peculiar minimalism. The Byzantine Christian roots and inspiration of Russian culture demanded that the Christian ideal somehow be wholly put into effect immediately, without preparation, without lengthy assimilation and adaptation—and these same roots, which traced everything back to religion, to gospel perfection, in some strange way facilitated the development of minimalism in Russian consciousness—an indifference toward prosaic everyday earthly affairs. To these two paradoxical factors of Russian cultural development today we will add a third—namely, the factor of utopianism.

Russian consciousness has sinned much and often by utopianism—not in some given period of its development or its history, but almost constantly. This development itself may in some sense be envisioned as a constant struggle between

realism and utopianism, between consideration of actual circumstances and actual reality and a certain continual excarnation of the mind and the imagination. Utopianism is a frame of mind that is the opposite of empiricism. The empiricist proceeds from sober consideration and analysis of the facts and the possibilities inferred from them; conversely, a typical trait of the utopian is indifference, if not disdain, for consideration of the facts and the actual circumstances. The utopian aspires to subject reality to the ideal, and for him what matters most is the conviction that this can be achieved.

The source of utopianism in Russian history and in the development of Russian culture must be acknowledged, once again, to stem from Byzantine influence, which for Rus' became the sole foundation of its culture. The elements of utopianism were present in Prince Vladimir himself, the first builder of Kievan Christian sovereignty. One chronicle contains an account of how the Greek bishops had to persuade Vladimir to employ the death penalty when necessary, which he, now a Christian, felt to be incompatible with his new faith.[60] And this is a very characteristic incident, especially when compared with certain general trends in early Russian consciousness.

Professor Fedotov, for example, convincingly demonstrated that the astounding popularity of the two first Russians to be canonized, or declared saints—namely, Vladimir's sons, Boris and Gleb—is due to the people's veneration of their ascetic feat of *non-resistance to evil*.[61] Boris and Gleb voluntarily accepted sufferings and death, seeing in this passivity the supreme imitation of Christ Himself. They could have defended themselves or fled, but they did not wish to do

so: they preferred to yield and sacrifice their lives. Of importance here is that public consciousness in the veneration of these saints adopted their feat as the standard, just as previously public consciousness had adopted and remembered the particular soft-heartedness of Vladimir, which would appear to have bordered on irrationality.

The element of utopianism, of faith in an ideal "fraternal love," may also be discerned in the establishment by Yaroslav the Wise of the system of domains that proved so destructive for the state.[62] Moscow's elevation and ultimate political victory were connected to a rejection of utopianism: here, on the contrary, a sober rationalism was apparent, at times even bordering on cynicism, but even then utopian tendencies did not vanish entirely from Russian self-identity. They manifested, for example, in the attempt to establish the ideology of Moscow as the Third Rome, particularly in its roots, its monastic and religious origins. This did not become the official ideology of the state, but heavily adorned in utopian hues, permeated with utopianism, it did influence the minds of that time. This ideology proclaimed that the kingdom of Moscow was called to implement a certain last, supreme truth on earth, as the curtain descended, so to speak, upon the process of history.

It is very typical of the utopian mentality that the ideal which it proclaims is not as a rule connected with a specific program for its execution and implementation. Tyutchev's famous statement that "in Russia one can only put his faith"[63] signifies, from this perspective, a peculiar self-sufficiency of the ideal and of faith in it, as if these neither presupposed nor required any effort or strain for their execution in practice.

Utopianism always contains an element of vanity and pride that is nevertheless wholly unfounded. Faith in "the simple people" and the ultimate, wisest answers to life's questions that these people allegedly preserve, a readiness to reduce all of life's complexity to simple, absolute theories, a habit of madly throwing one's whole being into any absolute, even one poorly thought out, if only it appears to be an "absolute"— all this is the fruit of utopianism, which all too often leads to starry-eyed idealism, to a paralysis of the will, to consoling oneself with ideals and ideologies that are sublime but utterly divorced from reality.

In the sixteenth century, indubitable utopianism tinted the struggle between religious and political innovators such as Patriarch Nikon and religious and political conservatives like Protopope Avvakum and other standard-bearers of the Old Believers. Here it is important to emphasize that utopianism was characteristic of both camps. Whereas the ferocity of Patriarch Nikon and his followers was founded on belief in a Greek Orthodoxy of utopian perfection, the ferocity of Avvakum and his confederates arose from belief in an ideal utopian "Holy Russia" that never actually existed.

Thus, gradually a habit was formed of acting, evaluating, and thinking in isolation from reality, and sometimes of disregarding it altogether, of not taking reality into account.

Utopianism in Russian consciousness particularly intensified after the Petrine revolution. In a sense it divided Russia into a "realist" camp and a "utopian" camp—and the more time passed, the more obvious and profound the gulf between

these two attitudes of consciousness became. Here it would be incorrect to equate (as is often done) "realism" with the state bureaucratic apparatus, and "utopianism" with the intelligentsia which the state apparatus allegedly separated from "reality." In this, perhaps, lies the tragedy of Russian culture, of Russian consciousness—that to a significant degree "utopianism" proved inherent in nearly all strata without exception of Russian society, in all its complexity and variety.

For example, one utopianist was Paul I, who saw a Russia modeled after Prussia as the ideal government. Another utopian was Alexander I, who aspired to subjugate Russia's foreign policy to the utopia of a Holy Alliance, one that almost overtly conflicted with the actual interests of the Russian state.[64] Utopian tendencies have in fact often been inherent in the government itself, when it acted not based on a realistic assessment of the interests and abilities of the country, but based on *a priori* utopian ideological attitudes.

Utopianism had a particularly powerful effect on the dialectic of Russia culture. Much in the latter, of which we will speak in later talks, is determined by a sort of utopian explosion against the transparent "realism" of Pushkin—an explosion rooted in social, political, religious utopianism. It is this that created the conditions for a singular persistence of Russian culture, its tendency to staggering ascents and to equally staggering falls. It is as though always open to a complete and unconditional reassessment of all values under the influence of the latest utopia, the latest "absolute" ideology. Utopianism rebels specifically against continuity, against

tradition: it always wants all or nothing, and it is prepared to burn the past to ashes in the name of its truth. It contradicts "form," the very principle of "form," for the absolute can never be confined by form, and demands from within that it be vanquished and destroyed. In this sense utopianism as a cultural factor is always an anti-cultural phenomenon, even when the loftiest vehicles of culture are its vehicles. Leo Tolstoy, for example, was at once the apex of Russian culture and the explosive charge placed within that culture.

Utopianism is characteristic both of Russian social thought and of Russian political consciousness. In his book on Russian communism Berdyaev noted that it is typical of Russian consciousness either to seek an ideal form of society or else to give way to overt cynicism.[65] The entire history of Russian social thought is permeated throughout with this inclination toward utopianism, with lofty disputes wholly divorced from reality. Throughout the entire nineteenth century perhaps no one had such "resonance" or was the center of such a cult as was Chernyshevsky. Yet Chernyshevsky was one of the most vivid adherents of almost total blindness to actuality, of a near-pathological lack of understanding of "possibilities" and "impossibilities."

Thus, utopianism is found to a greater or lesser degree in nearly all manifestations of Russian culture and Russian social consciousness, finding expression in a gravitation toward extremes, in a refusal to adopt a "medium," to agree to a necessary compromise. It is often an even squeamish repudiation of real life in the name of a life that is nonexistent and ideal.

In the gravitation toward utopia we naturally see the effects of moral maximalism, depth, sublimity, fidelity to "the music in the spheres" that could not replace the earthly "songs of the wearisome years" in Lermontov's unforgettable poem.[66] But in it there also lurks a terrible danger. This is the danger of ignoring reality, of a kind of blindness to evaluating and understanding life, which in turn often leads to an inability to arrange and organize everyday life, and incurs untold and unnecessary suffering and victims. All this we should remember as we attempt to understand the foundations of Russian culture and the complex path of its dialectic development.

Western culture began with the basics, with a laborious effort to master Latin grammar, as well as the art of linking ideas with reality, of checking them against actuality. Russian culture began with a kind of sudden spiritual ascent. And while it remained faithful to this ascent in all the finest and greatest of its creations, it likewise had to endure no little suffering for want of a prosaic but firm foundation. The astounding *Tale of Igor's Campaign* was incomprehensibly created without any preliminary preparation—and it saw no continuation throughout all of pre-Petrine Russian culture. In the same way, it appears, the magnificent edifice of nineteenth-century Russian culture often "imposes no obligations"[67] and is not reflected in a consciousness that is lacking a certain necessary discipline. This, apparently, is the fruit of utopianism in the culture whose foundations we will continue to discuss in the talks that follow.

THE "EXPLOSION" OF RUSSIAN CULTURAL IDENTITY IN THE NINETEENTH CENTURY (1)

The renowned French writer Paul Valéry called nine-teenth-century Russian culture the eighth wonder of the world.[68] And indeed, from many perspectives it is indeed a wonder. First and foremost, of course, what is astounding and nearly inexplicable is its florescence a mere century after the far-reaching revolution enacted by Peter the Great. We must not forget that when Shakespeare was at work in England, Ivan the Terrible reigned in Russia; that the golden age of French classicism—Cornelle, Racine—coincides with the reign of Alexei Mikhailovich and the church schism in our own country. We also must not forget that France and England required many centuries to produce the zeniths of their national cultures, while Russia made do with only one. Consequently, the first thing that strikes us in the development of Russian culture is that it almost immediately entered its own "golden age," and that its maturation took the form of a kind of "explosion."

The second distinguishing and also wondrous trait of this culture is that it was specifically created as the result of a profound "cultural revolution." We would be hard pressed to otherwise term Russia's transition from the old ways to the new which Peter the Great so dramatically implemented. In England, for example, a direct line of development and continuity links Shakespeare with Chaucer, one of the founding fathers of English literature. The French classicists of the seventeenth century would be unthinkable without the renowned poetic *Pléiade* of the sixteenth century and the entire gradual maturation of literary tradition that preceded. In Russia, however, this development occurred with nearly lightning speed, immediately, and without any preparation, without preliminary development—and led to a qualitatively new phenomenon. We need only compare the Russian language from the edicts of Peter the Great with the stanzas of "The Bronze Horseman,"[69] the most perfect in Russian poetry, in order to see the near gulf that separates them ...

Finally, the third wonder is the renowned gift of "universal sensitivity" of which Dostoevsky spoke in his "Pushkin Speech" and which indeed marked Russian culture at its zenith, which it reached in the nineteenth century, from the very beginning. A country which for several centuries had been disconnected from other cultures, from "the great family" of the human race, as Chaadayev expressed it,[70] not only joined this family with ease and managed to reflect in its own culture the cultural values of other nations, but also [succeeded] in producing within itself a kind of creative synthesis of these cultures.

All this must be borne in mind when speaking of the foundations of Russian culture and attempting to understand its complex and at times tragic "dialectic" of development. We will therefore dwell briefly on each of the aspects of the "wonder"[71] that is Russian culture. For this "wonder" is naturally a rhetorical expression—a kind of conventional term. "Wonders" of this magnitude and of this depth do not just happen, however wonderful the advent of individual geniuses, for example, may appear. The genius first and foremost requires the material and the environment for his genius to materialize. Dante could not have appeared had Italy then lacked the experience of creating many centuries of great medieval culture and the "world perception"—the understanding, vision, and experience of the world—that shone through for all time in the *Divine Comedy*. Consequently, the first "wonder" of Russian culture—its maturation with near-lightning speed—requires an explanation, which will in turn aid us in understanding its foundations.

In comparison with Petrine and post-Petrine Russia, Old Rus' is strikingly "silent." But, as one historian of Old Rus' wrote, in those centuries of silence much was thought over, lived through, and felt out. In other words, the remarkable culture that so swiftly emerged in Saint Petersburg—a city still under construction, almost still at the planning stage— and from there began its expansion throughout the entire vast country, did not arise "out of nowhere," out of the blue: such wonders do not happen. And Chaadayev was wrong, a thousand times wrong, when he spoke of Russian history as

a blank sheet of paper on which nothing was written. Chaadayev knew this himself, and said so in the last of his *Philosophical Letters.* And that is the crux of it: even if Old Rus' had no "literary" culture—although to a certain degree this too existed—it did have *experience,* without which there would have been nothing to express. This experience was not and could not have been created by Peter the Great. The Petrine reform primarily gave Russian culture the technical resources for *expression*—the tool without which experience would have remained experience and could not have become the foundation for a culture of astounding depth and breadth.

This brings us to what we have called the second aspect of the wonder of Russian culture. Outwardly it may appear that the Petrine "tool" was alien to this experience. Indeed, first and foremost Peter abruptly transplanted into Russia a secular Western-style culture, disconnected from the theocratic basis and foundation of Old Rus' that Peter found so repugnant. Groomed, clean-shaven boyars dancing Western minuets at the *assemblées* may have seemed—as indeed they did—a symbol of Russia's irremediable break with its original experience, its primordial tradition.[i] A language crippled by foreign words, a society arrayed in outlandish garb, a state restructured in the Western manner—all this, it seemed, signified a disruption,

i This tradition, it seemed, was fated to flee amid apocalyptic fear into the forest depths, doomed to die.

a disconnect, an inner self-repudiation. But herein lies one of the paradoxes of Russian culture: in actuality such was not the case. Ultimately the foreign *tool* that Peter supposedly imposed upon Russia not only succeeded in expressing her innermost experience, but itself became an integral part of that experience, and thereby became something that belonged to it, something native and no longer foreign.

This in turn explains the third "wonder" of Russian culture: its gift of "universal sensitivity." If this culture succeeded in becoming a *synthesis* of what is customarily termed West and East, this was only because at its very core the *experience* of Old Rus' was a part of the experience common to all Europe and to all Christianity—an experience that for historical reasons temporarily found itself isolated from that of the West, but which by its very nature was a *universal* experience.

In its finest aspects, in its dream, in its vision of the world, Old Rus' lived by a design that was global and universal rather than provincial. It received this design from Byzantium, and this design became its flesh and blood. Even when cutting ties with the West, withdrawing into its shell, Old Rus' did not forget this universal inspiration of its faith and did not renounce it. And this means that its cutting of ties was unnatural, abnormal, and most importantly crippling to Russian consciousness. All the disruptions and crises of the Muscovite period of our history arise from the artificiality and abnormality of the curtain by which Moscow—due to fright, an inferiority complex, and other reasons—attempted to cut itself off from the outside world.

Thus we find that by hewing the proverbial "window into Europe" Peter the Great did not destroy, but restored, albeit crudely and violently, the mutual link and interdependence outside which Russia was in danger of spiritual asphyxiation and sclerosis. Only a link with the world could lend authentic "context," the possibility of expression and embodiment, to the experience and the dream of Old Rus'.

It is for this reason that in Russian culture Paul Valéry recognized *his own* culture, not some outlandish, enigmatic exotica. This is the explanation for what Paul Valéry called a "wonder." The first aspect of this wonder—its extraordinary rate of maturation—signifies not only that the experience incarnated in the wonder of Russian culture was present and existed before the latter developed, but also that it had already achieved a depth, an inner maturity, that required only a push, an exposure to light, in order to find its embodiment. Derzhavin's odes were written, so to speak, already in *universal* language, and at the same time they were an embodiment of the triumph and the joy inherent in everything by which Old Rus' had lived at its very core since the day of its baptism.

This embodiment naturally achieved its supreme expression in the works of Pushkin. He—as we will discuss later on—was the first in the new post-Petrine culture to fully recognize and sense the *experience* that was destined, despite its Western guise, to become the source of nourishment for Russian creativity.

An imitator of Chénier and Byron, Pushkin also became Russia's first eternal love, her reconciler with her own complex

fate. Here, in Pushkin, lies the full explanation of the second aspect of the wonder of Russian culture: the Western cultural "key" or "tool" opened a door that had long ago been tightly shut. And the language of the Petrine *communiqués*, transfigured by Pushkin, became the national language, the only language, in which it became possible to express *everything*—both the mystical depth of the experience of Old Rus' and its nature. This language became an instrument specifically of *synthesis*, of harmony, of the reuniting of Christian humankind that had so long been divided.

All this does not mean that nineteenth-century Russian culture is an unqualified and unprecedented *success*. On the contrary, in our next talk we will be speaking about its *explosion* in another, intrinsically tragic sense. But were it not for this success, had not the sun of Pushkin shone upon it, we could not speak of its tragedy. In this lies the paradox of Russian culture: that it remained forever marked, on the one hand, by its indubitable *success*, and on the other by perpetual doubt concerning the very nature or "needfulness" of this success. Having fully justified Peter's cultural revolution, having revealed its vocation, its "wonder" to the world, almost immediately Russia seemingly began to consider whether this success had been necessary, whether the game was worth the candle.[ii]

ii And from out of this inquiry, from out of this doubt, there arose this second "explosion" that filled Russian culture with a singular explosive charge. To this also Paul Valéry alluded in calling Russian culture a *wonder*.

THE "EXPLOSION" OF RUSSIAN CULTURAL IDENTITY IN THE NINETEENTH CENTURY (2)

I n the history of European culture, classicism is customarily contraposed to romanticism and the other schools and trends that followed and emerged from romanticism. It would be difficult to make this contraposition with regard to Russian culture, since its development, as we have already said, unfolded differently and at a different rate than the development of European culture.

The word *classicism* may be infused with various content. One variation, which we will adopt for this talk, consists of adopting a particular period as normative in relation to other periods—as a yardstick for measuring and assessing various manifestations of a given culture. Need it even be argued that the yardstick, the classic standard for Russian culture, was and remains Pushkin? To him the other manifestations of this culture must be juxtaposed, and against him they must be measured.

"Pushkin is our everything"—we are accustomed to formulae of this sort, and Pushkin for us is so obviously the zenith

of Russian classicism that we rarely stop to consider what that "everything," of which Pushkin is the expression and embodiment, actually is. Both "the Right" and "the Left," conservatives and liberals alike, considered Pushkin their own long before the revolution, as did both its supporters and its opponents thereafter. All cite Pushkin, all consider him the expresser of their world perception; his is apparently equally intimate, comprehensible, and dear to all, and from this perspective no other Russian writer can be compared with him. This makes Pushkin truly the *foundation* and *measure* of Russian culture. But this also requires making the effort to understand: *what* is this phenomenon, why is it that Pushkin towers over all the habitual Russian divisions and passions? Is it because the conservative finds in his work the elements of conservatism, defense of monarchal autocracy, laudation of the glory, and grandeur of the empire? Is it because the liberal, and after him the revolutionary, finds in him a doxology of freedom and condemnation of tyranny? For some time now there have even been attempts to include Pushkin in the quest and the entire system of Russian religious thought.[i]

But if this alone were the case, if each person loved in Pushkin only that which corresponds to a given taste and a given ideology, this decidedly would not be sufficient to literally make Pushkin the foundation, the symbol, the measure, the

i ... attempts to include Pushkin in the quest and the entire system of Russian religious thought—apparently there is no end to this "appropriation" of Pushkin.

classical heart of Russian culture. The "mystery" of Pushkin, of which Dostoevsky spoke and which he enjoined all Russians to solve, must be sought at a deeper level.[72] And it is this "mystery" that stands at the center of the entire complex dialectic of Russian cultural identity, of its "explosions" and its achievements alike.

Much has been said concerning the harmonious, Mozart-esque genius of Pushkin. But what exactly does this imply? If it pertains to Pushkin's literary genius, to the inner equilibrium of his writings, to his lack of extremes and exaggerations, this definition could be just as aptly applied to other Russian writers, if we evaluate them specifically as *writers*. From the perspective of frugality, self-restraint, and skillful money management, the first chapters of *Dead Souls* are also classical and harmonious. On the other hand, Pushkin also has a certain "nocturnal" countenance—the madness of Eugene in "The Bronze Horseman"; the terrible figure of Saint Petersburg, even before Gogol and Dostoevsky; the germ, as it were, of everything that later gave rise to the spectral and terrible world of Gogol and Dostoevsky, followed by the Russian Symbolists and Decadents. Thus, neither Pushkin's world perception in and of itself, nor his eclectic ideology, nor his literary talent, colossal as it is, are the solution to the "mystery" of Pushkin, his exclusive, singular place in Russian culture. This solution, in all probability, must be sought elsewhere. But where exactly?

In simplified form, this question may be answered as follows: Pushkin was perhaps the only great Russian writer who

did not doubt the necessity of culture and sought neither justifications of it nor accusations. He was not subject to the corrosive, deep-set *doubt* that infiltrated our culture immediately following his death. Let us attempt to elucidate and clarify this definition.

Naturally, both before Pushkin and after Pushkin there were writers in Russia who doubted neither themselves nor anyone else, and who wrote poems, novels, and other literary works in good faith. For example, it is said that when Tolstoy once complained to the long-forgotten Boborykin that he was having trouble writing, the latter replied, "I myself, on the contrary, am writing a great deal, and quite well."[73] But the difference between Boborykin and Pushkin—the very comparison is ridiculous—is not only that Pushkin was a genius and Boborykin a mediocrity, but also that Pushkin was well aware and cognizant of the limits of culture, of which Boborykin had no concept. In other words, Pushkin's adoption of culture and his creative work in its context were wholly and veritably the fruit not of blissful ignorance, as they were for Boborykin, but of conscious, clear-sighted knowledge and understanding. And from this perspective classicism may be defined first and foremost as art, creativity, and culture that know their limits and even their limitedness. Classicism, so to speak, is by nature *modest*, since its creators know that art cannot replace religion, politics, or any other fields, and that it is a sphere of human activity—a sphere that effectively functions to the extent that it neither pretends to replace other spheres nor attempts to fuse them with itself.

Pushkin could never have said, as did Bryusov, that "perhaps everything in life is but a medium for vividly melodious verse."[74] On the other hand, he would hardly have understood and approved Gogol's decision to burn part of the manuscript of *Dead Souls* in the name of religion. At the same time, Pushkin had a very lofty concept of the poet: "You're king, so dwell alone"; "You are your highest judge"; "Burn hearts with the living word."[75] Pushkin was also conscious of the prophetic, religious, and political "ministry" of art: far was he from any sort of theory of "art for art's sake," or of the poet who withdraws into an ivory tower. But he knew firmly that he could only perform all these "ministries" of art by being and remaining himself. And this meant submitting to his own immutable laws, laying no "fraudulent claims" to spheres that were not his own. Throughout his life and work Pushkin seemed to invite Russian culture, chiefly and above all, to be *itself*, but at the same time to fulfill its ministry to Russia. But for Pushkin the concept of "being oneself" included not only technical perfection, not only writing "a great deal and very well," to borrow Boborykin's phrase, but also of course the embodiment of the *experience* of Russia of which we spoke in the previous talk—indeed, the embodiment of Russia itself. For the function of culture is first and foremost the function of *embodying* what would otherwise have remained disembodied or not fully embodied.

Perhaps no one so much as Pushkin was so acutely and so clearly aware of the *disembodiment* of Russia—of its experience, its "self-identity," and of their "embodiment" as the primary

task of Russian culture. In the sketches, notes, and diaries of Pushkin one can trace a sort of entire program for the creation of a national culture, and his work is without a doubt the first coherent "embodiment" of Russia—not partial, but comprehensive. He was the first who seemed to see Russia *entirely,* whereas before him and after him people saw her, loved her, affirmed and denied "bits and pieces" of her, adhering to partial, separate ideologies and preoccupations. And Pushkin not only saw and felt *all* of Russia: in that "all" he saw and pointed out the relationship between the separate parts, their inner hierarchy, their place.

Pushkin is our everything, because in a certain sense he "created" Russia, which of course existed before him, but which he embodied in his work and thereby as it were formed it, *revealed* and showed it to us. Pushkin also saw the fragility of this "whole," its susceptibility to the effects of the elements, of a sort of *blizzard*[76] of the same nature as Russia. He also felt her to be rearing in equine fashion at the edge of an abyss— and he knew firmly that this abyss must be filled with culture, which alone could preserve the "whole" from disintegrating and dissolving into its elements. In his "whole" Russia there was room for both Old Rus' and the Petrine empire, for both the West and the East, for both Tatiana Larina and Savelich from *The Captain's Daughter,*[77] for the government, and freedom, and conciliar efforts, and civil rights, and past, present, and future. There was room for the vertical dimension of religion and the horizontal dimension of culture and history. And it is important to understand and to sense that neither before

nor after him did this "whole," "coherent" Russia exist. Pushkin alone in the whole history of Russian culture accepted and affirmed it in its entirety: in him there is none of the renunciation and repudiation of culture by which the Russian often tries to define himself.

For this reason Pushkin and his work are the "embodiment" of the foundations of Russian culture; for this reason it is internally measured against Pushkin, although we have had writers and creators even more "profound" than he—prophets and harbingers, denizens of both heaven and the nether regions. But the tragedy of Russian culture, tragedy in the original Greek sense of the word, is that it did not follow Pushkin in this "coherence." It did not follow him, first and foremost, in his "classicism." Pushkin wanted to build culture, believing and knowing that Russia finds her embodiment in it. Russian culture after Pushkin desired to construct life itself, the salvation of the soul and of the world, a renewal of society … In this, I repeat, lie both its grandeur and its tragedy.

THE "EXPLOSION" OF RUSSIAN CULTURAL IDENTITY IN THE NINETEENTH CENTURY (3)

Today we will be speaking of the post-Pushkin departure of Russian cultural identity—from Pushkin and from his clarity and integrity.

In the previous talk we spoke of Pushkin as a vehicle of the *classical* norm of our culture and, by virtue of this, the expresser of its *foundation* in pure form, so to speak. The "normativity" of Pushkin's writings, we said, lies first and foremost in Pushkin's clear awareness of the limits and purpose of culture, and of his consequent clear understanding of the national vocation of culture. We concluded our talk by indicating the tragedy of Russian culture, which consisted of its gradual rejection of Pushkin's understanding of the purpose and essence of culture. We will now attempt to develop and substantiate this assertion in greater detail.

As we know, the thirties of the previous century were marked in Russia by a tempestuous awakening of *thought*. The direct encounter with Western Europe during the Napoleonic Wars, an influx of ecstatic Russian students into

Western universities, an unstoppable wave of Western books and adherents of philosophical, religious, social, and political movements of every kind—all this led to a certain intellectual explosion and, first and foremost, to intensified reflection, to analysis of oneself and Russia's fate in world history, its past, present, and future. Amid the conditions of the political reaction that ensued following the Decembrist revolt and the enthronement of Nicholas I, this reflection was fated, so to speak, to stew in its own juice, to manifest more in passionate debates than in actual reality. And amid such conditions, with no opportunity to apply its views in practice, to put them into effect, criticism naturally develops via the means at its disposal: the development of positive, constructive ideas. And so it may be said that if Pushkin was a *builder* in the profound sense of the word, a builder of culture first and foremost, the generation that followed was predominantly *critical*.

Our cultural identity had hardly been formed before it immediately became the object of corrosive analysis and self-criticism—as Turgenev put it, it was "eroded by reflection."[78] Pushkin clearly saw and recognized Russia's needs, above all her need for culture building, but after Pushkin instead of Russia's needs people began to see the *problem* of Russia, so that her culture also proved to be a *problem,* becoming problematic. Because Pushkin focused on Russia's needs he proceeded from reality, not from abstract ideologies: he saw Russia as a whole, embracing the whole diverse spectrum of her life by his thinking and his consciousness. Conversely, the generation of critics, who customarily criticized from

abstract positions predominantly dictated by Western ideologies, reduced Russia to some given part, some single aspect of her life, and substituted it for the whole. It cannot be said that Pushkin wrote or created from any particular "perspective": his work, to use a hackneyed turn of phrase, *reflects* reality to the degree in which it also *transfigures* it. After Pushkin, *perspective* reigned supreme in Russian cultural identity as the condition and premise of thought and creativity.

By reading all of Pushkin one may obtain a certain coherent picture of Russia, of the bright and dark aspects of her life, of the interrelation of various elements within her: one may see her specifically as a whole. But this effactually can no longer be said of any other Russian writer, excepting perhaps Tolstoy alone, who must be treated separately. All other writers wrote of Russia in one way or another; they were perhaps even more consciously focused on her than was Pushkin, but the works of Pushkin capture Russia alive and whole, while other writers always capture only some single part of her, some single dimension, from which it is no easy task to reconstruct the whole. And this naturally occurred not for lack of talent—of which Russia has no lack—but because of the disintegration of that coherence and that "classicism" that were given us in the works of Pushkin.

Starting in the 1830s, the object of reflection and criticism was, in equal measure, both "Russia and Europe" and "Russia and the West." On the one hand, Russian cultural thought recognized, as it were, that Russian culture was permeated not only with Western influences, but also with the West itself, its

spiritual structure and spirit; on the other hand, it recognized Russia's profound dissimilarity to the West, a certain innate self-subsistence, its irreducibility to the West alone. This theme was acutely set long ago by Chaadayev in his renowned *Philosophical Letters*—and since that time it has become as it were the fate of Russian consciousness, the theme that polarizes Russian culture from within.

The renowned clash between the Slavophiles and the Westernists was only one manifestation of this polarization, one of its watersheds. The disintegration—not of Russian culture, naturally, but of cultural "consciousness"—took place at a far deeper level, at certain bottommost strata, because the profound question that Russian cultural consciousness put to itself from that time on was the question of what culture actually is and in the name of what it exists. In the West this question was put by German idealist philosophy, but there it arose due to many centuries of complex cultural development, as a question that marked the close of a given section of this development and, so to speak, as a synthesizing question. It was a question of the meaning of history and of the spiritual assets accumulated within it. At the same time, at the moment when this question was put to it, Russian cultural identity was essentially facing a task of a completely different sort, one indicated to it by Pushkin: that of using the "technical" resources of Western culture to assimilate and embody all the variety, all the complexity, and all the contradictions of Russian experience or, still more simply, of Russia herself. Pushkin never doubted for a moment that Russia belonged to "the great family of the

human race," but nor did he doubt Russia's self-subsistence, or the necessity and the possibility of building a national culture in her, one that would become all the more national the less isolated she became from the spiritual and cultural unity of Europe. Pushkin did not doubt this primarily because for him there was no "problem of culture," no problem of its conceptualization and justification. For him there was only the question of the best, most suitable means for Russia to build culture.

It is this "simplicity" of Pushkin's formulation of the question that Russian cultural identity after Pushkin rejected, under the influence of the Western agenda of culture and history that it had adopted. It was stricken by a *weltschmerz* or worldpain that was wholly foreign to Pushkin, and began searching for solutions to the world's problems—and to this search it likewise subjugated the very concept of culture.

The unconditional adoption of Western ideologies, on the one hand, and a kind of frenzied adulation of "the people" on the other, equally attested to an unwholesome rift, a loss of sobriety and perspective in Russian cultural identity. Pushkin, for example, knew that he owed much to his nanny, Arina Rodionovna, but it is unlikely that he would have chosen to hold up his nanny as a symbol of some metaphysical mystery and wisdom; it is unlikely that he would have understood the Slavophiles' preoccupation with peasant coats and bast shoes. Yet this preoccupation, incidentally, led the highly intelligent Khomyakov to a lengthy correspondence concerning his heroic attendance at some Saint Petersburg reception wearing a Russian folk costume rather than evening dress.[79]

Pushkin knew the need for Russia to assimilate Western culture, but in all his work there is not a hint of any sort of subservience to it. On the contrary, he was the first to mockingly point out the "ecstatic speech" of Lensky and his countless descendants. When Chaadayev wrote his *Philosophical Letters,* in which he declared that Russia was a blank page with nothing written upon it, the greatest works of Pushkin, Baratynsky, Delvig, and Odoevsky had already been produced. Whence then this "blank page"? Where Pushkin saw boundless opportunity for enterprise and for creating, Chaadayev, who had drunk from the spring of Western waters, saw *nothing.* Why? Clearly, because he was prevented from doing so by the Western eyeglasses that he had donned once and for all, which in his consciousness compromised his integrity of vision.

Thus, the deification of Pushkin, the recognition of him as the unconditional foundation of Russian culture, paradoxically coincided in our country with an inner renunciation of Pushkin. This renunciation manifested in that for a long time "ideologies" reigned supreme in Russia—numerous ideologies that fought against each other, each proclaiming itself to be sole and absolute. The drama of Pushkin's life consisted merely of external hindrances to his work: the scrutiny of the censors, the pointlessness of secular life, the affront to his human dignity. The actual work of Pushkin was the center of no such dramas. But after him we may speak of the creative drama of nearly every Russian writer, from Gogol to Tolstoy, Blok, and many others. This drama, however, is no longer external: it arose and proliferated in the actual creative consciousness of the writer.

After Pushkin, Russian literature, followed by all of Russian culture, became a story of unparalleled successes, but also of tragic collapses and contradictions. Its life was one of explosions and soaring ascents rather than of continuity, and it contains more rejections and ruptures than solidarity and unity around a common cause. And naturally the most striking phenomenon within this culture must be acknowledged to be the paradoxical existence and recurrence within it of a repudiation of culture itself, a renunciation of culture in the name of other values recognized as absolute. Gogol burned the second part of *Dead Souls* in the name of religion; Pisarev and Dobrolyubov renounced culture in the name of an absolute reconstruction of the world, and Tolstoy in the name of morality—effectually, all this was renunciation in the name of one utopia or another. These renunciations must be traced, since in them is revealed the singular dialectic of Russian self-identity up to and including our own time.

TALK 10
Renunciation of Culture
in the Name of Pragmatism

T here are words, outwardly simple and unpretentious,
but difficult to translate into any foreign tongue in a
way that preserves the meaning and significance that
they have in the Russian language. These words include the
word *pol'za,* or "usefulness," which is so widespread in the
Russian language. It may be said that few topics have been dis-
cussed so extensively and with such enthusiasm among Rus-
sian intellectuals of the second half of the previous century as
usefulness.

In the dialectic of Russian cultural identity of which we
have spoken in the preceding talks, in the middle of the pre-
vious century there came a time when the word *usefulness*
was, in essence, equated with the concept of culture. Culture
began to be measured by the degree to which it was useful,
or, still more simply, it was subjugated to the reasoning that it
was essential that it be put to use. But what was "usefulness"
intended to mean, and why did it become so firmly established
in Russian consciousness, acquiring a nearly religious halo?

Most importantly, why were people prepared to sacrifice fully half of authentic culture—and the better half, at that—in the name of this "usefulness"? In the name of "usefulness," for example, they disregarded the culture of Pushkin, while rating "boots" as "superior to Shakespeare."

All these questions are not at all easy: they are linked with deep-set traumas in Russian consciousness. A preference for "usefulness" over culture oddly united the pragmatic pathos of Chernyshevsky, the destructive provocativeness of Pisarev and Dobrolyubov, Populism, Smerdyakov's disdain for poetry, the "simple life" of Tolstoy, and finally the dream of some distinctive "proletarian culture." Here there emerged an irrepressible pull toward reduction, which at different times took on the hues of various ideologies, while in actuality remaining essentially the same. Everyone no doubt remembers Bazarov from Turgenev's *Fathers and Sons*, and how he fussed about with frogs in unconvincing literary fashion. Unconvincing because—and this is most important—frogs, that is, zoology or anatomy, or more broadly science in general, was a subject in which Bazarov took not the slightest interest. He was concerned with and captivated by the fate of "the people," followed by the fate and happiness of all mankind: the Bazarovs would settle for no less. The Bazarovs saw the path to universal human happiness specifically in being "useful," which at that time coincided for them with the natural sciences.

For the generation that followed, "usefulness" meant "going to the people" in order to educate them, to be of direct use

to them and to mingle with them. A short time later we see other forms, other incarnations of this "usefulness." In Bunin's *The Life of Arsenyev*[80] the young hero of that autobiographical book—that is, Bunin himself—briefly becomes a Tolstoyan, takes up residence with some tradesman in southern Russia, and starts learning to make barrels. Generations upon generations of Russian people, from every possible social stratum, greedily threw themselves upon any "usefulness" that struck them as a unique absolute, an all-engulfing deity. And in the name of that "usefulness" they were prepared to give up everything, starting with culture in the "Pushkin-esque" sense of which we spoke in the preceding talks.

Consequently, the question in its initial form must be put as follows: how did the spheres of "culture" and "usefulness" become separated from each other? How and why did authentic culture start to appear "useless," and why did simplified and often superficial pragmatism come to be considered "culture"? For Pushkin there was no such dichotomy. In culture, authentic culture, he saw the greatest of all possible usefulness, and he did not measure culture, creativity, and art against any extraneous yardstick of "usefulness." But Gogol was already tormented by this problem of "usefulness": he considered it insufficient and useless to have written *The Inspector General* and *Dead Souls*, and decided that he was called to teach and to preach, to be "useful," for which purpose he launched into his *Selected Passages from Correspondence with Friends*—a book that never ceases to amaze. Turgenev was also tormented by the fact that younger readers saw his novels as insufficiently

"useful." As for the others, there is no use talking of them: they subjected everything to this "usefulness," striving to dissolve everything into it.

We may cite two sources of this dichotomy, this disconnect between culture and pragmatism. On the one hand, there is the inner permeation of Russian consciousness after Pushkin with the Western ideologies of the eighteenth and nineteenth centuries—first and foremost the ideology of popular enlightenment[81]—and the philosophical rationalistic systems derived from it. Pushkin assimilated and absorbed Western *culture;* those who followed after him began to absorb reflections *about* culture, reflections in which rationality now predominated over direct intuition—in which, in other words, there were already the beginnings of a split between a coherent perception of life and a rational explanation of the same.

Russian consciousness was particularly enamored of *socially* tinted Western ideologies, with those dreams of justice, social equality, and a future paradise on earth that tinted the intellectual life of Western Europe after the French Revolution. In Russia this infatuation could not help but manifest, from the very beginning, as a mournful concern for the benighted Russian peasantry left in serfdom, untouched by modern culture. In the end the very concept of "culture" became a synonym for a thin stratum of prosperous people— hence the sense of *guilt* before the people, which over time gradually became the dominant feeling and demanded that culture as such be viewed as luxury and feasting while the

poor and needy looked on. This led to a growing conviction that in order for culture to be acceptable it had to be *useful* to the suffering people: it had to be measured against the people and their needs. And under the influence of this conviction there began a process of the fundamental simplification of culture, a rejection of its refinement and inaccessibility. Pushkin, if in his day he had chanced to take part in debates on the objectives and meaning of culture, would likely have said that the goal is to raise the people to the level of culture—that is, simply put, to make them a cultured people. But the successors of Pushkin, tormented by guilt, decided that on the contrary *culture* must be degraded to the level of the people.

Nowhere but in Russia, it seems, has a peculiar "culture for the people" been deliberately and selflessly constructed. Gradually a stream of "booklets for the people" began to be written and published; a kind of "semi-culture" emerged, and a special "semi-cultural" language was created, one that seemed terribly degraded compared to the language of *The Captain's Daughter* and *A Hero of Our Time*.[82] All this meant that a dichotomy had emerged within culture itself. One part of the latter became fundamentally oriented toward being of use to the people, and in the name of this usefulness it renounced and ascetically rejected the "luxury" of culture—that is, the refined, authentic culture that comprised its other part. And yet it must be said that this culture that was specifically focused on the people hardly reached them at all, while at the same time this dichotomy tragically degraded the country's overall level of culture. A few decades after Pushkin, Lermontov, and

Tyutchev, nearly all Russia was engrossed in reading Nadson and wept over his poems.

We must also indicate another, more cryptic source of the intelligentsia's universal devotion to the simplistically understood concept of "usefulness." In Russia, Western pragmatism and radicalism had fallen upon fertile soil. "What will it profit a man if he gains the whole world, and loses his own soul?"[83]— these Gospel words, although perhaps not recalled as such, defined the attitude toward usefulness of an enormous part of Russian society, almost from the very beginning of Petrine Russia. In the subconscious mind of the people, including the intelligentsia, post-Petrine Russia retained a mysterious memory of a completely different approach to life, to the state, to the nation, and to creativity—an approach nourished by centuries of the Byzantine Christian perception of the world. In this world perception there was not and is not a place for some autonomous "culture," just as there is no place for a self-sufficient state, defined by its own interests, glory, and grandeur. All is subjected to an ultimate, supreme *usefulness* that supersedes the bounds of the world and history—and for this reason everything in the world hinges on this final question: "What will it profit ... ?"

What shall *Eugene Onegin* ultimately profit, or the iambic tetrameter, or Pushkin's concern for the development of Russian theater? Having renounced Byzantium and, in part, Christianity, Russian post-Petrine consciousness, even in its new, worldly, secularized form, seemed to retain a consummate *seriousness,* dictated by a consciousness of the "empty

vanities" of this world—and this seriousness corroded from within that which people had seen as the frivolous pastime of culture.

For them there remained two options: either to sate culture to the utmost with this "seriousness," making it not only pragmatically, but also supremely and all-embracingly *useful*—or else to reject culture altogether for the sake of "the one thing needful," however that "one thing needful" might be understood at any given time. And now the pages of *Dead Souls* lie smoldering in the fireplace; Leo Tolstoy[84] leaves Yasnaya Polyana amid a November frost; Blok struggles for breath: "There are tidings of gloom and disaster / In your secret melodiousness ... "[85] All this, one way or another, is about "usefulness," about the demand presented to culture—that it not just be culture, but that it save, that it transfigure, that it create a new earth and a new heaven. Russian culture, as it were, darts back and forth between these extremes and outer bounds. It has been illumined for all time by the bright sun of Pushkin— and for all time it is as though contaminated by the dream, the passion, and the thirst for "usefulness." In this lie both its profundity and its tragedy. In this lies its wealth—and also its downfall.

The renunciation of culture in the name of pragmatism brings us, consequently, to the subject of its renunciation in the name of religion.

RENUNCIATION OF CULTURE IN THE NAME OF RELIGION

B oth Russian and foreign authors have often spoken of the religious depths, the *religious* inspiration, of Russian culture. Indeed, beginning at a certain point, in one way or another every Russian writer reflected his religious quest or religious experience in his work. From Gogol to Pasternak and Solzhenitsyn, not excluding officially nonreligious, non-believing writers such as Turgenev or Chekhov, Russian literature and Russian culture after it are indubitably permeated with the theme of religion or at least with a certain religious tonality. At the same time, in conversations surrounding the religiosity of Russian culture it is rarely noticed that for Russian culture itself, far more often it was a question of *a choice between culture and religion*, rather than of the religiosity of culture itself.

The stubborn, insistent quests, doubts, and inspirations that imparted so great a significance to Russian culture simultaneously decayed Russian cultural consciousness from within, as it were, so that here there is no question of any synthesis

of religion and culture. On the contrary, here we are dealing with a variation on the general premise that we have already mentioned in connection with the theme of Russia's renunciation of culture in the name of "pragmatism": just as culture was called into question in the name of usefulness (usefulness to the state, the people, the revolution, etc.), it was also called into question in the name of religion. One might say that upon reaching a given stage of religiosity, a writer or creator seemingly would ask himself the question: why am I writing? To what purpose? In the name of what higher ideal? And then the decay and discord would begin, often tragic and painful, between his creative consciousness and his religious faith or quest—a decay and discord that inflicted harm first and foremost on the fragile edifice of Russian culture.

This discord did not begin at once, and in order to understand its causes and effects for our culture it is appropriate once again to begin with Pushkin, to whom all creative threads and paths lead in one way or another. It is noteworthy that in Pushkin there was no hint of this dichotomy, this discord. At the same time there is no doubt whatsoever that Pushkin was a believer. And not only a believer, but a vehicle for a very definite Christian worldview. For this reason the refined Russian literary expert and critic, Professor Georgy Petrovich Fedotov, called *The Captain's Daughter* the most Christian work in Russian literature.[86] And perhaps it is this assessment of Fedotov that will enable us to make sense of the complex question of the interrelations between religion and culture within Russian creative consciousness.

In *The Captain's Daughter*, as in the vast majority of Pushkin's works, there is no overt religious theme, to say nothing of any specific religious exploration or musings. Consequently, Fedotov had something else in mind when he called *The Captain's Daughter* the "most Christian" work in Russian literature, despite its lacking[87] the religious pathos of Gogol, Dostoevsky, and Tolstoy. To what exactly was Fedotov alluding? Naturally, to the fact that in his approach to people and events, in his sketches of them, Pushkin remained faithful to the general conception of the world, of life, and of morality that may and must be called Christian.[i] Pushkin, if you will, did not reexamine Christianity, and to all appearances he gave no particular thought to its metaphysical and philosophical depths. But he accepted the world as he had received it from the age-old tradition created by Christianity. In this world there is heaven and there is earth, there is an obvious and impassible threshold between good and evil, there are criteria of beauty and ugliness. There is also something that is perhaps most important of all: how to regard people—not idealizing them, on the one hand, while on the other hand naturally seeing in them an object of admiration, of compassion, of pity, and of respect. Immersed in this clear, simple light, living and acting in it, are Grinev, and Savelich, and the Mironovs, and finally Pugachev himself.

i Good and evil, beauty and ugliness, anger and pity, and underlying all this something profound and inexpressible—a light nearly impossible to convey, that pours out of Pushkin's writing—all this is rooted in a certain absolute, and this absolute is that of Christianity and the Gospel.

Pushkin is a believer, but it cannot be said that he was religious in the sense that the word later acquired, when "religious" began to mean people who were obtrusively, passionately, exclusively focused on religion. We know that Pushkin rendered tribute to the skepticism of the eighteenth century: in his younger years he could even be blasphemous, as for example in his *Gabrieliad*. But this was all superficial and could not compromise the coherence of Pushkin's world perception, which remained, as we have said, unquestionably Christian at its foundation.

However—and this must be emphasized—it was because Pushkin still possessed a coherent Christian world perception, and accepted it without deliberation, that in him there was no discord between his consciousness and his creative work. As we have already stated in one of our previous talks, for Pushkin a constant awareness of the limits of culture was typical. He knew that faith and religion were undoubtedly above culture, superior to it,[88] but culture is not contraposed to them, for everything in the world—both great and small—is rooted one way or another in the God Who created it.[ii] Culture is doing a God-pleasing work, and the better it does so, the more strictly it submits to its own laws. So reasoned Pushkin—or if not reasoned, felt—and it was the disintegration of this feeling or sense which, after Pushkin, very differently presented the question of how to regard culture and religion.

ii In reflecting beauty, embodying the inexplicable and ineffable as it is able, culture is …

This disintegration took place under the influence of those two "discoveries" made by cultured Russian society in the 1830s and 40s—the influence of Western thought, on the one hand, and the world of Russian religious experience and tradition, on the other. One historian of eighteenth-century Western European thought called this way of thinking "Christianity on Trial."[89] First the rationalism of the Age of Enlightenment, then the French Revolution, and finally the critical analysis of German philosophy gradually broke down that integrity of the Christian worldview and world perception which people in the eighteenth century could still live by, as did Pushkin. As a result, Western culture and Western consciousness were split into "for God" and "against God." Religion ceased to be the self-evident and often-unconscious foundation of culture, and became one of the objects of culture, merely another of its themes. And it was this impassioned conflict, one that had not yet reached its conclusion, that Russian culture entered beginning with Gogol.

But although religious consciousness—passionate, agitated, and covered with the wounds of historical setbacks—became merely one "theme" of culture, in a sense it inevitably turned against culture. For religious consciousness, culture gradually began to take on the character of rebellion against God and denial of His all-encompassing and absolute rights. For this reason religious consciousness gradually began to agree to acknowledge culture only insofar as it becomes "the handmaid of religion"— in essentially the same way that philosophy in the Middle Ages found itself obliged to fight for God and for His rights.

Here, however, the second source of dichotomy and discord manifested—namely, the contact between Russian cultural consciousness and the fascinating world of folk faith that it found so mysterious, with its seeming integrity, its estrangement from corrosive analysis and skepticism—the world, in essence, of another culture, another tradition, one wholly, joyfully, and unshakably focused on "celestial beauty." Why have culture at all if this simple faith creates such moral beauty, like that of Lukerya in Turgenev's "A Living Relic"[90] or in Platon Karataev?[91] Father Matfei Konstantinovsky in the life of Gogol, the Optina Elders to whom people of culture were drawn in search of lost integrity, the peasants who knew how to live "according to God" and from whom Levin longed to learn in *Anna Karenina*[92]—all this seemed an exhortation to abandon the ephemeral world of earthly creative work in the name of spiritual activity,[93] in the name of the one thing needful.

And here is what is striking: the shattered Christian world perception, through which the world, despite all the evil and darkness within it, in essence remained for Pushkin a world of light. For writers of "religious consciousness" this world became a dark, unenlightened world, and religion came to be equated with only one possible option: abandonment, rejection, renunciation. Only the "world of the people," the world of faith, shines and enlightens. Everything else—meaning the world of culture—is reflected in vulgar physiognomies, plunged into the hopeless darkness of "The Overcoat",[94] the nightmare gallery of *Dead Souls*. After Pushkin, Russian

culture is as though poised upon the brink of a precipice. Its successes are in a sense paradoxical, as these successes were not the result of the gradual development of cultural tradition and culture building, but only personal successes, which frequently—as in the case of Gogol and Tolstoy—turned to terrible personal tragedy.

One Western critic noted that Russians have great writers, but they have no literature in the Western sense of the word— as a continuity of tradition, as a common creative solidarity. Indeed, only during the brief era of Pushkin was there a certain circle of writers, a literary world in which the elite and the masses had something in common, a common tonality. After the era of Pushkin writers found themselves in isolation: the isolation of Dostoevsky, the isolation of Tolstoy, the isolation of Chekhov. A creative, though not necessarily existential, isolation was formed. It was as though each Russian writer, tormented by conscience and doubts, was condemned to produce his own creative world, and in isolation to ask himself: what is the purpose of this creation that I have produced?—and often to cast it aside, rejecting it, once again, for the sake of "the one thing needful."

This religious consciousness inextricably became part of the foundation of Russian culture. Doubt, not of religion, but of the religious justification for creativity—this doubt, we repeat, led to staggering personal successes. But at the same time it stripped Russian culture of the immovable, self-evident foundation without which uninterrupted growth is impossible. Successes and setbacks—such proved to be the fate of Russian culture.

Renunciation of Culture in the Name of Social Utopia

"Sociality—sociality or death!" This ecstatic exclamation of Belinsky, who had only just converted to the socialist faith, has often been quoted.[95] And it may indeed stand as the epigraph to the history of Russian consciousness, Russian thought, and the Russian dream, beginning with the forties of the previous century. From this point on, for a large part of the Russian intelligentsia the social question, or more precisely social utopia, became a kind of all-encompassing, all-engulfing passion. In simplified form, it could be said that if in the eighteenth century people were building culture, in the nineteenth century interest in culture was almost wholly subjected to the social agenda. And this naturally had far-reaching effects on the fate of Russian culture. And not of Russian culture alone: it should be noted that the nineteenth-century obsession with "sociality" was common to all of Europe, and here Russia was no exception. The nineteenth century in Europe was the age of Proudhon, Marx, Engels, and Bakunin; the age of revolutions, the Paris Commune, the start of the

worker's movement, and the development of sociology and economics as scholarly disciplines.

Unlike Russia, however, in the West this social passion did not become all-engulfing, and it did not halt or suppress the continuation of cultural tradition and culture building. For example, the history of nineteenth-century French or English literature may be studied entirely separately from the social and revolutionary movement that was developing in those turbulent decades. We could speak of the drama of the life or literature of Flaubert, Baudelaire, or Rimbaud without reducing it to a social agenda. And this is because cultural tradition in Western Europe was too strong and resilient to be eroded and engulfed by the new social passion. As for Russia, here it must be acknowledged that the passionate preoccupation with "sociality" led to a degradation of our cultural level, becoming a source of profound and significant "disruptions" in the Russian cultural consciousness.

The reduction of everything to "sociality," the unqualified subjection of culture to it, became the standard and, so to speak, the breeding ground for a new phenomenon in Russian life—an illustrious phenomenon, long-suffering, remarkable, yet largely hazardous for the Russia of the past: the *intelligentsia,* which emerged specifically in the nineteenth century. If once again we take Pushkin as our starting point and yardstick, it must be said that he did not yet evince a single distinguishing trait of the "intellectual," nor, more importantly, an inner subjection of culture to the social question. This does not at all mean that Pushkin was a stranger to social interests,

or that he was not concerned by the tragic lack of political freedom, the enslavement of the serfs, social inequality, and so on. In his "Exegi Monumentum" he could truthfully say of himself that in his "cruel age he sang the cause of freedom/And for the fallen called for mercy."[96] His interest in the uprising of Pugachev and the depth of his historical analyses bespeak his indisputable understanding of Russia's social problem in the broad sense of the word. Simply put, Pushkin stood for freedom, justice, human dignity, and elementary equality no less than the Russian intellectuals of the future.

But Pushkin was a stranger to the chief trait of the intelligentsia: *utopianism.* For this reason on December 14, 1825, in the Senate Square in St Petersburg, which saw the historical birth of the consciousness and vital mindset of the intelligentsia, Pushkin was absent not only physically but also, so to speak, spiritually. The Decembrist revolt was when utopia took the historical stage in Russia. Pushkin was able to sympathize with the personal valor and heroism of the Decembrists, but he could not share their utopian passion. He could not, first and foremost, because in his hierarchy of values culture stood first, not second, and the betterment of social status depended upon it, upon building and entrenching it, and not vice versa. It was this hierarchy of values that was upended in the consciousness of the intelligentsia: the social question was prioritized, with culture made subordinate to it.

The Russian intelligentsia, not as a particular stratum of the populace, but as a *type*, was created in Russian society as the result of a twofold process: the comparatively swift spread

of enlightenment beyond the bounds of the upper noble class and, almost simultaneously, a tragic inability to creatively and constructively apply that enlightenment in practice, in life. The birth of the intelligentsia as a mass phenomenon coincided in our country with the years of reaction after the Decembrist revolt, with the gradual transformation of the empire under Nicholas I into an official, military state, a colossal, unwieldy bureaucracy. Then, for the first time, the comparatively educated Russian was faced with a choice: either to transform into a semblance of the Chekhov official who in his old age suddenly discovered that in all the millions of government papers he had written he had never had to place a single exclamation point to express, as he had just learned, delight, anger, or any other strong feeling;[97] or else he would have to withdraw specifically into *utopia*. And so it was that utopia became a kind of second nature to this educated man, absorbing the fire of his soul, all his imagination, all his energy.

Utopia arrived already formed—from Western sources, from the hastily prepared and simplified global, all-encompassing diagrams of Hegel and his followers, from textbooks on physics and chemistry, from a West seething with ideas of every possible kind. The delight experienced by the young Herzen and Ogarev in Sparrow Hills was not a one-time event, but rather a collective phenomenon. In circles and salons, and later in the flats of conspirators, there arose and expanded that endless, enthusiastic, lofty conversation, consisting almost solely of exclamation points, which then lasted for this part of the intelligentsia almost to the very end of the Russian Empire.

And what is important to note is this: as time passed, it became increasingly obvious that the level of culture among the conversationalists and the exclaimers was faltering. If in the Moscow salons of the forties—those of Khomyakov and Chaadayev, the Elagins and Granovsky—the conversation was replete with authentic, profound, refined culture, in the sixties—the generation of Pisarev and Dobrolyubov—this culture no longer existed: it had evaporated, vanished, replaced by a sort of drab semi-culture, which may be studied by reading the "thick journals" of the latter half of the nineteenth century. Here a strange law seemed to be in effect: the broader or, so to speak, more global the utopia, the dryer its cultural coefficient then became. One truly had to forget *The Captain's Daughter* and *A Hero of Our Time,* those pinnacles of the Russian language, in order to become enamored of Chernyshevsky's novel *What Is to Be Done?* and weep over the poems of Nadson.

Culture among the intelligentsia of this period came to be understood from an exclusively pragmatic perspective—as a minimum of essential, obligatorily practical, obligatorily "useful" information for "the people." Enlightenment was reduced to mere universal "literacy," without the slightest concern for national culture. Russian culture came to be ruled by the elite intellectual, "idealistic and ungrounded," in the words of Fedotov[98]—an ascetic who disdained not only the material good things in life but also every "elegance" that he deemed needless, caught in the fanatical grip of one dream and one alone, but one in which culture had no place.

The tragic paradox of Russian culture lay in the fact that beginning at a certain point in time it found itself a "foreigner" in its native land. It ceased to be needed by the empire's bureaucratic and military apparatus; indeed, that apparatus even held it under suspicion. But it also ceased to be needed and [was] placed under suspicion by the intelligentsia who worshiped revolution. The imperial utopia and the revolutionary utopia formed a sort of unspoken alliance—against the supreme "realism" of Pushkin, against the truth about Russia that he sensed and to which he exhorted Russian culture.

One can only wonder at the fact that despite this twofold oppression—on the part of an empire that was increasingly distancing itself from culture and on the part of the intelligentsia with its negative view of the same—Russian culture nevertheless continued to exist, nourished by imperceptible sources of Russian creativity. Furthermore, it may even be said that this bilateral pressure lent it new depth, a new creative dimension, since this culture voluntarily and involuntarily found itself obliged to give an *answer* to the twofold renunciation directed against it, to overcome it from within. Without exaggeration it may be said that Dostoevsky and Tolstoy marked the beginning of the *emancipation* of Russian culture from its internal, psychological enslavement to the military-bureaucratic and revolutionary-intellectual parts of Russia, into which it had split after the death of Pushkin.

The pragmatic renunciation of culture, the religious renunciation, and finally the social-utopian renunciation of culture—these are the three dimensions, the purgatory through

which Russian culture had to pass after its blinding embodiment in Pushkin. And pass through this purgatory it did. Did this mean a return to Pushkin, to the program he had mapped out? How did this passage affect the very fabric of Russian cultural consciousness? What height and depths did it achieve?[i] These are the next questions, the answers to which must be sought first and foremost in two giants, two global pinnacles of Russian culture: Dostoevsky and Tolstoy.[i]

i What new tragedies was it fated to encounter?

TOLSTOY AND CULTURE

T olstoy, like Pushkin, is a pinnacle of Russian culture. This means that other manifestations and magnitudes of this culture must be measured against him. Bunin, incidentally, cited these words of Chekhov in his memoirs: "When Tolstoy dies, everything will go to hell. Literature? Yes, and literature, too."[99] But the paradox of Tolstoy, that second pinnacle of Russian culture, is that he is simultaneously the pinnacle of its self-denial. Like a kind of focal point, Tolstoy joins all the threads of doubts, explorations, denials, and assertions of which we spoke in the preceding talks devoted to the foundations of Russian culture. Ultimately, the result was that, on the one hand, not one Russian writer was so closely linked to Pushkin in his work as was Tolstoy or, on the other hand, became a greater sort of "anti-Pushkin" than did Tolstoy. Thus, between these two there unfolds a unique and complex dialectic of Russian cultural consciousness.

Let us begin with what we have called the intimate link between Tolstoy and Pushkin. This link, profound and organic,

consists of the general creative mindset, which may simplistically be termed *positive.* What does this mean? It means—in the deepest sense of the word—*acceptance* of the world as a positive entity, a certain inherent admiration of it. Neither in Pushkin nor in Tolstoy is there a hint of Lermontov's "demon," who "nought in all nature ever wished to bless,"[100] and who initiated another trend in Russian literature, which found its apex, as well as its vanquishment, in Dostoevsky. Neither in Pushkin nor in Tolstoy is there any metaphysical agitation, any challenge to the heavens, any ticket returned to God in the style of Ivan Karamazov.[101] "It is not God that I deny; I deny His world," says that personage in Dostoevsky's novel.[102] No such personage, no such world perception, do we find in either Pushkin or Tolstoy.[i, 103]

The world of Tolstoy, like the world of Pushkin, is permeated with a certain inherent, divine "and indeed, it was very good."[104] If people suffer and are tormented, it is not because the world is bad, but because they do not perceive its essential goodness, its beneficence, and their own life's subordination to that goodness. All the vanity, all the tension, all the pointlessness of life embodied in the Battle of Austerlitz disintegrates in an instant when the wounded Prince Andrei suddenly looks to the sky, the heavens, sees the *sky* and yields himself to it. Let us be clear: he did not see God, or the solution to some metaphysical riddle, or the answer to

i The French critic Charles du Bos observed regarding Tolstoy: "If life could write, it would write as Leo Tolstoy wrote" [see note 103].

the question of eternity—no, only the simple sky, high, pure, and luminous; a symbol of the harmony instilled in the world, which man infringes. And by inwardly giving his all to an organic commonality, one not dependent on the will, doubts, or passions, a man can conquer, vanquishing in himself even the most overt evil and pointlessness—here the modest Captain Tushin at his battery outside Schöngrabern is a prime example. The abandoned, debilitated battery in the hell of fire appears for a moment in the mind of Prince Andrei like a figure or a glimmer of something familial, resilient, and comfortable. All of Tolstoy's work is essentially an ode to life, including even his visceral horror of death, so forcefully depicted in *Anna Karenina*, in the chapter on the death of Nikolai Levin, and in *The Death of Ivan Ilyich*. This horror is not metaphysical, but specifically visceral—a horror of the destruction of life, the disintegration and decay of that which alone is given, beautifully and harmoniously.

Despite his moralism, Tolstoy admires the passionate Steva Oblonsky with his zest for life—a man of no great morality. It is in his house[ii] that the love between Levin and Kitty triumphs, and the frivolity and even depravity of Oblonsky does not defile or degrade that triumph.

This acceptance of life, this direct immersion in the world with all its scents, its complexity, its simplicity and balance,

ii It is in his house after a gay supper, which dispels even the gloom of Karenin, that the love...

creates a kinship between Tolstoy and Pushkin. In reading *War and Peace* we find ourselves amid the same human life that fills the world of Pushkin's *The Captain's Daughter,* despite all the differences between these two works. Both here and there we see and sense the triumph of small but organic life, of love, of simple relationships against a backdrop of immense historical events. Both here and there life triumphs over the Moloch of history. Grinev marries Marya Ivanovna Mironova, and upon a Russia ruined and burned by the madness of Napoleon the resilient, essentially good world of Rostov's Otradnoe is rebuilt.

Russia's love for Tolstoy is by no means a love for Tolstoyism. It is essentially the same love with which Russia came to love Pushkin. It is a love for her positive foundation, for the luminous acceptance of life embodied by both these pinnacles of Russian culture.

But what constitutes that which we have defined as Tolstoy's "anti-Pushkinism"? How are we to reconcile his profoundly positive works with his own impassioned rejection of those works, his renunciation of them, the terrible, lonely anguish that ultimately led Tolstoy to go out into a cold, damp autumn night to a lonely, joyless death at a little godforsaken railway stop?

To answer this we must ask the question: are we justified in calling all this "anti-Pushkinism"? Despite their vast difference in fate and biography, in all this do not both these writers have something in common? Pushkin's mindless duel, the body writhing upon the snow, death—did not Pushkin desire these also, albeit unconsciously? In some supremely

profound, innermost sense, is this not his own "withdrawal"? This question may seem strange, contrived, forced. But let us consider it carefully.

There is one thing that unites Tolstoy and Pushkin, something that unites them *above* their "positive" world perception. This is a sensitivity of conscience, an openness to a moral, ethical perception of the world and of the individual. While both were strangers to metaphysics, to metaphysical doubt, both were also superlatively familiar with the reality of moral anguish. It is highly typical, for example, that in the figure of Pugachev Pushkin included the episode with the "hareskin coat," which gradually becomes a symbol of the possibility of Pugachev's moral rebirth, which permits Pushkin to "trust" him, so to speak. The core of the outlook of both Pushkin and Tolstoy consists not only of their acceptance of this world, but also of their acknowledgment that they are absolutely governed by the moral law. Tolstoy was tormented not by a search for God, not by metaphysics, but by conscience—that is, by an intolerable and inescapable sense of evil and falsehood. But effectually the same experience of evil and falsehood, only under wholly different conditions, also tormented Pushkin. Tolstoy *withdrew.* Pushkin wished to find an escape from the web of falsehood and evil, to find it at any price, and he threw himself into it, knowing and recognizing that he was doomed. The compromise with reality in which Pushkin lived for the sake of his "cultural" conception eventually proved unbearable, and it suffocated him. But the theme of withdrawal, the longing for it,

was evident in his poetry before this: we need only recall the inimitably sorrowful strains, "'Tis time, my friend, 'tis time! / The heart to peace aspires," ending with the words, "Thence, to a cell beyond the clouds / In God's vicinity to hide … "[105]

In both Pushkin and Tolstoy, culture and awareness of its value are governed by the conscience. In Pushkin the conscience did not have time to erode, burn up, and incinerate culture itself. Tolstoy renounced culture in the name of conscience. When it became clear to him that even culture itself is a concession to the spirit of falsehood and conventionality that he was called to vanquish, Tolstoy discarded it completely. And it matters little what "doctrine" he replaced it with. There is every reason to think that the rejection and renunciation, the withdrawal, the break were far more significant in Tolstoy's life than the "Tolstoyism" that he began inculcating. For a time he was able to seek salvation in a life of farming and in establishing various "worker's communes." But sooner or later Tolstoy [would have] renounced them also, and his *withdrawal* was a withdrawal not only from culture, family, and society, but also from "Tolstoyism."

What does all this mean in the dialectic of Russian cultural identity? We know that from the very beginning in this identity there was a certain unrest, which led to a crisis of renunciation of culture—in the name of religion, in the name of social utopia, or in the name of all-engulfing, absolute "usefulness." Perhaps the kinship between Pushkin and Tolstoy, their shared paradoxical combination of acceptance of the world and culture with a tragic awareness of the moral maximalism of *truth*

as the inner yardstick of culture—perhaps this explains and shows to us the inner mainstay and meaning of this unrest, these disruptions to Russian culture. With good reason even in the writings of Turgenev—the cool, Western-minded agnostic—was the personage of *Kassian from the Beautiful Lands*, who said, "Many of us go wandering through the wide world, seeking for the *truth*."[106] Pushkin and Tolstoy were equally estranged from the tendencies and processes in which the Russian cultural consciousness, under the influence of the West, struggled to find itself in the nineteenth century. Both were *above* these foreign processes, of which they had no need.

DOSTOEVSKY AND RUSSIAN CULTURE

Dostoevsky is one of those writers whose work evokes the concept of "mystery." This word is inapplicable, for example, to Tolstoy. There is drama in Tolstoy, there is tragedy—but there is no "mystery." The world of Tolstoy, for all its complexity and depth, is nevertheless clear and transparent. And if we do not understand it, Tolstoy never tires of explaining to us what it is that he wishes to say in any given work that enraptures us, astounding us with its ideas and masterful imagery, but which there is no need for us to decipher. And Tolstoy can never be "appropriated": he is, as they say, a man who walks by himself.

Dostoevsky is another matter. Who has not attempted to explain him, what methods have not been tried?! And who has not tugged him toward his own theories, convictions, and ideas? Materialists and idealists, Freudians and Christian existentialists, Formalists and Symbolists, mystics and rationalists—yet he remains a "mystery" that flares up anew each time he is reread, in each new reader. For this reason it

is infinitely difficult to speak of Dostoevsky's place in Russian culture, in the history of Russian cultural identity.

Tolstoy knew what he was doing in the majestic edifice of Russian culture, and we know also: upon reaching the pinnacle—indeed, upon becoming that pinnacle himself—Tolstoy began to renounce and destroy culture. He saw, in his conviction, the futility of culture as a separate, self-contained sphere, the futility of its objectives, its travail. In Tolstoy, every manifestation of culture seems to encounter the vividly reproachful question: "Why? What for?" Does it really pertain to "the one thing needful," to the Gospel call: "Seek first the kingdom of God"?[107] For Tolstoy, the later Tolstoy, it was clear: *either* culture *or* "the one thing needful." He recognized no bridges or compromises.

This discord between the author and the man of faith was wholly absent from Dostoevsky, and it is very important, even essential, that this always be remembered. In the course of his life Dostoevsky suffered and agonized much; he was beset by implacable passions, he knew all the fractures and dichotomies of human life. And the only thing from which he did *not* suffer was doubts concerning the objectives and meaning of creative work, doubts as to whether or not it was necessary. It never occurred to him, as it did, say, to Gogol or Tolstoy, that perhaps it were better not to write, that literature was a distraction from "the one thing needful," that it is futile and naught but vanity. On the contrary, what tormented Gogol and Tolstoy in their later period was for Dostoevsky perhaps the only path to healing, to "integrity": only in his work did

he escape the agonizing dichotomy from which he suffered throughout his life.

This is of extraordinary importance for the history and understanding of Russian culture and its foundations, and the reason is this: everyone agrees, albeit from varying perspectives and based on varying premises, that the works of Dostoevsky are fraught with explosive power, that he introduced a certain subtle *toxin* into Russian and global culture, which gradually poisons it, making it impossible to return to the simple, reliable, self-confident, and, as it were, self-contained literature of the foregoing era. But this toxin acts from within, not from without. At some point in his life Tolstoy simply walked out on culture: he abandoned it, deciding that there was no point in writing novels, poems, or plays. All this was useless—an idle, deleterious pastime. But in making this decision—and practically only with regard to himself, at that—Tolstoy did not actually bring about any revolution *within* culture.

A writer may imitate Tolstoy the writer or learn from him. But that writer cannot adopt the teaching of Tolstoy the preacher and still remain a writer. The teaching of Tolstoy, if adopted, means not a rebirth of culture, but its end and its demise.

These observations are absolutely inapplicable to Dostoevsky. Nowhere did Dostoevsky ever say, "Write no more poems, novels, or plays, for these do not pertain to 'the one thing needful.'" On the contrary, throughout his work he seemed to assert that culture itself, creativity itself, must be permeated with "the one thing needful." And if Dostoevsky

was so passionately oriented toward Pushkin, appearing to
be his antipode, this is because he considered Pushkin's "The
Prophet" a behest to culture, and was absolutely convinced
that the vocation of the writer is specifically and exclusively to
"burn hearts with the living word."

Consequently, in Dostoevsky culture itself was called upon
to embody "the one thing needful": he elevated it to the level
of a prophetic ministry. From this perspective, in Russian cul-
ture Dostoevsky is on equal footing with Pushkin, Gogol, and
Tolstoy—its other pinnacles. From Pushkin he assimilates a
coherence of cultural identity—that is, a simple faith, uneroded
by doubt, in culture, in its capacity, in its divine essence, so to
speak. And for this reason, paradoxical as it may sound, no
one in Russian literature proved so closely linked with Push-
kin as was Dostoevsky, and with good reason his "Pushkin
Speech" was perceived by all Russia as the apogee of his work.

In a certain sense, out of all Russia's complex culture Dos-
toevsky alone unconditionally says "yes" to Pushkin, restoring
the link with him that was severed at some unknown depth
by Lermontov and Gogol. Few noticed this organic kinship
between Dostoevsky and Pushkin, because it was custom-
ary to compare the "healthy world" of Pushkin to the "dis-
eased world" of Dostoevsky. And so they overlooked the fact
that Eugene in "The Bronze Horseman," for example, has
far more in common with the characters of Dostoevsky than
do the characters of Gogol or Tolstoy with those of Push-
kin; that Herman from *The Queen of Spades*[108] and Dostoev-
sky's *Gambler*[109] are people from the same planet, of the same

spiritual constitution. Most importantly, they overlooked that which unites Pushkin and Dostoevsky in kinship—that is, the authentic, profound regard for creative work and, more broadly, for culture, that defines their creative *health*. And it is this kinship and this health that contraposes both of them to another line of Russian culture—the one originating from Gogol and Lermontov, a line in which the very source of creativity was placed in doubt, which stretched all the way to Tolstoy and defined his cultural nihilism.

Small wonder, then, that the *new* Russian literature, or more precisely the new *chapter* in the history of Russian culture and Russian cultural identity, began with Dostoevsky rather than Tolstoy, and that all attempts one way or another to "circumvent" Dostoevsky, to forget him or to blot him out, are futile: without Dostoevsky it is impossible to understand either Russian or even global culture in its modern evolution.

Incidentally, it is by no means a coincidence that so passionate an admirer of Tolstoy as Bunin had a savage hatred for Dostoevsky[i]—nor had Bunin any love for the whole of the new Russian literature. This was the hatred of the conquered for the conqueror: Bunin with his creative intuition knew of course that if there was a future for Russian literature and culture, it was rooted in the creative personalism of Dostoevsky, and not in the creative nihilism of Tolstoy.

i …as Bunin had a savage hatred for Dostoevsky, that "accursed medic," as he called him—nor had…

In the brilliant, well-honed writing of Bunin himself, ultimately hardly any people are left: they are displaced by a world that is beautiful and terrible in its indifference, in its eternity and in its silence. In this world man's dissolution can progress no further. All has been said. All are "superfluous people"—superfluous because to be an individual is inherently superfluous: everyone smolders away to nothing and dies.

"I was tasting a little honey ... Behold! I must die"[110]—this is not only the epigraph to Lermontov's "The Novice"[111]; it is the epigraph to an entire stratum of Russian literature. But in this vast, cold world there suddenly flares up the brilliant light of a completely different world: the world of Dostoevsky. In him, on the contrary, all is maximally charged with personal fates, lives, and concerns, so that even nature itself seems to exist for the sole purpose of participating in man's personal life, and from it to draw its own existence. Man, who became a kind of grim mask in Gogol, tediously superfluous in Turgenev, and impersonally natural in Tolstoy, was suddenly resurrected in Dostoevsky in all his complexity, inimitability, and irreducibility. And he began to live a life of such intensity that the author himself seemed no longer able to keep pace with him.

This suggests to us that the old, familiar concepts have long been in need of correction and clarification. It is held, for example, that Tolstoy is an artist, while Dostoevsky is rather an ideologist, a preacher. But for some reason it has been but little noticed that the works of Tolstoy are in fact full of ideas and oft-repeated preaching. Tolstoy never tires of continually "moralizing," as they say, whereas the "mystery"

of Dostoevsky lies specifically in the fact that no one has ever yet managed to discover exactly what "ideas" he preached. The essence of Tolstoy's preaching may be presented in a single page, while the attempts of lengthy treatises to "explain" Dostoevsky remain unconvincing.

This begs the conclusion that Dostoevsky was extraordinarily endowed with the pure gift of creativity—that is, of building a world that becomes reality, though not at all "realistic." Tolstoy chiefly delights us by presenting everything in a way that is staggeringly "lifelike," by the incredible precision, clarity, and depth with which he shows us this life and everything that we often overlook in it. Conversely, in Dostoevsky there is little that resembles everyday reality or ordinary life: in his work all is flooded with a unique light unlike any other, and has a unique, inimitable life of its own. But it is this life that proves to be the truest reality, imbued with unique qualities that we have not exactly failed to notice—we simply knew nothing of them before, and here Dostoevsky has revealed them to us. With Dostoevsky a certain primordial power of *creativity* returned to Russian culture—and for this reason he and his work became the foundation for the subsequent development of Russian culture. And the explosion, the fundamental changes that began taking place in Russian culture at the close of the last century [that is, the nineteenth century] and the beginning of the present, was linked chiefly with his work.

TALK 15
CULTURAL IDENTITY AT "THE BEGINNING OF THE CENTURY" (1)

The watershed in Russian cultural identity had already taken shape at the close of the last century, and by the early twentieth century it had become an established fact, so that a new cultural identity may be said to have emerged.[112] This watershed has been the subject of numerous books, but in them we will find no united assessment, no united opinion on what exactly then occurred. Much is said of a rebirth, of the Silver Age of Russian literature and art, of a new wave of creativity typical of that period—and all this is naturally accurate.[i, 113]

Assuredly, there was a rebirth of creativity, a new wave; Russian culture was enriched by several dozen illustrious names that would remain in it for all time. There was a special atmosphere, there was an excitement, a subtlety, an openness that had not been there before. But is mere recognition

i One need only compare Blok, for example—one of the pinnacles of the Silver Age—with Nadson, a "master of thoughts"[see note 113] or feelings 20–30 years before Blok, to realize the fundamental truth of these assessments.

of all these phenomena enough to determine the place and significance of the Silver Age in the history of Russian culture as regards its foundations? This question is already raised by the fact that the Silver Age was typified not only by a wave, but also by a profound divisiveness within Russian consciousness, a perturbation and confusion that created irreconcilable contradictions. And since Russian culture has yet to escape these contradictions, they must be considered, and an attempt must be made to understand them.

We recall that from the outset there was a great gulf separating the Russian culture that emerged and grew out of the "revolution" effected by Peter the Great from a vast portion of the people,[ii] and that this isolation from "the people" comprised its chief tragedy. But this culture was internally united. And any disputes and dissensions, even divisions into outwardly irreconcilable camps, could not fully destroy its inner unity.

Belinsky might cruelly berate Gogol, or Nekrasov quarrel with Dostoevsky, or Turgenev take offense at Tolstoy—but all this stayed within a common framework and did not violate a certain organic unity of the common culture. But what occurred in it at "the beginning of the century" was from this perspective an entirely new phenomenon. Russian cultural identity did not so much divide[iii]—as *dissolve*. The creators

ii … a vast portion of the people, who had been untouched by the Petrine revolution, and that this isolation from "the people" comprised its chief tragedy. But from the very outset and up to the final decades of the nineteenth century this culture was internally united.

iii … divide—for divisions, as we have said, had occurred before…

of the "renaissance" of Russian culture were found to lack even a common language, and we see that the history of this "renaissance" is filled with fast-emerging "schools," trends, manifestos, declarations, a spirit of some intracultural civil war. These refused to acknowledge those, and neither made the slightest effort to understand nor listen to the other.

Bunin, for example, died without ever hearing anything in the music of Blok; another follower of the Russian Silver Age, Nabokov, denies outright not even Dostoevsky's ideas, not his philosophy, but his creative genius itself. Lermontov and Gogol, albeit in different ways, were antipodes of Pushkin and the Pushkinian "world," but it could never have occurred to them that they "did not understand" Pushkin or that they were contraposing their own work to his. It is therefore important to ask: What constituted the unity of Russian culture and how did the dissolution of that unity manifest itself?

The answer to this question must naturally be sought deeper than the creative plane, as such, alone. The unity of Russian culture, or rather of Russian cultural identity, that emerged after the Petrine revolution consisted first and foremost of a unity of *moral criteria.*

To our modern perception this sounds naive, but there is no getting around the facts: at its core, Russian culture in the eighteenth and nineteenth centuries was occupied with the problems of good and evil. This does not of course mean that it consisted of moral precepts or that it was occupied with preaching. But it does mean that it absolutely measured itself against a certain absolute hierarchy of values. And the debates within it centered on the ultimate source of this hierarchy of

values, on its application in life—not on whether or not it existed as the measure of everything in life, including culture. Perhaps in the context of creativity this peculiar moral absolutism may even at times have caused a cultural decline—when creativity was exhausted, for example, and there remained only moral pathos, as in the case of Chernyshevsky. And yet it was this moral solidarity, so to speak, this recognition of the primacy of the moral criterion of culture, and not just the aesthetic, for example, that laid the foundation for the inner unity of Russian cultural identity, its fundamental principle.

It is this principle which, if not wholly discarded in the creative work of the Silver Age, was at any rate greatly obscured. It should further be emphasized that this was not a deliberate, principled "amorality," not a proclamation of some new principles in place of the old, but first and foremost a change in the very atmosphere, the spiritual atmosphere of the development of Russian culture during its "rebirth" at the dawn of the current century. From this standpoint, it would seem, the "new consciousness," as it soon came to be called, proved far more open to spiritual reality and religious themes, even to mystical insights, than nineteenth-century consciousness had been. To see that this is indeed the case we need only recall the writings of Merezhkovsky and Gippius, Blok's *Poems About the Beautiful Lady,*[114] the mystical agitation of Andrei Bely, the topics of Vyacheslav Ivanov, Vrubel, and Skriabin. But, paradoxical as it sounds, all this mystical agitation proved foreign to the preceding moral inspiration of Russian literature.

If the moralism of Russian literature ended with Leo Tolstoy, who reduced everything in life and culture to the

Sermon on the Mount, it was to the Sermon on the Mount that turn-of-the-century cultural identity may be said to have been deafest and blindest, even in its religious quests. All these ambiguous monasteries and monks living in various backwater swamps, Khlysts[115] and imps, arousal by the eternal feminine, dark temples and narthexes and waiting there for daybreak, which filled the literature of the Silver Age—all this, tinted in mystical hues, was very far indeed from that of which the works of Gogol, Dostoevsky, and Tolstoy spoke, albeit diversely, with such white-hot spiritual intensity.

From this perspective the drama of Blok—at once the pinnacle of and a synonym for the Silver Age—is emblematic. Blok delved first and deepest into the atmosphere of mystical excitement that marked the dawn of the current century, and with his truthful soul he was the first to realize its deceit. Blok cast it off and rejected it—but all his subsequent writings were inherently permeated, utterly saturated, with the tragic gall of the disappointment he had suffered. Blok found himself powerless to truly overcome the void created, to find new ways or return to the old, and alas, with his last ounce of strength he conceived a desire to find the very mysticism that he had renounced in the bloody blaze of revolution, in his renowned poem "The Twelve."[116]

The example of Blok shows that at the most decisive, fateful moment in Russian history, during the revolution, when quite literally faced with Hamlet's question "To be, or not to be," Russian culture effectively found itself without a common

moral worldview.[iv] Throughout the entire nineteenth century, for good or for ill, Russian culture—first and foremost Russian literature—was, aside from its other functions, the *conscience* of Russian society. But this it failed to be at the moment when all the moral might of the country needed most to be exerted.

Let us reemphasize: what occurred during the revolution does not at all mean that the creators of and participants in our "renaissance" were immoral or amoral people. On the contrary, with few exceptions, they personally proved to be people of acutely sensitive conscience. But this means that moral norms and concepts of morality ceased to be the determining factor in their cultural identity. Gumilev, for example, was a hero and a thoroughly principled man. But in an era of horrific shock to the entire social organism of Russia, the pupils of his studio were learning to rhyme, playing hide-and-seek and blind man's bluff between classes, then quite seriously analyzing the vapid poems of Neldikhen.[117] And such examples are countless.

The old Russian culture was of one mind in opposing cruelty, violence, injustice, and inhumanity. The "new consciousness"—for all its preoccupation with apocalyptic dawns, the birth of a new world, the music of the future—ceased to notice the "suffering man" who in various forms had reigned in Russian literature for two hundred years, forever rendering it something more than literature.

iv This seems utterly astounding—and in this lay a true, profound tragedy. It should further be emphasized that it was a moral criterion, and not one political or aesthetic, that was found wanting.

Consequently, at the moment of truly apocalyptic collapse and profound rebirth, Russia was effectively left without a genuine, united cultural identity. Her cultural identity was caught off guard, unprepared for the very storm to which it had itself exhorted and of which in its mystical maximalism it had dreamed for two or three decades. And so it was that Blok suffocated and perished. Gumilev was executed by firing squad. Bely, entangled in his own fate, fell silent. Bryusov began sinking toward bottom. Others went into exile—to remember and finish writing the Russian literature of the past. As for the writers and people of art both new and old who remained in the country, in those uncertain 1920s they undertook to reflect upon what had occurred—and were forced to cut short their reflections by the menacing downshouting and by order of Stalin, who so swiftly came to power. And effectively no genuine *answer* was given to the terrible challenge issued by the unprecedented collapse of all Russian culture and of Russian cultural identity.[v] An answer began to emerge and originate far later—only when there began a return specifically to the moral foundations of Russian culture, now enriched with new, terrible experience. But before we speak of this answer we must still more closely and minutely examine the "renaissance" of the early twentieth century, its fate and its tragedy.

v If such attempts were indeed made, they were conducted from the positions of the old culture, remnants of which still survived in the familiar past world of moral and human values.

CULTURAL IDENTITY AT "THE BEGINNING OF THE CENTURY" (2)

L ast time we said that the indisputable florescence of Russian culture in the early twentieth century was also indisputably a time of spiritual uncertainty and bewilderment—a time of spiritual crisis, which tragically resulted in the fateful unpreparedness of Russian cultural self-identity for what was to be a nationwide crisis: the revolutionary explosion of Russia itself. This clearly shows the exceptional significance of this crisis, the spiritual pandemonium of turn-of-the-century cultural consciousness, for the fate of Russian culture. We also spoke of how the crisis stood out most prominently in the life and work of Alexander Blok, who remained in a sense the symbol, embodiment, and pinnacle of the Silver Age, the florescence of Russian poetry at the beginning of the current century.

It would hardly be an exaggeration to say that love for Blok may be compared only with love for Pushkin, of whom we say that "Pushkin is our everything." But there was a time when very nearly the same could be said of Blok. Marina

Tsvetaeva, for example, recalled his poems concerning the "blue cloak"—"Prowess, heroic deeds and deathless fame"[118]— these poems, she wrote, were "loved to anguish by all of Russia."[119] Another contemporary wrote that in those years, on the threshold of World War I, two lines of Blok meant more than everything else in the thick journal in which those lines were printed.[120] Blok had enemies and detractors, but no one ever denied the exceptional place that he held; no one ever disputed his supreme position in Russian poetry and, more than that, in turn-of-the-century Russian culture. The chief explanation for this was that what determined Blok's place was that he was universally loved. For the same reason it is by Blok, his work, and his spiritual path that the "specific weight" of the turn of the century may be measured and assessed in the development of Russian culture, and an attempt made to understand its significance at the most fateful hour in the history of Russia. And so it is that when we examine Blok and his work more attentively, we cannot help but see that for him what mattered most was an almost constant spiritual discord, a lack of coherence.

Truthfulness and discord—in these two words the spiritual image of Blok, his spiritual tragedy, may be typified. Blok's truthfulness, his organic incapacity for falsehood, was attested by many of his contemporaries. Zinaida Gippius, who rejected "The Twelve" with a shudder of horror, wrote: "Your soul is innocent. I shall never forgive it."[121]

In the astounding lyrical wave in which the poetry of Blok materialized, everything was *true*—in the ultimate, most

profound sense of the word. Against this truth Blok was defenseless. This renders still more astounding the incredible discord and disparity inherent in this poetry, how Blok— ever truthful, ever sincere—constantly shifts from one world perception [to] another, and even from one truth to another. From the poems of Pushkin, Lermontov, and Tyutchev we may more or less reconstruct a certain basic "world perception," if not the worldview, of each of these poets. It may be brighter in Pushkin, darker and more melancholy in Lermontov, steeped in mystery in Tyutchev. But it existed, and to a greater or lesser degree it was this world perception that the poetic works of each embodied and reflected.

What then was the world perception of Blok? What can be said of it? Even if we confine ourselves to the post-revolutionary, three-volume Musaget edition of his poems,[122] we cannot help but see that each succeeding volume reflects not an evolution, not a development of the preceding world perception, but a complete break with it. The first volume is wholly permeated with overtones of Soloviev's mysticism; it is full of anticipation of mystical dawns, "universal light from the spring of this world,"[123] adoration of the Beautiful Lady. But in the second volume all this has been extinguished: the "mystical dawns" have given way to a "terrible world,"[124] night in the city, despair, and loneliness. Then, in the third volume, once again Russia and enlightenment appear: "On Kulikovo Field,"[125] and later, on the horizon, "The Twelve." In all of this you will find no unifying feature: there is none. Instead of a unifying basis you see only a certain terrible and ambiguous

gift for reincarnation and excarnation, as well as an inability to "collect" his stance on what is happening. Furthermore, the "world perception" that had previously governed Blok is not merely abandoned, but is even discredited as deceitful and false, as a delusion.[i, 126] And only the unforgettable *backdrop* of Blok's poetry remains—the dawns, the snowstorms, the sunsets, all in the grip of sadness, pain, and despair. What remains is the aching despair that fills his poetry.

We could say that the authenticity of Blok's poetry is inversely proportionate to the "inauthenticity" of the worlds which he alternately adopted, only to abandon them once again—to abandon them because they proved inauthentic, a deception; because from them came there out not blood, but cranberry juice.[127]

This once again begs the comparison with Pushkin. A unique feature of Pushkin's mind is sobriety. The greatest of all Russian poets was sober in the extreme. But his sobriety did not lead him to disillusionment, or to despair, or to delusion. Pushkin had his own *personal drama*—but there was no drama in Pushkin's work, nor was there discord between him and his world perception. With Blok it is the reverse: his personal drama is wholly, entirely rooted in the drama of his work, while the drama of his work was specifically a drama of *insobriety*.

i And there remains "A night, a street, a lamp, a drugstore, a meaningless and dismal light. A quarter century outpours—It's all the same. No chance of flight. / You'd die and rise anew, begotten. All would repeat as ever might: the street, the icy rippled water, the store, the lamp, the lonely night." Essentially only ... [see note 126]

From the outset Blok lacked any criterion that would have enabled him to differentiate reality from "seeming reality"— or, in other words, authenticity from an imitation of authenticity. His poetry is "mediumistic," as it were, containing a mere "medium" that allows mysterious waves to pass through it, transforming them into words and sounds, but that effectively takes no responsibility for them. And one may have a great love for Blok's poetry while recognizing that it is dysfunctional at its core, and that this dysfunction is something new and hitherto unknown in Russian poetry.

This brings us back to what we said in the preceding talk, which probably comprises the chief tragedy of Russian culture at the turn of the current century. This tragedy lies in a terrible abandonment of the moral criterion that sustained the inner unity of Russian culture and Russian cultural identity until the late nineteenth century.

Here, once again, the problem is not that Russian literature in the person of Blok and his confederates became indifferent, "protesting neither good nor ill."[128] No, it is by no means indifferent. Rather, the problem lies in the instability and indistinctness of the criterion that distinguishes good from evil. There can be no doubt, for example, that Blok passionately aspired all his life to what was good; that art and creativity remained for him a "ministry," a service specifically to the Absolute; and that his despair was sublime in nature: it came from failure to find that Absolute. But nevertheless it is apparent that neither Blok nor his peers succeeded in finding, hearing, or speaking of that Absolute. And here the problem

is not one of religious faith: Turgenev was an unbeliever, but the primacy which he accorded questions of good and evil is indisputable.

The explanation must apparently be sought in the profound *rebirth* of creative identity itself. This rebirth consisted of the following: poetry and all cultural creativity conceived a desire to effectively become something else, something other than what it had been for Pushkin, Lermontov, Tyutchev, and the other masters of nineteenth-century Russian culture. Let us put it this way: Pushkin had a very high opinion of the vocation of the poet, calling him a king and acknowledging no supreme judgment over him but that of the poet himself. But it would never have occurred to Pushkin to confuse poetry with religion, or philosophy, or any other field of human activity and knowledge. Conversely, we need only read Bely's famous recollections of Blok, the chapters covering the very dawn of the century, to see what all-encompassing, what downright stratospheric significance the poets of the Silver Age ascribed to their work.[129]

Creative work, poetry, and art seemed to them the *only* true path to all the secrets of life, to the solution of all problems, and above all to the solution of the eternal problem of discerning good and evil.

Blok personally was a very modest person. But in the creative wave that he and others created it was *modesty* that was missing: instead there was defiance, there was self-assertion, there was the claim that just a few more poems, a few more symphonies, and then new heavens and a new earth would

ensue.[130] Consequently, each powerful personal feeling of these new artists expanded for them into nearly stratospheric events—events that directly concerned Russia, the whole world, and the transfiguration or destruction of both. In rejecting the authority or oversight of anyone, poetry demanded authority over all things, declaring itself and its subjective truth to be the inner criterion of absolute truth, of good, and of evil. And all this because of the dubious conviction that poetry is the sole true path to discovering all the secrets of life.

All this must be discussed in order to attempt to determine the causes of the catastrophe that befell Russian culture at the close of the Silver Age. The simple, harsh truth is that nineteenth-century Russian literature made no claim to be the "conscience" or "measure" of all things—and yet it was indeed both the conscience and the measure, insofar as it freely submitted to the supreme moral law, seeing it as its judge. By comparison, the creators of the Silver Age began by declaring *themselves* prophets and theurgists. In actuality, however, their work reflected a dissolution of moral awareness, and it blanketed Russia with a kind of fog of ambiguity and confusion, which at the dread moment of trial stripped her of moral power.

 TALK 17

ABANDONMENT OF THE MORAL FOUNDATIONS OF CULTURE

An examination of the development of Russian cultural identity invariably leads us to one indisputable conclusion: "at the border of two centuries"[131] something important and decisive occurred in this identity. We could say that there was a violation of the profound inner unity of this identity, which in spite of all was the chief distinguishing feature of its development over the course of nearly two centuries. This unity was neither political, nor philosophical, nor religious. Politically, Russian society became divided rather early: albeit with qualifications, Gogol, for example, may be termed "right-wing," while his early admirer and later foe Belinsky may be termed "left-wing." Consequently, beginning in the 1840s Russian society had both a conservative camp and an opposing so-called progressive camp, each with numerous different gradations.

Russian cultural identity likewise had no philosophical unity, if by this we mean a certain common worldview. Once again, by the 1840s differing philosophical premises caused

close friends such as Herzen and Granovsky to part ways forever.[132] Finally, Russia—at least its educated class—also had no religious unity: on the contrary, quite early on there appeared, if not avowed atheists, agnostics such as Turgenev and Chekhov.

Nevertheless, despite all these differences, even divisions and conflicts, *unity did exist* in Russian cultural identity. As we have already said, this was a *moral* unity—that is, it was a profound concord in the sphere of basic ethical principles. We could say that the Russian culture that emerged and grew out of the Petrine reformations lived in a united "moral atmosphere": it concordantly and unanimously perceived *good* and *evil*, and it had a concordant stance on how to apply this perception to life and reality. Once again we emphasize: this concordance and unity in the perception of good and evil was common to all camps and schools of thought, and for this reason, despite all differences, a commonality that united cultural consciousness was able to form.

As in all else that concerns Russian culture, Pushkin must naturally be considered the first and chief expresser of this ethical unity, this moral concord. Of *ethical* unity, let us be clear—not political, philosophical, or religious. Pushkin was a singer of Peter and of the Empire—and this alone sets him apart "politically," so to speak, from both the Slavophiles and the Westernists. Pushkin was not an "agnostic," and this sets a bound between him and, say, Turgenev and Nekrasov. But he also was not a "religionist" in the sense in which this neologism may be applied to Gogol, Dostoevsky, and Tolstoy. Pushkin was unaffected by the philosophical agitation of the Schellingites,

the Hegelians, and so on. But in terms of ethics, in his fundamental moral mindset, without a doubt he expressed that which united all these schools and camps. "And for the fallen called for mercy"—this same motif from Pushkin's "Exegi Monumentum" is heard in Turgenev, Gogol, Nekrasov, Dostoevsky, and Tolstoy. In it, in this verse, Pushkin expressed, felt, and said once and for all something deeply fundamental and self-evident, something that requires no proof or justification.

Gogol's *The Overcoat* and Turgenev's *Notes of a Hunter*, Nekrasov's *Who Lives Well in Russia?*[133] and Dostoevsky's *The Insulted and the Injured*,[134] Tolstoy's *War and Peace* and *Anna Karenina*—all these works are permeated with one and the same moral *tonality*. In reading them, preferring one over the other, arguing over them, establishing the differences between them, we nevertheless remain in the same *moral* world, we breathe the same atmosphere—the atmosphere that filled Russian culture after the appearance of *The Captain's Daughter*, the *Tales of Belkin*,[135] and in general all the works of Pushkin.

It is difficult to express this atmosphere in precise language, to present it as a sort of clear ethical system, but then it is hardly necessary. One line of Pushkin—"and for the fallen called for mercy"—may perhaps better and more fully express this moral inspiration than any lengthy reflections, by its music alone. "Mercy" and "the fallen." On the one hand, there is the constant emphasis not of "form"—on rights, rules, and laws—but of this hard-to-define *mercy*, pity, compassion, humanity. On the other hand, there is the constant focus on

the weak, the dispossessed, the *victim*, wholly regardless of the circumstances.

And it is here, in the definition of moral inspiration and concord, that we may go one step further and call this concord *Christian*. These ethics are indisputably Christian, although adopting them does not at all mean adopting Christian *dogma*. On the contrary, it was disputes and disagreements specifically concerning dogma, concerning philosophical and religious premises and rationales for ethics, that *divided* Russian cultural identity—yet in spite of all disagreements its ethical unity remained immutable. "The Heavenly Tsar has traveled / In servile guise across you, / My native land, with blessing,"[136] wrote Tyutchev of Russia, following the dictate of Christian ethics—that is, ethics are first and foremost compassion, pity, and mercy, the ethics of moral *rebirth*, and not of law; hence the general focus of Russian cultural consciousness on *the people.*

Let us be clear: for this consciousness the people were not just the chief object of compassion, pity, and sensitivity, but also the vehicle of *ethical* inspiration, the source of this ethical, self-evident standard. We might further cite the same poem by Tyutchev:

Proud eyes of foreigners
Will never grasp nor note
The inner light beneath
Your humble nakedness.

We could put it like this: Russian cultural identity drew its moral inspiration not from secondary sources—not from

Western philosophy, not from organized religion or the Church—but directly from "the people," and to the extent of its living contact with the life of the people. "The people," in the understanding of this consciousness, had nothing—neither culture, nor freedom, nor even the most basic forms of public life—and in this sense they were an object of compassion, pity, and mercy. But the people did have one all-important thing: a living moral awareness, that mysterious "truth" that they apply to all things, against which they measure all things, and which secretly shines with an "inner light" in their life. In this sense the people were a living teacher and mentor for the "proud" Westernist culture created by Russian post-Petrine self-identity.

Only by clarifying this and knowing the foundations of moral, ethical inspiration can we see the full depth of the spiritual watershed that occurred in Russian cultural consciousness at the dawn of the century. We have already defined its essence: it was a disintegration of ethical unity, an abrupt departure from self-evident moral concord, and moreover a departure in opposite directions. What exactly were these *opposite directions*? In the preceding talk we spoke of Blok, one of the chief expressers of the "new consciousness," the new perception in Russian culture, whose work typifies one of the chief trends in this process. It began with a certain religious "explosion," but a characteristic feature of this "explosion" was the fact that it signified a transition from "ethics" to "dogma." Blok, Bely, Merezhkovsky, Vyacheslav Ivanov, and the other representatives of this phenomenon were

interested in "the secret of Christianity," but not in Christian ethics. Faith and creative work, the transfiguration of the world, cosmic renewal, the secret of the Three,[137] esotericism—these are the themes of this explosion. And all these themes consciously or unconsciously led from moralism to something else, to a certain "beyond good and evil."[138]

The advent of the Symbolist movement meant the end of the moral "concord" of Russian cultural identity. And not only of the Symbolist movement: it also ended in another trend on the other side, which was unaffected by the religious explosion. The atmosphere of Gorky, Korolenko, and after them Bunin and that entire trend was likewise no longer the atmosphere breathed by nineteenth-century Russian culture. Outwardly, Gorky, for example, was focused on "the people," but his "people" were no longer a vehicle of the "inner light" of moral doctrine and ethics, to which Russian culture turned as the source of these ethics. The world of Gorky is effectively a world separated and cut off from the rest of Russia—a world that promised only "unparalleled revolt";[139] a world of energy, bent on the destruction and annihilation of the former culture.

In Bunin's story *The Village*[140] there is no longer any inner light; nothing secretly shines. Its world is filled with a kind of irrational pointlessness that is on the verge of explosion. Everything is reduced to a single menacing black storm cloud, from which thunder and lightning may come crashing down at any moment. Pushkin's "and for the fallen called for mercy" can no longer serve as the epitaph for the world of Blok, nor for the world of Gorky and Bunin, nor for the world of Esenin

and Klyuev, nor for the world of Gumilev and the Acmeists; and the works of these writers are no longer indisputably permeated with that "mercy" that united the older writers and masters of Russian culture. After the collapse, some began dreaming of "unheard-of revolt," of various stratospheric changes, of the theurgical role of creative work in this revolt; while others lived by the menacing music of popular uprising and dreamed of "the red rooster."[141] And all these expectations, all this excitement, all this prophetic focus on bloody dawns was foreign in the extreme to the moral light by which Russian culture had lived up to the close of the preceding century. In this new atmosphere there was perhaps more of religion—but of a religion divorced from ethics. In it there was a greater focus on the people—but on a people that had become somehow abstract, irrational, with whom no moral connection was any longer felt.

This is the explanation for the spiritual bewilderment, the spiritual confusion of the new culture of "the beginning of the century." It entered the night and the storm of the revolutionary avalanche spiritually disarmed, stripped of its unity.

And considerable time was needed before the post-revolutionary ordeal of trials and tribulations compelled a reassessment of the newly acquired experience.

TALK 18
THE INITIAL REACTION TO THE REVOLUTION

It must be admitted that the question of how Russian cultural identity reacted to the cultural collapse caused by the revolution of 1917 has yet to be comprehensively addressed. Yet a great deal hinges on how that reaction is understood and evaluated.

The revolution of 1917 was a superlative crisis, a superlative watershed, and naturally the future of Russia, and hence the future of Russian culture, very largely depends on how that crisis is evaluated in Russian consciousness. In our preceding talks we said that to a significant degree the revolution was the result of the internal disintegration of pre-revolutionary Russia, the result of a profound crisis that took place in the pre-revolutionary years in Russian cultural identity. Despite its considerable creative upsurge, the so-called Silver Age of Russian culture also proved a time of spiritual disarray and disintegration of the unity which, all conflicts and differences aside, had united nineteenth-century Russian culture. This disintegration was first and foremost a disintegration of the

moral inspiration and concord that united Russian culture—a concord founded upon an ethical basis expressed in a line from Pushkin's "Exegi Monumentum": "And for the fallen called for mercy." It is this, as the supreme manifestation of humanity, that formed the sole, universal basis for all trends and schools in Russian cultural creativity prior to the dawn of the current century.

The early twentieth century saw a departure from this unifying ethical basis, and neither the mystical excitement and religious endeavors of the Symbolist movement, nor the refinement of cultural consciousness, nor—on the other side of Russian life—the realism and Populism of the new Russian prosaics had any remaining blood ties to this united basis. And this disintegration of cultural identity at the turn of the century, its departure from the common ethical basis, could not help but also influence the initial reaction of that consciousness to the revolutionary avalanche.

The initial reaction of Russian cultural consciousness to the revolution was typified first and foremost by an absence of clear, precise criteria, reflected in turn by an absence of coherence—if not of worldview, at least of world perception. Russian cultural consciousness encountered the revolution in a state of disarray and disorientation, and this state was effectively the same in both camps—both for those who accepted the revolution and for those who rejected it. Both lacked a clear world perception, any definite criteria, and it was this that made their acceptance or rejection of the revolution deliberate and, consequently, insufficiently responsible.

In order to further elucidate what then occurred, let us turn to a certain concept, one fraught with meaning, from the lexicon of religious asceticism. There we find the word *fantasy*,[142] which signifies a dangerous spiritual state, one that is the opposite of a state of spiritual composure, sobriety, and responsibility. Consequently, we may say that the stance of Russian cultural identity regarding the revolution was tremendously, perhaps decisively, influenced specifically by "fantasies"— by the unclear, nebulous frames of mind that pervaded that self-identity at the turn of the century.

In his *Recollections of Blok*, Andrei Bely wrote the following concerning these fantasies, this mystical excitement: "Something unconfined has come rushing into the confines of the old life, and something eternal has manifested itself within time. ... We experienced the abruption of time as an assault of Eternity. ... Our generation faces either rebirth or death."[143]

These words of Bely refer to the most important question of that era—the intrusion upon the consciousness of maximalism and absolutism. Everything was denoted as the end and the beginning; everything turned into an anticipation of some cosmic conflagration in which the world would be consumed and then reborn. And it was this excitement of the consciousness, its pervasion with apocalyptic frames of mind, that engendered the first tragic misapprehension, which developed only considerably later, in the years of the revolution. This consisted of equating the revolution with these mystical dawns, in viewing it through the prism of the mystical excitement of the early twentieth century.

Professional revolutionaries—Populists, social democrats, Bolsheviks, Menzheviks, who paved the way for revolution in Geneva, Paris, or London, debating the paths and goals of revolution—had not read Soloviev, or Blok, or Bely. Revolutionaries and people of the "new consciousness" had neither a common language nor a common perspective, nor could they. And when the revolution occurred, the people of Russian culture initially saw it merely in the light of their own vague, mystical frames of mind, in light of their own "fantasies"— and not as it was in actuality.

Blok's poem "The Twelve" stands as an eternal and tragic monument to this chief misapprehension. Blok was the most pure, most consistent and truthful expresser of turn-of-the-century "mysticism." He believed in it wholeheartedly. And even after he became disillusioned with its initial content, its religious tonality, Blok remained a medium, a mystic, a visionary to the end. And for this reason he heard "music" where there was no music, for it is impossible to discern or hear any music in Lenin and the whole of his "tonality," however one might wish it. But Blok did "hear" it—and he did so first and foremost because he wanted to hear it, because he perceived creativity itself as mediumistic. Then, upon hearing this "music," Blok used it to justify the revolution and placed Christ at the head of the Twelve. And this was the action of the truthful, thoroughly honest Blok: others, who had long since become entangled in the labyrinths of their elaborate Symbolist constructs, were still less conscious of their own words and actions.

Consequently, the first, tragic misapprehension lay in the fact that although the revolution spoke—indeed, screamed—the same very plain, very simple language, a part of Russian culture heard in it and ascribed to it another language altogether.

The "fantasies" obscured the reality, making it almost impossible for people of a certain spiritual mindset to see the simple truth. And so the misapprehension became a moral catastrophe also. The subjectively truthful Blok became a liar, for "The Twelve," however that poem is interpreted, ultimately proved a lie. And it has long been universally acknowledged that when Blok realized this lie, he died. Before his death, suffocating in semi-madness, he begged his wife to find and burn all copies of "The Twelve,"[144] and this of course is deeply symbolic.

The tragedy of Blok outstripped his personal drama: over the course of many years it obscured reality from Russian culture, making it difficult to uncover the truth. This truth became overshadowed by and intermingled with revolutionary romanticism. Naturally, it was not just the "fantasies" of the turn-of-the-century Symbolists and mystics that were at fault. The nearsightedness of the literature and art of another, seemingly "realistic" camp proved equally tragic: its nearsightedness was a consequence of "fantasies" likewise long since romantic, but of another kind—fantasies of "sublime stormy petrels."[145]

Consequently, when history demanded a reckoning, Russian culture was found lacking in depth. Gone was its strange yet obvious gift of clairvoyance, of discerning truth from fraud, good from evil, which had distinguished it almost from the outset of its creation. Writers, poets, artists, and

composers saw what they wished to see in the strange, univer-
sally staggering events; they heard what they wished to hear,
imbibing the music, the maelstroms, the driving snow which
they created in their imagination and which had already been
created in it by earlier "fantasies." In these days of feuding and
bitter strife there was even a sort of "feast in time of plague."[146]
And so it was that in the cold, hungry, fear-crazed city of
Petrograd[147] the young men and women of Gumilev's studio
could play at hide-and-seek and argue over rhyme and meter.
Futurists of every shade came into their hour, their era, amid
the eruption of the social elements. To the sound of gunfire,
in the fear-saturated atmosphere, refined debates were held
at night, clearly affording the participants particular pleasure.
Even the death of Blok and the execution of Gumilev did not
rouse the members and followers of the Silver Age to sobri-
ety and reflection. The result was that in this most difficult
time for the great Russian culture, in the years of the col-
lapse of Russian nationhood, the most remarkable people of
this culture remained in the grip of the same "fantasies" and
illusions, when what was then needed most was responsibil-
ity, truthfulness, and sobriety.

It should once again be underscored that this resulted not
from fragmentation or waning talent. No, the loss of sobriety
resulted from an inner deviation of the spiritual seismograph
amid the florescence of the Silver Age. Music and mysticism,
dawns and noise, aesthetics and Khlystism—all this somehow
supplanted the firm moral foundation that Pushkin created for
Russian culture and by which the latter lived and grew, in spite

of all crises and divisions, throughout the whole of the nineteenth century.

Both acceptance and rejection of the revolution were typified first and foremost by personal stance, based more on "taste-based" personal perceptions and experiences than on firm moral criteria.[i, 148, 149, 150, 151]

Only by realizing this bitter truth can we understand the fate of Russian culture in the initial, pre-Stalin decade of the Soviet regime. This we will discuss in future talks—but already we may speak of its chief import, which comes down to the fact that Russian culture faced the arduous task of inner purification, a gradual, agonizing return to its own foundation. But doing so proved extraordinarily difficult. Russian culture entered the new era having squandered much of its former wealth. It is this that we see in the first Soviet decade, but at the same time there were already glimmers of a possible rebirth. In this lies the undying interest of those years, which we will analyze in greater detail in our next talk.

i Khodasevich once wrote of Yesenin that Yesenin was caught up in his search for Rus',[147] Raseya, [148] and Inonia,[149] and only the word Russia never occurred to him.[150] Something of the sort may be said of nearly the entire cultural atmosphere of those years. Reality, the flesh and blood of Russia, her complexity—all this was supplanted by myths, and this peculiar mythogenesis enervated creativity for a long time to come.[151]

The Enslavement of Culture

L ast time, in defining the initial reaction of Russian culture—or rather, of its most prominent representatives—to the revolution, we said that at that time they lacked firm, clear criteria for their stance on what was happening, and that this stance hinged on the illusions that gripped them. A highly characteristic symbol or foundation of this vague, ambiguous reaction was Blok's poem "The Twelve." Blok was joined or followed by Bely, Yesenin, Mayakovsky, early Pasternak, and many other prominent writers and poets. In various ways and in various shades, one way or another all of them believed in a kind of myth or illusion, rather than the reality of the revolution, and they devoted themselves and their creative work to this myth.

The myth that gripped them may briefly be defined as follows: the revolution is the fulfillment of the prophecies,[i] a metahistorical event; it is Russia's mystical encounter with its ultimate destiny, the beginning of a completely new era.

i …and visions…

While living in emigration, the well-known poet and critic Vladislav Khodasevich wrote the following of Yesenin— an opinion that may also be extended to others: "It was … explained to Yesenin that the Rus' that was to come, the one he had been dreaming of, was, in fact, the new state. This new state would also be built on a religious foundation: not on a pagan or a Christian foundation, but, rather, on a socialist one; not on a faith in redeeming gods, but on faith in the self-organized human being. They explained to him that 'there is socialism and then there is Socialism'—that socialism with a lowercase letter is merely a social and political program, but that there is Socialism with a capital letter, too: a 'religious idea, a new faith and a new knowledge to which the knowledge and old faith of Christianity are giving way.'[152, ii, 153]"

Yesenin, intoxicated like many of his peers by the universal storm and the cosmic crisis, exclaimed:

> I'm not scared of hell,
> Nor the rain of spears and arrows, —
> I read but one book of the Bible,
> The Prophet Esenin, Sergei's.[154]

These writers and poets, raised in the mysterious wood of the Symbolist movement, in a world of reflections, prophecies,

ii Ivanov-Razumnik, in his foreword to Yesenin's Ionina, wrote: "In Christianity, the whole world was saved by the sufferings of one Person: in the Socialism that is to come, each person will be saved by the sufferings of the whole world" [see note 153].

and premonitions, caught fast in the grip of their own religious excitement, perceived the revolution through the prism of a feverish imagination stripped of sobriety. Mandelstam exclaimed:

> Glorify, brothers, freedom's twilight—
> The great crepuscular year.
> …
> Oh sun, judge, people, you rise
> Out of hollow god-forsaken years.[155]

Echoes of "The Twelve" may also be heard in Voloshin, in his words addressed to Rus':

> Shall I be first to cast a stone,
> Condemn your passion, your unbridled flame?
> I'd rather kiss the mud before you
> And bless the imprint of your naked feet:
> My Russia, besotted, wandering, roofless,
> Blessed fool in Christ.[156]

The pinnacle, the final embodiment and conclusion of these illusions in terms of splendor and tragedy, was Mayakovsky. One literary historian wrote of him: "He was a vassal of revolution, loud and direct, and he trod heavily through his era, disdaining traditional finery, ready to slit the throat of his own song if necessary for the triumph of the new, socialist way of life."[157]

It could be said that Mayakovsky's suicide in 1930 marked the end of the era of illusions, the era of the mythical belief

that, in spite of all, the revolution would bring about a strat-ospheric renewal of the world and of existence. The twenties were years of a faith not yet spent, of unfinished prophecies and expectations. For example, in his story *Envy*,[158] which at the time garnered considerable attention, Yury Olesha still believed that the concrete gatehouses of socialism and col-lectivism not only were compatible with personal freedom and personal dreams, but even lead to this freedom and these dreams. It was still the same faith, in spite of all, in a certain decisive breakthrough of "humanity."

The "Serapion Brothers"[159] believed this likewise; Boris Pilnyak lived and wrote in obedience to the same myth. It is no accident that Trotsky called these writers, who were at the center of the literary stage in the 1920s, "the fellow-travelers of the revolution."[160] To be sure, this generation no longer preserved the memory of the dawns of the Symbolist move-ment,[iii] or the aspiration to interpret and perceive the revolu-tion in a spirit of mysticism. The illusion of that time was a faith in the possibility of creative freedom even under a sin-gle-party regime, a faith in a peculiar alliance of collectivism with creative individualism. The "Serapion Fraternity," for example, saw the original sin of nineteenth-century Russian culture in its psychological enslavement by ideologies of every possible kind, in its organic union with "the general public." They declared: "We renounce utilitarianism; we will not write

iii … nor the former revolutionary tension …

for propaganda. Art is as real as life itself. And like life itself it has neither purpose nor point: it exists because it cannot not exist."[161]

Here, however, in this defiance and affirmation of the freedom and independence of art, there is also the rottenness of nihilism, a continuation of the break with the moral criterion of which we spoke previously as the foundation of the nineteenth-century Russian cultural tradition. As with other schools, there was no firm moral foundation: the disarray continued, and it is no surprise that the "Serapion Brothers" parted ways[iv] even before the Stalinist reaction.[162]

The illustrious founder of the critical school known as "Formalism," Shklovsky, soon effectually renounced himself, and under the Stalinist regime he chose a drab bureaucratic career. Nikitin likewise conformed, settling on drab propagandist prose, as did Vsevolod Ivanov, along with all the other surviving writers who had not yet emigrated. Faith and the associated voluntary submission to at least the mythical goals of the revolution had come to an end: obligatory, practically compulsory servitude to the regime now ensued, under the guise of serving "the building of socialism," employing the methods of socialist realism. All freedom of cultural creativity was conclusively eradicated.

The harsh, systematic crackdown on culture began in 1928, the first year of the first five-year plan. In the 1930s it ended in the complete enslavement of culture.[163] We need not speak in detail here of this enslavement: it is impossible

iv and their movement exhausted itself

to name all the victims, or to list all the mutilated talents. These talks are not a history. To certain writers of those terrible decades we will yet have occasion to return. For the present it is important that we reemphasize what appears to be of the greatest importance: Russian culture, and Russian literature especially, entered the era of totalitarianism, the years of enslavement of the individual, of renunciations of spiritual values, of a new rampage of terror—that is, of all that is linked with the name and regime of Stalin, but which had already begun under Lenin—not only in a state of "fragmentation," but also infinitely weakened by the spiritual crisis it had suffered at the turn of the century. At the most terrible moment in Russian history it proved powerless, incapable in that moment of recognizing, of correctly determining for itself and for the people, in order to preserve what should not have been given over to destruction. This naturally did not preclude either the personal courage or the genius of individual artists and representatives of Russian culture. But on the whole the latter was left without a backbone, an axis, a foundation upon which it could have constructed some coherent response, some coherent statement.

While the old regime fell not so much before the force of the revolutionary onslaught as due to its own weakness and degeneration, Russian culture was found lacking the necessary fire and ardor with which it could have aided a country swept up in a whirlwind, which had lost its ability to contemplate its own history. The terrible catastrophe, the disastrous calamity, it perceived either in aesthetic categories, as a spectacle

furnishing new food for creativity, or as the confirmation and fulfillment of their dreams and fantasies.

There is something almost terrible in the descriptions of the peculiar cultural "feasting" that took place in the early years of the revolution—*against the backdrop* of the wholesale sufferings, famine, blood, and hatred that inundated the wretched country. Never, it seems, had there been such talk, such debates, such clamor over culture, poetry, and art in Russia as at that particular time. But in all these debates there was no authentic tragedy, no authentic depth. This does not of course mean that poets and writers should have turned politicians, becoming "red" or "white"—political preoccupation at the time, incidentally, was more than sufficient. No, we are talking about the chief function of culture as a reflection of the conscience, as a search for meaning, as the purification and transfiguration of elemental forces. Or, still more simply, as responsibility for the fate of the people and of the country. This responsibility was felt by Pushkin; it was born (whether poorly or well, correctly or incorrectly, is another matter) by Gogol, Dostoevsky, and Tolstoy. All these knew, perhaps even without being fully aware, that their own work, no less than the political struggle and the activities of the general public, was forging that integral wholeness that the people could not do without.

This essential sense of responsibility was found lacking in the cultural and artistic class reared on the fantasies and illusions of the Silver Age. Naturally, the art of that time "reflected" Russia, the storm of revolution, the uprising of the elements.

But that was all it did—reflect, almost passively. It wanted either to keep pace with events, not to fall behind history, or else—another part—wanted to withdraw from what was happening, to obtain its own "freedom" and the right to create without giving events a backward glance.

But it did not create this history, nor did it wish to. The snow, the icy blast, the primordial forest, fragments of ancient fairy tales equally frightful and primordial—these are the symbols and images oft repeated in this creative work, which was as though permeated with a sense of helplessness, of the elemental violence of what was happening.

This art was ruptured by a command: to engage in the work of building, to serve and submit. There is no point, no need to list all the defeats of Russian culture, the humiliations that it was forced to undergo. Most probably it is more important to turn our attention now to the almost inaudible resistance that began in those same years—to the process of the slow search for firm foundations.

TALK 20
CREATIVE RESISTANCE (1)

Today we will be talking about how Russian cultural identity first began to push back against the threat of destruction.

In the talks that we devoted to the tragic fate of Russian culture during and following the revolutionary crisis, we spoke at length and in detail of the indistinct and illusory atmosphere that reigned in Russian cultural consciousness during the first decades of the current century. We said that this indistinctness and incoherence gradually resulted in a departure from what we have termed the moral criterion to which nineteenth-century Russian culture was subject. Due to the gradual erosion of this criterion by aesthetic refinement and sophistication, mysticism or the pursuit of "modernity," at the tragic moment of nationwide crisis the "voice" of great Russian culture proved weak and divided, either devoid of clarity or preoccupied with illusions and utopia. Consequently, Russian culture was unable to exercise any decisive influence over the brewing catastrophe, to keep it properly confined.

Even before an unheard-of tyranny was unleashed upon the land, even before a brute command, backed by the cudgel of terror, made Russian culture a tool of tyranny, Russian cultural consciousness had not the strength to offer the necessary resistance.

Now let us discuss another aspect of this complex process. It could be said that, despite severe trials, the illness did not prove fatal. At first almost inaudibly, imperceptibly, then more distinctly and clearly, there began—if not yet a recovery—a sort of cleansing, a return to sobriety. There began a slow, gradual return of Russian cultural identity specifically to the moral yardstick whose abandonment in the early nineteenth century had incurred such calamitous consequences.

Jumping ahead, we might say that if in Russia today, along with obedient bureaucrats who follow every directive of the party authorities, we also have Solzhenitsyn, Sinyavsky, Daniel, Brodsky, and many other heralds of truth and freedom, this is because the continuity of an internal tradition that may be traced back to the very roots of Russian culture was never severed. For this reason we can speak of a "creative resistance"—of a resistance of the creative powers of Russian culture that can be traced as far back as the protest of Blok, Yesenin, and many other victims.[i]

i For this same reason we can also state that the renewal and rebirth of Russian culture was possible at all, for it was linked specifically to this creative resistance, being founded upon it.

How did this "creative resistance" begin? It would probably be no exaggeration to say that to find its origins we must turn to the same poet who more than all others bears responsibility for the fateful ambiguity that typified Russian culture in the first Soviet decade. The name of this poet is Blok, and the chief symbol of this fateful ambiguity is "The Twelve." But the creative essence of Blok was a *defenseless truthfulness*: unlike many of his peers he was endowed with a courageous conscience, and for this same reason he was the first to realize *what* exactly was happening in Russia, and where, into what terrible driving snow, cold, and horror, his "Twelve" were headed.

In the final winter of his life, the terrible winter of 1920–1921, Blok knew that he was mortally wounded—not by any physical ailment, but wounded by conscience, wounded by the terrible error of his own hearing and vision. On February 11, 1921, he gave a speech at the All-Russian Celebration in Memory of Pushkin.[164] Here is how Vladislav Khodasevich, a participant at the assembly, recalled the event:

> Blok, who occupied the end of the table, sat with his head bowed low. ... He went on last with his inspired Pushkin speech. He wore a black jacket over a white turtleneck sweater. Wiry and desiccated, with his weather-beaten, reddish face, he looked like a fisherman. He spoke in clipped tones and in a slightly muffled voice; his hands were stuffed into his pockets. He would periodically turn his head in the direction of the party representative and say distinctly: "Bureaucrats are the rabble, they were the rabble of yesterday and they are the rabble of today ... May those bureaucrats who seek to turn poetry to their own ends, to encroach upon

its secret freedom and to prevent it from fulfilling its inscrutable purpose, guard against this vilest of appellations. … "

Coming from Blok's lips, this speech … had been endowed with a deep sense of tragedy and perhaps even an element of *repentance*. The author of "The Twelve" was entrusting Russian literature and Russian society with the preservation of Pushkin's final legacy: freedom, if only of a "secret" kind. As he spoke, you could feel the barrier between him and his audience gradually breaking down. In the ovations that accompanied him off the stage, there was a whiff of that peculiar brand of enlightened joy that attends a reconciliation with a loved one. . . . On that evening … he was more melancholy than ever. He spoke about himself at great length. It was as if he were talking to himself; he became deeply introspective. He spoke very restrainedly, sometimes in allusions, sometimes vaguely and confusedly, but one could sense a stern, sharp honesty behind his words. It seemed as if he were seeing himself and the world around him with a tragic rawness and simplicity. And this honesty and simplicity forever remained connected in my mind with memories of Blok.[165]

Such was Blok on the day of the celebration of Pushkin's memory in 1921, as recorded by the poet and literary scholar Vladislav Khodasevich, who soon departed for the Russian diaspora. And it is of course no accident that Blok titled his last article "Without Divinity, Without Inspiration."[166] In this article, over the heads of his immediate opponents—the Acmeists and the Formalists—Blok contended with all who stripped art of its *soul* or, in other words, who *morally* devastated it. In this article Blok wrote: "They are all drowning themselves

in the cold swamp of soulless theories and formalism of every kind; they neither have nor desire to have even a faint concept of Russian life and of the life of the world in general; in their poetry (and consequently in their own selves) they suppress what is most important, the only thing of value: the soul."[167]

This is what Blok felt, realized, and said before his death: Russian culture is at risk of *the death of the soul.* And the "creative resistance" of which we have just spoken practically begins with these words, this behest of Blok. This "resistance" was essentially none other than an attempt to restore Russian culture to its *soul,* to that supreme and moral truthfulness that was its air, its food, its depth.

In his memoirs Korney Chukovsky wrote, "Once, in Moscow, in May, 1921, Blok and I were sitting backstage at the House of Printing while onstage some two-bit orator merrily expounded to the crowd that Blok was already dead as a poet: 'I ask you, comrades, where is the dynamism in these lines? They're carrion, written by a dead man.' Blok leaned over to me and said: 'He's right.'"[168]

But in actuality Blok's death proved a sort of "signal," a starting point for a slow return to sobriety and recovery. Upon the cross at Blok's grave someone wrote in pencil: "He was the child of light and goodness, he was triumphant liberty."[169]

Goodness, light, liberty—such was the signal that Blok gave for the start of many long years of "creative resistance."

Four years after Blok's death, on January 27, 1925,[170] Yesenin died by suicide—Yesenin, whose name may be placed alongside that of Blok in the history of the aforementioned

turmoil that proved so tragic for Russian culture. Albeit differently than Blok, Yesenin nevertheless also lived by a dream, a faith, a vision, and by his work he increased the dichotomy and the intellectual vacillation with which Russian cultural consciousness entered the new, tragic era. And that is why it is important that both Yesenin's suicide and the death of Blok proved symptoms of revelation, of awakening: they were a terrible reckoning for spiritual error. Khodasevich wrote of the death of Yesenin: "At last, he drew the final, operative conclusion from the poetry he had written long ago, when the truth about the unfulfilled Inonia had only just begun to dawn on him:"

> My friend, my friend! *Eyes that now see*
> Can only be shuttered by death.

"Esenin's eyes had been opened at last, but he did not wish to see what was happening around him. There was only one thing left for him to do: he had to die. … " "But, nevertheless, in spite of all of the errors and lapses that occurred throughout his life, there is still something deeply attractive about Esenin. It is as if there is some enormous, precious truth that binds together all these errors. So what is it about Esenin that makes him so attractive, and what is that truth? I believe that the answer is clear. What makes Esenin so wonderful and noble is that he was *endlessly truthful* in his art and in his conscience; that he saw everything in his life through to the end; that he was not afraid to admit his mistakes; that he took responsibility even for those mistakes that others had seduced him into

making—and that he felt the desire to pay a terrible price for everything he did."[171]

These two deaths—of Blok and of Yesenin—are deeply symbolic. These, we repeat, must be considered the landmarks from which a cleansing of the atmosphere began—an inner reassessment of valucs, a spiritual liberation. The voice of Anna Akhmatova was heard in a new light, though it soon fell silent for many years. It was Akhmatova who first reacted to the death of Blok by transforming his death into light:

> And the flowing of the Requiem
> Is no longer sorrowful, but radiant.
> …
> We have brought to the Intercessor of Smolensk
> We have brought to the Holy Mother of God
> In our hands in a silver coffin
> Our sun, extinguished in torment —
> Alexander, pure swan.[172]

This marked the beginning of a unique spiritual mobilization, imperceptible at first, whose influence was felt only a long time after. As we said in the previous talk, the pre-Stalinist decade was still deeply marked by the same disorientation, ambiguity, and disarray of ideas, valuations, and expectations. And only over time, as the clandestine process of spiritual rebirth gained momentum, did it become clear that the *watershed* falls along not ideological, not political, not aesthetic, but *moral* lines. Gradually there began a fight *for secret freedom*, for the freedom of Pushkin, for "goodness" and "light," for the soul of Russian culture. To trace the history of this fight right up until our own time, at least in brief—this will be the subject of the talks that follow.

CREATIVE RESISTANCE (2)

In speaking of the creative resistance of Russian culture
to the terrible spiritual totalitarianism that began to rule
over it in the first post-revolutionary decade and became
firmly entrenched for many years after the consolidation of
Stalin's authority, we must naturally focus not on any par-
ticular declarations or demonstrations that reflected that
resistance. No, we must refer first and foremost to *spiritual*
resistance—to an opposition, not outward and frequently
secret, to the state oppression and spiritual terrorizing of
authentic, spiritual values. It is of this resistance that we
began to speak last time, when we recalled its first manifes-
tation, still open and undisguised—of Blok's dying behest
to preserve that "secret freedom" which Pushkin bequeathed
to Russian culture.[173] And Blok's words at the Pushkin cel-
ebration of 1921 were a sign of the need to preserve one's
own countenance, one's own soul, one's own inner creative
independence.

This begs the question: Was Blok's behest heard? Was it received and carried out, and if so, how and to what degree? The most general answer to this question could probably be formulated approximately as follows: yes, Russia culture preserved the "secret freedom" of Blok's behest, for everything truly talented and authentic that was created in it over the past decades, which will outlive our time and remain— all this, one way or another, was created freely. And vice versa: all that was done under the cudgel of coercion, under orders, out of fear and a desire to please those wielding that cudgel—all this was simply ejected from the concept of culture and creativity; it does not pertain to them. In other words, despite all its internal contradictions, doubts, conflict, and disorientation, in those areas where it preserved in itself the stamp of creativity and authenticity Russian culture did not wholly surrender its final freedom—the "secret" freedom of Pushkin.

One very interesting and characteristic circumstance should be noted—that which even the most revolutionary, left-wing, and even so-called "proletarian" writers defended, albeit in their own, rather peculiar way, against the authorities and their orders, right up until Stalin's evisceration of freedom. These writers included not only those of the LEF,[174] Pereval,[175] and the All-Russian Union of Rustic Writers,[176] but even members of the renowned Russian Association of Proletarian Writers (RAPP)[177]—the seemingly all-powerful association of proletarian writers headed by such party-line writers as Averbakh and Kirshon.[178] The party, the authorities, placed

all their hopes in this organization, viewing it as a vehicle for party ideas and a tool for influencing literature and writers.[i] In actuality, however, the tool turned out to be not quite what the party leaders needed. The reason for this was that the proletarian writers themselves wanted to depict life to the fullest, in its "dialectic development," as the party itself taught—that is, with all its conflicts and contradictions, as they actually were, and not only viewed through the prism of party policy. One rallying cry of the RAPP stated: "For the living man!"[179]—for the "full-length" depiction of man in literature, with all his feelings and emotions—and not of what the party needed to depict at any given moment.

Other literary groups of the time proclaimed similar mottos that amounted to a rejection of what later came to be called "varnished reality," and that called for showing the world "as it really is." The members of LEF called for "tearing off all masks";[180] the leading writers insisted that literature had a duty to denounce evil, vices, and faults in every arena of public life. Incompetence within the bureaucracy, lies, abuses, and hypocrisy in the party, crudeness and ignorance among the workers and the peasants—all this had to be denounced through art. And although the majority of literary "products" of the time, written under the influence of similar openly utilitarian precepts, could not become part of authentic culture, it is important to note that literature was then caught up in the

i The writers united within the RAPP likewise saw and considered themselves as just such a tool.

pathos of serving truth and man—that is, it was once again subject to a moral principle, like all of Russian culture prior to the dawn of the twentieth century. And for this subjection, which party ideology viewed as anti-revolutionary and anti-party, the Soviet writers were soon to pay dearly.

During the first five-year plan it had already become apparent that service to the truth was inconsonant with the goals of the party. The authorities needed books on collectivization and construction; they wanted to see depictions of positive figures and bright, joy-inspiring horizons. But even the proletarian writers were writing about the disillusioned communist and the obtuseness of bureaucracy. Consequently, the proletarian literary group, narrow as it was, proved insufficiently narrow and obedient for the authorities, and in 1932 it was disbanded. The time of the wholesale enslavement of literature, and more broadly of culture, had arrived: the time had come for the creation of the Union of Soviet Writers.[181]

Thus, we repeat, even the proletarian writers had an ineradicable need to defend creative freedom in one way or another, and for this many of them were to suffer. The same may be said of other literary groups, and to a far greater degree. One of the most striking examples may be the fate of the well-known talented critic of the 1920s, Alexander Voronsky, and the literary group Pereval connected with him.[182] Voronsky quite sincerely considered himself a Marxist. Nevertheless, all his work effectively rejected the possibility of reducing the creative process to economics and sociology. First and foremost, Voronsky asserted that art leads to experiencing the

world by means of sensory images. The creator, the scientist, and the philosopher alike all deal with reality. But whereas the scientist studies and analyzes the nature of this reality, while the philosopher generalizes the knowledge of it, the creator allows us to experience it in sensory form. Hence, Voronsky concluded, every work of literature and art, though determined by the social origin of the writer and by its historical era, has objective value as "life experience." Consequently, for Voronsky the sole criterion for the value of creative work was, once again, its "truthfulness,"[183] but truthfulness at all levels, in all its depth.

Voronsky, as we know, ultimately perished. He perished for the same thing as many other writers, including his most malignant enemies from the proletarian camp: for defending not so much the "formal" freedom of creativity as its inner yardstick—truthfulness and authenticity.

Voronsky's friends and followers from Pereval held the same position. They too quite sincerely accepted the revolution and the Soviet government. But for them the Soviet government of the 1920s was not a fixed, static "value," but rather a mere moment in human development, and the current era was an arduous path to new horizons. The members of Pereval, we repeat, "accepted" the revolution, and many of them were even party members. But they insisted that each writer must freely find his own "social" theme and content, his own particular style.

Pereval published neither manifestos nor directives: rather, in its general declarations it insisted on qualities such as

"sincerity" and "truthfulness," and expressed sorrow over the conformism of the majority of Soviet literary figures. "The inner world," "the subconscious," "creative intuition"—these are the most frequently encountered terms from the lexicon of the "Perevalists." They insisted that for the writer it was "humanity," and not "party spirit," that must have primacy. And we need only reread Ivan Kataev's story *Milk*,[184] published in 1930, to sense this humanism, this humanity, that inspired the "Perevalists."

All this leads us to an observation that may seem strange: in some profound sense it was the 1920s that saw the start of a gradual return of Russian literature to the "moral principle" from which it had departed in the era of the fireworks of the Silver Age. From a literary standpoint, the works produced by many writers of the 1920s may seem impoverished; one might reject their aesthetic and worldview as false—but it is impossible not to see that the literature and art of those years once again recognized themselves to be subject to the yardstick of a certain "truth," a singular morality, and in the name of this morality and this truth they opposed themselves to the totalitarian oppression of the authorities.

Naturally, not all literature and not all writers were of this sort. The authorities always seemed to have plenty of literary bureaucrats and literary higher-ups who persecuted their brothers of the pen. And yet, surreptitiously, an entire tradition of creative resistance formed, and it grew out of a moral root—out of resistance not to the idea of the writer, or to creative responsibility for the country, the people, and the

nation—but to the fallacious interpretation of that idea by the authorities. And it is no accident that in those years no name was so often repeated as the name of Tolstoy—for Tolstoy was seen as a vehicle specifically of incorruptible truthfulness in literature. It was not "Tolstoyism" as a religious doctrine, but rather Tolstoy's merciless depiction of actual life, his elimination of all that hindered the truth, that attracted Soviet writers to him. It was these Tolstoyan qualities that they wished to learn and to assimilate from him. And in this there was effectively no difference between those who accepted the revolution and those who rejected it.

The reign of Stalinism put an end to this resistance. It likewise put an end to disputes regarding the place of creativity and creative methods in the new society. An ominous silence settled upon the country, despite all the triumphant reports and shouts—because the literature that had replaced the literature of the 1920s could no longer be easily designated as part of Russian culture.

But, as we will later see, the actual tradition and kernel of this culture had not died: its "secret freedom" yet remained, surviving against the day when—albeit in allusions, surreptitiously, and with limitations—it would once again be possible to bear witness to it.

CREATIVE RESISTANCE (3)

For nearly a quarter century Stalin's oppression of writers, artists, composers, and other figures in literature and art continued.[i] Yet despite a truly unprecedented reign of terror, the dictatorship nevertheless failed to wipe out and suffocate Russian culture—and it failed to fully suppress the resistance of its creative forces.

This fact is probably more important, more significant, than the plain and obvious fact of the meek, obedient submission of many cultural figures to the demands of the dictatorship, their spiritual capitulation, as well as the obsequiousness and toadyism of many others. There have always been and always will be people who are willing to serve any government, who will do anything for personal gain. But how much

i For nearly a quarter century they were deprived of all opportunity to freely think and create, and on pain of concentration camps and death they were forced into absolute service to the dictatorship, submitting to its every whim, these whims being masked by loud but empty statements about "serving the people." Yet despite this a truly…

more significant is it that despite employing every possible means of suppression, despite intimidation, executions, and tortures in the camps, the authorities failed to completely tear Russian cultural consciousness from its deep-set foundations? And that is not all: in some sense those terrible twenty-five years forced that consciousness once again to seek the foundations it had lost and to return to them, or at least to seek a way back to them. "And as a hammer / Shatters glass, she forged steel blades."[185]

From the severe trials, the element of "play," the tinge of flippancy, pseudo-depth, and ambiguity that had so typified Russian culture on the threshold and at the outset of the revolutionary crisis, fell away from it of its own accord. For as we have stated repeatedly in these talks, by the time the revolution began Russian culture was diseased and feverish: it stood at a crossroads, stripped of what had once united it, no longer possessed of these unifying principles. This illness had many symptoms, presenting in many different ways: mystical anarchism, an amalgamation of religion with unwholesome eroticism, irresponsible aestheticism, and cheap apocalyptics. And we may fully agree with a certain philosopher who reduced this strange and uneasy era to a single line born in that same time: "Dreams hovered still—and, grasped by dreams, / My soul said prayers to unknown gods."[186]

These gods were unknown—and the void was filled with dreams, confusion, unbelief, or a short-lived belief in utopia. And from this perspective the terrible decades of Stalinism also brought with them a certain inner purification. Much was

destroyed, broken, and crushed.[ii] Outwardly the picture was terrifying: it appeared that Russian culture had "surrendered without a fight," obediently submitting to the yoke of social realism and the "personality cult." But later it was found that this was not the whole picture. Something had survived, something had escaped the terrible destruction—and this surviving "remnant" was fated to begin the inner, spiritual rebirth which now permits us to look to the future of Russian culture with hope.

In our brief talks it is naturally impossible to analyze all these complex, multifaceted processes in detail, and we are obliged to employ what may be termed the method of "symbolic examples." In this instance the most expressive symbols of purification and a return to the foundations of Russian culture may well be two writers, of whom we may say that fate itself destined them to be the link between pre-revolutionary cultural consciousness and the new offshoots that began to emerge after the tragic Stalinist desolation. These writers are Akhmatova and Pasternak. Both were formed psychologically, spiritually, and culturally in the atmosphere of a waning but still-extant Silver Age, which clearly marked the early work of both. Both lived through the revolutionary crisis and the twenty-five years of Stalin, and in their later work they came to an inner, spiritual conclusion, elucidating the significance of past experience for

ii … crushed; many who did not break perished, while the weaker were broken, crudely shouted down and pressured into servitude.

Russian culture as a whole. For this reason they may be considered "symbolic examples."

In examining these "symbolic examples," Akhmatova and Pasternak, it must first be said of both that between their "early" and "later" work there is a tremendous, namely, spiritual difference. This difference is not only natural, not only "evolutionary," so to speak, which could be easily explained by skills developing over time, but a difference of a certain profound inner substance.

The advent of Akhmatova in Russian literature in the final years before the war and the revolution was first and foremost an event of indisputable poetic good fortune. But at that time this good fortune naturally struck no one as profound or significant. The poetry of Akhmatova wholly corresponded to the strange, carefree atmosphere, the strange lightness, unreality, and irresponsibility that marked the years of the collapse of the Symbolist movement, the years of "Stray Dogs"[187] of every possible kind, the years of a sort of "masquerade"—concerning which Akhmatova herself wrote with astounding accuracy many years later in her "Poem Without a Hero."[188] Then, before the war, Akhmatova wrote quite differently: recall, for example, her line: "The gray-eyed king died yesterday … "[189] In these and similar poems, as though detached from the gravity of Gogol, Dostoevsky, and Tolstoy, art was a game, purposeless and beautiful, in obedience to the commandment of Bryusov: "Perhaps all in life's but the means / For brilliant, melodious verse … "[190]

Early Akhmatova was and remained a kind of ultimate symbol, a symbolic *embodiment* of this atmosphere. What is

154 FOUNDATIONS OF RUSSIAN CULTURE

important, however, is that this was not *the ultimate embodiment* of Akhmatova herself as a great poet. Of this she prophetically wrote in a poem devoted to the day when World War I was declared:

> We aged a hundred years, and this
> Happened in a single hour.
> …
> Like a burden henceforth unnecessary,
> The shadows of passion and songs vanished from my memory.
> The Most High ordered it—emptied—
> To become a grim book of calamity.[191]

So it was that something imperceptibly trembled, something was altered in the voice of Akhmatova. After the avalanche of the revolution, when all seemed "plundered, betrayed, sold out," Akhmatova was the first to pose for all time her wonderful question—to herself, to others, to Russia, and first and foremost, naturally, to Russian culture: *"Why, then, is it so bright?"*[192] To this question she responded with all her subsequent work, all her subsequent life—right up until the appearance of her "Poem Without a Hero" and "Requiem."[193] It was this creative work of hers, embodied in "Requiem" and "Poem Without a Hero," that in a certain sense became the *foundation*, the measure, the spiritual criterion. It became the foundation, we might say, of a new classicism, of a return to "classicism." For in this instance classicism signifies not a particular aesthetic, but a certain spiritual mindset—a "coherent" mindset, as opposed to the emotional and spiritual dichotomy of all types of "romanticism," from authentic romanticism to various means of approximating it.

In the post-revolutionary work of Akhmatova it was the "romanticism" of the Silver Age, its inner vulnerability to storms and disasters of every kind, that played out and burned out. And most importantly, of course, this new classicism, this new coherence emerged in Akhmatova's work as a result not of any literary choice or "manifesto," of which the Silver Age saw so many, but of an existential choice and a spiritual deepening. "And it was I, your ancient / *Conscience*, found the burnt pages / Of a story," says Akhmatova in her "Poem Without a Hero."[194]

Yes, this classicism was a choice of conscience and truth. This does not mean of course that art began to "serve" truth or purpose: it became the reflection, the embodiment, the power of truth—of volitional truth, truth of *conscience,* and not merely of indiscriminate depiction.

The same, though in a different way, occurred with Pasternak. Pasternak emerged in Russian literature as a downpour of light, as a creative, elemental magnanimity, very nearly as eyes, hearing, touch, smell, and voice. He was a *festival* of life, an elemental onslaught of words, images, and sounds. And one may love early Pasternak for all this—and yet sense that this festival, this "downpour of light"[195] lacked a certain depth, and perhaps even lacked *truth* in the Pushkinian and Tolstoyan sense of the word. Naturally, Pasternak's later work also remained an ode to life and of gratitude to it. His novel *Doctor Zhivago* and his later poetry are likewise an ode to life. But one can hardly deny the tremendous spiritual difference between early and late Pasternak; one can hardly fail to observe the

new dimension that comprises the essence of Pasternak's later work:

> Creation's way is—to give all,
> And not to bluster or eclipse:
> How mean, when you don't signify,
> To be on everybody's lips![196]

Pasternak seemed to sense that his early heyday had contained these elements of blustering, of eclipsing, and he felt a need to solemnly renounce them. He also found his own term for the new coherence he had acquired, for his own conscience: *"to give all."* "In my utter conquest by them all / Is the sole of my victories."[197]

Pasternak's novel *Doctor Zhivago* is essentially one long exhortation to restore the coherence which was lost, to restore all that was broken, fractured, and squandered in the terrible first half of Russia's twentieth century. And the natural result is that, at the heart of this formerly lost coherence, in Pasternak's work we find that which is above literature and culture, above politics and ideologies, in a sense above even religion— at any rate, the religion at which the Silver Age had "played" in its pursuits.

The later work of Akhmatova and Pasternak is "symbolic" because in it is accomplished the inner purification of Russian cultural identity, its restoration to the hierarchy of values that had been lost. In them and with them once again the *foundation* of Russian culture is brought to light. One way or another, this foundation is also the focus of the more recent quests which we will proceed to examine in the talks that follow.

TALK 23
THE PAST AND TRADITION

The preceding talks discussed not only how complex but also how tragic was the path of the development of post-Petrine Russian culture. The chief and even decisive factor in its fate was a constant conflict on two fronts. On the one hand, there was conflict with uncultured or anti-cultural authorities, to which culture always seemed a danger, a challenge, and an erosive element. On the other hand, there was internal conflict, dichotomy, and struggle within cultural consciousness itself against the tendency toward self-denial and self-destruction, against attempts to reduce culture to social, religious, or apocalyptic principles. Consequently, in the formation and development of Russian culture, coherence was present least of all. It was always in danger, under pressure, in a state of tension. The first to depart from it, and even to rebel against it, losing its common language with it, was the imperial government that created it

by establishing a new, post-Petrine Russia.[i] Nicholas I, in his own words, still merely "observed" Pushkin, imposing himself as his "censor." But Alexander III gave Russian culture over to the glacial control of Pobedonostsev—and since that time the imperial government has only known of the existence and life of Russian culture from a distance, so to speak.[ii]

No less tragic was the divergence between Russian culture and the Russian intelligentsia. Here the correlation differs. The Russian Empire produced the Russian intelligentsia, but that intelligentsia became fearful of it and withdrew from it. In place of the search for and building of culture, the intelligentsia preferred the simplified radicalism of Western ideologies, dogma, and fanaticism. It is the widening of this twofold rift and the increasing isolation that explain the immeasurable fragility of Russian culture, its existence on the brink of an ever-threatening abyss. This also explains an increasing spirit of unreality within it, a detachment from real life, a withdrawal into mirages and utopias—all that comprised the atmosphere of the pre-revolutionary Silver Age and that determined the organic feebleness of Russian cultural consciousness at the

i This new Russia made possible the emergence of Derzhavin, Pushkin, and the entire magnificent Pushkinian pléiade, followed by the emergence of the Russian intelligentsia.

ii For it, culture became a foreign and even hostile phenomenon, as did the intelligentsia. And while Pushkin could laud Peter and still be a singer of the Empire, the 1830s marked the start of a gradual divergence between the Empire and culture—a divergence that developed into a fateful mutual hostility.

most decisive, most tragic moment in Russian history. In the outpouring of revolutionary hatred, in the blood of the Civil War, in the quests and disputes of those years, Russian cultural consciousness was as though absent—as though it had nothing to say, nothing to declare, nothing to contrapose to the catastrophe then unfolding.

It is this sense, this consciousness of a sort of "failure" on its part, of its own impotence, that was apparently the starting point for the new quest which, despite all prohibitions, despite the reign of terror and the suffocation of culture, comprised the inner, hidden theme of what was now the Soviet period in the history of Russian culture. This period, as has been said, began with the death of Blok, the suicide of Yesenin, the overstrain of Mayakovsky—that is, it commenced with death, it began with failure, with catastrophe, with the fulfillment of the prophetic line from Blok's "Retribution":

> The consciousness of the terrible defrauding
> Of all former petty thoughts and beliefs.

The time of Stalin was an end, an impasse, a pointless conclusion to the long and tragic history of Russian culture, after which all had to begin anew—in other words, its foundations and unifying principle had to be sought once again. For the *awareness* of an impasse is simultaneously a call to *find a way out* of the impasse. Consequently, all creative work, everything of significance since that time, has one way or another been marked by *quest*—by the search not for new forms or details, but specifically for a *basis*, a *foundation*. This process continues

to this day, and what is happening today in the depths of Russian cultural consciousness can probably be defined as Russian culture's search for its foundations. And although this search has not yet been sufficiently defined, already we may attempt to trace it, at least in the most general terms—to pinpoint its chief landmarks.

If the Russian culture that exists *in spite of* pressure from the authorities, *despite* the suffocating control over it, is now deprived of inner integrity and stylistic unity, if it breaks down into various trends and is defined by heterogeneous outlooks, this is most likely due to the absence of a foundation that is self-evident to all, and indeed to the *quest* for one. For this reason, as has happened more than once in the complex and much-suffering history of Russia, creative consciousness is considering various directions, various areas of focus. Let us try to examine these more closely and list the chief among these areas.

One such area of focus is *the past* and the past sense of *tradition* associated with it. As one historian of Russian thought has noted, people usually speak of the past and tradition primarily at critical times of breaks with tradition, in times of critical junctures and disunity of opinion. For example, the deep cultural, social, and religious crisis of the seventeenth century that manifested in a church schism was caused primarily by a crisis in Russian national and religious tradition in the Time of Troubles. "The past" only takes on its full importance when it ceases to be part of "the present," becomes estranged from it—and then suddenly its absence, a deficiency, a void, begins

to be felt. And if in our time so many people are turning to the past, to the traditions of old and the study of them, this is naturally not due solely to aesthetic or historical pursuits. No, these people are interested in the past because in the restoration of continuity, of tradition, of the organic link with the past they see or *sense* the foundation without which culture is left suspended in a sort of artificial, airless atmosphere. This is one area of focus, the primary focus in the quest of modern Russian cultural consciousness for its *foundation*.

The second area of focus, also known to Russia and its culture almost from time immemorial, is the West. For Russia and its culture, from of old the West has been at once a pole of attraction and of repulsion. Of attraction because Russia always felt itself, in the words of Chaadayev, a member of "the great families of the human race," and always instinctively knew that a break with this intercourse, with the common responsibility and the common quest inherent in all of European culture, was ruinous for Russia. But also of repulsion, because Russia also always recognized that she differed profoundly from the West and understood that it was essential that she likewise preserve something organically *her own* and irreducible to the West. For this reason there were waves of Western influences that periodically flooded Russian consciousness—in the sixteenth century, the seventeenth, the eighteenth, the nineteenth, and the twentieth; and at the same time there were reverse waves—of resistance, of distrust, of fear ... Now, after long decades of artificial, compulsory isolation from the West, an attraction to it, an inclination to

search there for answers to our Russian problems, is quite natural. Back in the 1920s Akhmatova wrote, "In the west the earthly sun shines yet …."[198] The rush to a new and inevitable encounter with the West may be termed the second area of focus of modern Russian consciousness in the search for its foundations, its coherence, its rebirth.

The third area of focus pertains to neither the West nor the East, but to the unified world of *science*—of the scientific outlook on the world, of scientific solidarity, in an era of so-called technological revolution. The consciousness of a significant percentage of educated people is focused in this direction, and looks to the scientific brotherhood, scientific freedom, and scientific solidarity for the healing of Russia's afflictions, as well. Here the defining factor is a focus not on the past, nor even on the present, but on the *future*; on a world whose contours, though only just beginning to be outlined, are breathtaking in their potential.

The fourth area of focus is social inspiration. However frightful the aftertaste left by the heinous, failed communist social experiments, however deep the awareness of failure, of collapse, of defeat, there nevertheless remains a memory of a design, a dream, and an early inspiration. "We will build a new world, a world of our own"[199]—however great the disappointment at the failure to build a "new world," the dream of social justice, engendered in Russian consciousness long before it was taken captive by the dogmatic ideologies of the West, cannot die.

Finally, the fifth area of focus, the fifth path of the searches of Russian consciousness for the foundations of its culture,

is the reawakening religious agenda, ever acute and vivid in Russian consciousness. Apparently it is no accident that the two spiritual and cultural pinnacles of recent years—Pasternak and Solzhenitsyn—found the center and mainstay of their hopes, their work, and their assertions specifically in the religious worldview. And they naturally were neither alone nor isolated. And here, though as yet feebly and not overly conspicuously, a new wave is building, a growing thirst and desire for knowledge.

Russian consciousness once again stands at a crossroads. United against a clear evil, unanimous in its defense of freedom, justice, and humanity, it is not yet united in its positive area of focus. And each individual path of hopes and quests is not yet interlinked with the others. Between them there is no dialog, no joint quest, no mutual verification. And yet each of them taken individually can hardly lead us to the anticipated coherence, can hardly find the *foundation* which Russian consciousness so intently seeks and which it so vitally requires. In the talks that follow on the foundations of Russian culture, after at least briefly analyzing the areas of focus we have named, we will also attempt to discuss the last and most important question: the question of synthesis.

 TALK 24
THE WEST

First and foremost we must note that Russian culture has always had a complicated, sometimes tragic relationship with the West. It could be said that from the very beginning of its historical path Russia could not make up its mind as to its identity: was it "West" or "East"? And it is naturally no coincidence that "Westernists" and "Slavophiles" existed in Rus' not only in the nineteenth century: they can be found in various forms practically throughout all of Russian history.[i]

Whence this complexity, and why the emergence of this now age-old tendency of Russian self-identity to shift from one extreme to the other, this odd love-hate relationship?

i It is also no coincidence that in the current searches of Russian cultural consciousness for a foundation and for coherence the question of the West is arising once again. And perhaps it is only now, as the tragic past half-century draws to a close, that this question of the West may be seen in all its depth.

Why did the highly cultured Slavophile Khomyakov feel an overpowering need to shock Petersburg society by appearing publicly in a peasant coat, while the Russian intellectual Pecherin became a Catholic priest and ended his days in far-off Ireland?[200] These are only two examples picked at random, but they symbolize an ongoing phenomenon: the primordial polarization of Russian self-identity. And its roots must be sought first and foremost in a certain primordial ambiguity inherent in Russian history. Kievan Rus' decided to adopt Christianity from Byzantium not only for purely religious reasons, but also from cultural and historical considerations. In choosing Byzantium after wrestling at length with agonizing doubts, Rus' chose "universalism," a certain all-encompassing concept of human history and culture. By its ideology alone Byzantium was the heart and the vehicle of a global empire and a global culture—the Christian embodiment and perfection of Roman universalism. And it could be said that Kievan Rus' specifically chose the *West*, as opposed to the East of the Khazars, the Persians, and the Chinese; and that it chose the West specifically because of its "universalism." It wanted and awaited precisely this inclusion into "the great family of the human race" of which Chaadayev spoke. And for this reason the only time when Rus' did not have a "Western complex," when there was not a "Western question," was the zenith of Kievan Rus' before the invasion of the Mongols.

At the same time this choice proved ambiguous, since the "West" that Kievan Rus' chose in contrast to an anti-historical East seemingly doomed to immobility was in fact

already disintegrating, losing its unity and universalism and splitting into "Eastern" and "Western" parts—into East and West within itself. The baptism of Rus' very nearly coincided with a growing crisis in the West, which culminated in 1054 in the famous and conclusive rift between Constantinople and Rome.[201] Consequently, the Christian world gradually lost the religious, cultural, and historical universalism that had determined the choice of Kievan Rus'.

In choosing the West as an integrated whole, to its surprise Rus' found itself in the orbit of the Eastern part of that West, which increasingly—along with the Western part—narrowed and limited its universal range of vision. Consequently, between Rus' and the Western part of the once unified and universally inspired Christian world there was raised the first "iron curtain," the first barrier—the barrier of religious division and estrangement. Christian ideology and Christian historiosophy cordoned Rus' off from the non-Christian East, while the schism within Christianity in turn drew an impassible line in the sand between Rus' and the West. It is this that must be seen as the beginning and the source of the tragic paradox that marks the complex history of Russian self-identity and Russian culture. From the very outset at its foundation there lay a plan for and an impulse toward universalism, but these were hobbled by the collapse of Christian universalism. And Rus' psychologically and culturally became, on the one hand, a sort of outskirt of a now decayed and dying Byzantium and, on the other hand, a sort of "anti-West," a boundary to Western cultural and religious expansion. For this reason

the joy of the initial universalism gave way to fear, suspicion, distrust, and, inevitably, an increasing egocentricity. And this distrust left its mark on Russian self-identity for all time.

Nevertheless—and this must never be forgotten—the initial inoculation of universalism, the plan for and choice of universalism, could not vanish from Russia's memory without a trace. This is why the break with the West was traumatic to its consciousness. And the windows and doors that were barred against the West were a cause of unrest and alarm, constantly calling attention to themselves. This alarm especially increased when Rus' found itself cut off from the Byzantine world as well, when it was plunged into the dark centuries of Turkish rule. The result was an even greater increase in this strange state of attraction and repulsion, of distrust and interest, of a superiority complex and of an inferiority complex. Nor could the European West, which soon entered the era of its own cultural zenith, forget its Eastern periphery, or resist making it the object of its cultural and political desires. Thus two mindsets within Russian consciousness arose, two attitudes toward the West, two "poles" between which Russian cultural consciousness vacillated—a vacillation that gradually transformed into one of the chief factors or elements in the culture being formed.

The first mindset was defined by the consciousness that *we are alone.* The West had fallen, becoming mired in heresy. Byzantium had fallen likewise. We alone had *not* fallen. Consequently, we are the elect, and our isolation is a witness to that election. And for this reason we take great care lest we be defiled, lest we become infected, that this purity of ours be

sustained to the end of time. In terms of religion and culture this manifested in the apocalypticism of the elder Filofei and his theory of the "last kingdom," in the proud self-assertion of the Stoglav Synod, in the pathos of the standard-bearers of the Old Believers, Neronov and Avvakum; then, after Peter, in the preaching of Slavophilia, in the peasant coat of Khomyakov, and—right up to our own time—in the passionate assertion of and quest for exclusivity, for Russia's messianic self-subsistence.

The second mindset is the polar opposite: faces turned toward the West, toward its culture, toward its technological knowledge, its humanism, its justice, humanity, and historicism—and away from the sacrosanct immobility of "unhappy Byzantium."[202] And this mindset appeared not with Peter the Great, but far earlier: Westernism had already appeared in Kiev and Novgorod, as it did later in Muscovite Rus'. The reverberations of the Western Renaissance are visible in Moscow in the early sixteenth century, and later in the seventeenth. Tsar Alexei Mikhailovich often dressed and amused himself in the Western manner, and it was from the West—and by no means from Byzantium or the Greeks—that Patriarch Nikon took his ideas of the primacy of the Church over the state.

The reform of Peter the Great, which brought the Western bent to completion, now on a national scale, clearly showed that this bent was not a random occurrence and that for Russia the West was not something foreign, not an intriguing overseas oddity or exotica, but something of substance,

something that *belonged* to it—otherwise there would have been no Pushkin, Gogol, Dostoevsky, or Tolstoy. This did not merely hew open a window into Europe: it was a return to the original plan, a restoration of the plan of universalism.

And yet the fracture and the polarization remained. "West" and "East" in Russia became wholly *Russian*, but Russia itself, its consciousness, its soul became divided. And Russia entered the tragic crisis of its twentieth century in precisely this state of division.[ii] On the one hand, what came to power in Russia was the most *Western* ideology possible, which stripped Russia of its very name, and at least verbally replaced the national vocation of the people with an international one. On the other hand, Russia separated from "the West" still more emphatically, asserting its self-subsistence and exclusivity.

Today the old phenomenon is recurring once again. Some are beginning to seek deliverance from "Western" ideology in a rebirth of the national messianic tradition of the past, in a world captured for all time in the Russian icon, in the architecture of the churches of Suzdal and Novgorod, in "the deeds of days of other years."[203] A sort of surreptitious "Slavophilia" is springing up, which Blok proclaimed in his "On Kulikovo Field" cycle of poems or in the poem "Russia":

> O Russia, half-starved, beggarly Russia,
> Your humble cabins, mean and grey,

ii Whence this crisis—from "the West" or from "the East"?

Your songs, wild as the wind and wayward,
Are like the first tears of love to me![204]

This tendency understands the restoration of the founda-
tions of culture, the rediscovery of lost integrity, first and fore-
most as a return to the roots of the world perception of the
people, which had been suppressed by the Western luster of
post-Petrine Russia.

At the same time, however, a new "Westernism" is also
emerging. There is a growing note almost of shame for the
revival of slavery and tyranny, for the forced abandonment of
law and order—for all that to many seems the time-honored
Asiatic way. This school of thought demands an opening of the
doors and windows to the West, a return to learning, a return
to intercourse, a return to "the great family of the human race."
For this school, the West is not just a country of "holy marvels"
and "precious graves"[205]: it represents a salvation from dark-
ness, from lawlessness, from mediocrity and backwardness. It
is the key to freedom and to creativity. In the bleak present it
is the promise of the future. And so Western books acquired in
secret are read to tatters, rock and roll blasts, and a dream wafts
on the air: to travel to the West, to breathe in the unique, inim-
itable Western air … And naturally there can be no thought
of any "synthesis" or coherence of Russian culture until there
is some resolution to the problem of the confluence, the
"peaceful coexistence," so to speak, of these two schools.

TECHNOLOGY AND SCIENCE

As late as the close of the nineteenth century Russian remained chiefly an agricultural country, and her ideal was the psychologically patriarchal, static structure best suited to her population, in which the peasant class predominated. And by the 1950s this country, which had been in no particular hurry to progress—having lived through two bloody wars, a revolution, and a Leninist-Stalinist reign of terror of unprecedented scope and duration—found itself not only an industrial giant, but also one of the two global superpowers that effectively polarize life on our planet today.

The official explanations attribute this astounding jump to the civil authorities and the ideology they propagate, but in actuality it is first and foremost the result of tremendous effort on the part of professionals—the country's scientific and technological intellectual class. It is therefore no wonder that in today's quests, in the searches of Russian cultural identity for its foundations, its lost coherence, the voice of this intellectual class is acquiring particular weight and significance.

But before discussing this voice we must recall that the scientific and technological intellectual class as a separate group of the population, a spiritual stratum of sorts, is a relatively recent phenomenon in Russia. And this despite the fact that the new history of Russia actually began with a singular technocratic revolution. Psychologically speaking, to a large degree Peter the Great was of course a "technocrat." It is no accident that even in the West he preferred countries where technology and the scientific approach had begun to displace medieval ideocracy—the primacy of ideologies, beliefs, and outlooks over the prose of industry and matter.

Peter felt at ease in Holland and England, but not in Versailles. He was always drawn to men of action, of the natural sciences, and not to abstract philosophies and ideologies. But very soon after Peter leadership in the country passed from the hands of the technocrats into other hands—not necessarily of ideologists, but of men for whom exact knowledge and a pragmatic perception of reality were no longer central to their consciousness. As for Russian society as a whole, by the mid-eighteenth century it was showing signs of a prevailing inclination toward utopia, toward "the dream"—and at least a significant portion of educated Russians spent the hundred and fifty years of the imperial period lost in a sort of dreamlike state. These dreamers included Radishchev and Novikov; these dreamers included the Russian masons, who studied their esoteric science of mystical triangles, but not geometry. In the nineteenth century Russia's youth inundated Western universities—but they preferred to listen to the lectures of

Hegel and Schelling, becoming intoxicated by "ideas" rather than pursuing the exact sciences. The vast majority of even the most radically minded Russian young people in the nineteenth century enrolled in courses on law, history, philology, and the like, rather than pursuing technological studies. And even when in the 1960s a rebellion arose against the refined, superfluous culture of the nobility, which the youth held to be not "of the people," the symbol of this rebellion was not science as such, but the county physician, the veterinary school, and pedagogical courses.[i]

The Populist-minded Russian intelligentsia was a great and sincere believer in "enlightenment," but somehow the result was that this enlightenment manifested chiefly in popular scientific pamphlets for the common people. And even when in the 1880s a portion of the Russian intelligentsia plunged headlong into the allegedly "scientific" ideology of Marxism, this science remained divorced from even basic interest in the exact sciences.

All this naturally does not mean that in Russia there were no scientists and no science, no scientific thought or scientific quests, nor only those that were narrow, wholly engrossed in

i Bazarov's fussing with the frogs in Turgenev's *Fathers and Sons* is wholly unconvincing: in reality the frogs were of no interest to Bazarov, and he had no need of them. The pursuit was ritualistic, symbolic, so to speak: in Bazarov and those like him one sensed no scientific world perception whatsoever. Chernyshevsky was in love with science, but his was a platonic love, for he pursued no true science and lived in a world of abstract ideas and philosophical designs.

merely one aspect of knowledge and incapable of broad generalizations. The work of Mendeleev proves this conclusively. But this means that for Russian society this kind of scientist was far less a spiritual and intellectual authority than a representative of the so-called humanities, where the pursuit of common ideas, vast horizons, and a fairly abstract love for mankind and his destiny predominated. Too many people in Russia preferred "thick journals" to thick books. The civil authorities likewise offered little encouragement for pursuing authentic science, as they too were captivated by the "ideocratic" approach to life, and held that the best defense against "kooky ideas" was not science or an objective quest for truth, but enough Latin and Greek to choke a horse.

And so it happened that science in the proper sense of the word found itself relegated to second or third place in Russia, and those few who selflessly pursued scientific work as such played a very small role in society and government. Nor did they truly participate in the crises that racked the body of Russia, or in planning the life of the nation. The people conducting the revolution in Russia were not in this category, although they too held that they were conducting the revolution on scientific principles, in keeping with their "scientific ideology": it never even occurred to them that to their ideology the word "science" can in no way be applied. For in those same years a real revolution was taking place—one that had long been building in the quiet of laboratories and scientific sanctums, which had nothing in common with hasty and largely pseudo-scientific ideological conclusions. This revolution was

wrought by Einstein, Planck, and other founders of modern physics, biology, and the other sciences. And for the first time the "ideologists" who had thought they had all the answers found themselves stymied. This was because for the first time scientists found themselves possessed of knowledge not only in isolated spheres of life: they could now attempt to embrace the whole of it and undertake to resolve the chief question, "To be or not to be?"

Science—genuine, profound knowledge—permitted scientists to attempt to address issues where the "ideological experts" had floundered and failed. This gave rise to a unique brotherhood of scientists or, at least initially, an awareness of a brotherhood united by the same knowledge and the same scientific methods, as well as the same understanding of the issues, irrespective of their national dispersion. It became clear to them that these issues demanded a unified, all-encompassing, global approach at a planet-wide level, for otherwise they would not be resolved. It was likewise clear to the scientists that the choice lay between a global solution of this kind and the destruction of humanity. In the Soviet Union the voice of this brotherhood was the voice of the father of the Soviet atom bomb, the academician Andrei Dmitrievich Sakharov, who in 1967 discussed the matter in his pamphlet, "Progress, Peaceful Coexistence, and Intellectual Freedom."[206]

In its author's homeland this pamphlet was not printed in a single official publication, but this is of no critical significance. What matters is that for the first time in history Russia heard the calm, firm, masterful voice not of yet another "ideologist,"

but of a man who drew his convictions, his concern, his call to action directly from the very "science" that the ideologists claimed as their own basis—from that science without which the Soviet Union would not have become the powerful giant that we know today.

The stance of the academician Andrei Sakharov appears to lend Russian culture yet another inalienable dimension: henceforth its future is unthinkable without its scientific verification, without critical evaluation on the part of the scientific intellectual class. When in his brochure Sakharov writes of the danger of "the stupefication of man by mass culture with its intentional ... lowering of the intellectual level and content, with its stress on entertainment or utilitarianism, and with its carefully protective censorship,"[207] he is writing not of his personal tastes, but of a danger determined by science, just like war, terrorism, or mass failure to maintain geohygiene. He knows that the result here is the same: mass destruction, tremendous suffering, and ultimately mutual annihilation.

For this reason, naturally, the voice of people such as Sakharov, their call to adopt a *scientific* approach to foreign and domestic policy, cannot but carry weight. Henceforth it becomes a part of Russian culture's intense quest for its foundations, its coherence, which we have discussed in these talks. Science—as this event implies—abandoned its neutrality; it had to leave its ivory tower. And now it becomes part of cultural consciousness as a kind of essential verification and evaluation, outside which all "ideology" and every "value" proves abstract, divorced from reality and from its own true

needs. More importantly, science has once again affirmed the connectedness and reciprocity of all phenomena in the world of ideas and facts, ideologies and human existence.

But there remains one question that is likewise of primary importance: is science capable, as reading Sakharov's pamphlet might suggest, of supplanting "ideology"? Sakharov writes of progress, of the individual, of freedom, of fairness. And these seem to him to be scientifically *possible*—just like global catastrophe, the self-destruction of mankind, and the end of life on our planet. It is here that the question arises: the concepts of the individual, of freedom, progress, and fairness, ultimately outgrow "science" and its innate abilities: with regard to the latter they are autonomous. And if modern science demands intellectual freedom as one of the conditions for the world's "scientific" deliverance from destruction, can it then determine how this freedom is exercised and toward which ultimate values it is directed? If the quest for the foundations of culture neither can nor should manage without "science" any longer, does this not entail the involvement of science in the common quest and its dependence on other, spiritual "dimensions" of culture? This question—the question of long-awaited synthesis—has been irrevocably posed to Russian cultural consciousness, and it must not be forgotten when discussing the foundations of Russian culture.

SOCIAL TOPICS

Russian thought and—more broadly—Russian culture have always been almost wholly consumed by questions of social structure, fairness, and protection of the weak. These questions have always been at the center of Russian cultural identity and have been of vital importance for it. In this sense Russian history developed differently from that of Western Europe. In the West the dominant factor in human history was the so-called feudal system—that is, a society constructed on the principle of hierarchical subordination of certain social elements to others, on the principle of a kind of hierarchical ladder. For this reason in Western consciousness the problem of legal safeguards arose quite early on. Each component of a hierarchical society was preoccupied first and foremost with preserving its own rights with regard to other parts of society. Kings defended their rights against the emperor, feudal lords against the kings, vassals against the feudal lords, and, finally, cities against the kings, feudal lords, and vassals. For a long time the peasants were uninvolved in

this struggle for rights and legal safeguards, but later their turn also came.

The problem of rights naturally led to the problem of the individual as a possessor of rights. Consequently, Western development was focused more on the problem of individual rights than on the problem of fairness. England's Magna Carta Libertatum talks of rights, not of fairness, as does the Declaration of the Rights of Man and of the Citizen in France. As for Russia, it never had a feudal system to facilitate the development of ideas of the individual and of rights. Almost from the outset of its history Russia was obliged to become a "tractive" government, to live in a state of constant mobilization of all its resources against Asia, against the climate, against space, against the West, and against her own innate centrifugal tendencies.

This constant tension led to a singular dissolution of the individual and his rights into the common, the collective, the governmental. For this reason the social problem in Russia was typified not by a quest for legal norms, but first and foremost by an aspiration to ease sufferings, to achieve essential fairness. It was moral categories, not legal, that defined the social thought and social quests of Russian society.

Russian thought was also drawn toward this same moral emphasis by the Byzantine tradition that Russia had inherited. It is characteristic, for example, that the chief duty and privilege of the head of the Church in the Byzantine and Russian governments was considered the duty of "intercession."[208] This intercession was not defined by any legal or judicial norms,

and its essence is expressed rather in Pushkin's verse: "And for the fallen called for mercy." What matters is not whether or not a criminal is guilty: what matters is that from the moment when he becomes "fallen" the moral law of pity, of compassion, of "intercession" comes into play. Metropolitan Phillip did not rebel against the state organization or ideas of Ivan the Terrible; he did not denounce the enslavement of the Church and society by a harsh and despotic tyranny; he did not contrapose any other ideas to those of Ivan the Terrible.[209] His protest was not legal, but moral: "Here we offer the bloodless sacrifice," he said to the tsar, "while beyond the altar Christian blood is being spilled."[210]

Thus, since nearly the very beginning of the history of Russia the solution to the social problem, the rectification of social ills, was seen by Russian consciousness as being rather on the path of moral concord, compassion, and love than on the path of rigid law and order. The Petrine reform still further intensified the tractive, servitorial character of the Russian government. And it is characteristic that in the Petrine legislation borrowed from the West the spirit and the letter of judicial care for the individual as such are almost wholly absent. For Peter was not inspired by the West as such: for him the West was needed only insofar as it could help Russia, in Peter's words, to live "in glory" and "well-being"[211]—that is, to value the government and state control over every facet of human life.

The idea of justice as a "natural law," and also as a universal judicial standard, began making inroads in Russia in the second half of the eighteenth century, with the wave of ideas

from the Western Enlightenment. This period effectively marks the beginning of the remarkable history of Russian judicial thought, of Russian "jurisprudence," later embodied, in the second half of the nineteenth century, in remarkable phenomena such as the judicial reform of Alexander II. Nevertheless, we cannot help but note that this judicial thought, this inspiration of law and justice, remained the province of a minority in Russia right up until the revolution. They did not truly become part of the "flesh and blood" either of the empire or of Russian society as a whole.

It is typical of our society that it far more easily embraces any radical social utopia than the difficult task of propagating law and justice. On the one hand, freedom as "liberty," and on the other, the dream of building a "truthful" world—these are the two constant pursuits, the two permanent dreams of Russian consciousness. But "liberty" smacks of an almost anarchistic individualism: "living however one pleases"[212] is after all not at all the same as the difficult feat of defending legal freedom. As for mysterious "truth," once again it is sought not in law or in judicial norms: no, "truth" is conceived as an almost mystical secret, a mystery belonging to the common people alone, untouched by Western, legalistic civilization. And this is apparently why peasant society exerted such an uncontrollable attraction upon almost the whole of the Russian intelligentsia: in it they saw—or passionately desired to see—this mysterious "truth," accomplished by methods that were by no means judicial or juridical. In search of this truth, the Populists went out "to the people."

Leontyev wrote with fury and disdain of the "Belgian constitution," which in his opinion embodied egalitarianism and pharisaism.[213] Tolstoy's hatred of judges and lawyers is known to all. And the quest for social justice most often led to revolutionary maximalism, to religious mysticism, to ecstatic monarchism, and finally to a kind of anti-historical nihilism, and not to a slow, persistent formation of judicial norms and respect for them. Such respect was but little evinced in Russian history, both *above* and *below.* Above, because there the law was perceived as a threat to the mystical essence of power; below, because there it seemed a half-measure and a compromise, when the heart thirsted for the perfect and absolute.

Such are the roots of the seemingly strange semi-distrust and semi-suspicion of "legalism" in Russian self-identity. All the more should we appreciate the fact that the Soviet intelligentsia of today is drawn specifically to judicial consciousness. In the current spiritual and intellectual quests of this intelligentsia, of considerable note is a movement that insists on the *rule of law,* that is, on the application of objective judicial norms that are the same for all.

One participant in these quests recently wrote, "Although the democratic movement is in its formative period and has not set itself any clearly defined program, all its participants at any rate infer a single common goal: law and order that is founded on respect for basic human rights."[214]

These words show that the decades of fearful lawlessness, dictatorship, and terror have affirmed for Russian consciousness the indelible value of objective judicial norms. And

perhaps it is only now that this consciousness will perceive the full significance and value of that philosophy of justice on which Russia's legal experts labored so greatly in their day.

The same author wrote that the modern democratic movement in Russia includes several schools: "true Marxism-Leninism," "Christian ideology," and "liberal ideology."[215] The supporters of "true Marxism-Leninism" hold that the regime, having perverted Marxism-Leninist ideology for its own purposes, is not governed by Marxism-Leninism in its practice, and a return to its true principles is essential for society to recover. Conversely, adherents of Christian ideology hold that public life must shift to Christian moral principles. The supporters of "liberal ideology" hold that a shift to a Western-type democratic society is needed, in order to preserve the principles of public and state property.

This enumeration alone may be reminiscent of the pluralism of ideological schools observed throughout the whole history of Russia, as well as of the singular continuity of these schools, their compliance with the chief precepts and chief focuses of Russian cultural identity. At the same time, it is infinitely important that all these schools adopted the idea of *law and order* as an unconditional and universal premise, as the sole foundation upon which a healthy society may be built.

Russia learned from bitter experience that formalism in the rule of law is the sole reliable defense against despotism, and this experience must be deemed conclusive. But the fact that within this general foundation there remains a pluralism of public worldviews is also of primary significance. Law is a

factor, but it is not *an end in itself*. And this is effectually what Russian thought always wished to express, although perhaps it too sharply contrasted "form" to "content." Law and order, or the "form," renders possible the free search for *content*. This is the meaning of what is happening today, at least in a marginal part of Russia's intelligentsia. With what *content* must it imbue the "form"? Of this we will speak in the following talks on the foundations of Russian culture.

Religious Themes

I n the Soviet era, as we all know, one of the chief tasks undertaken by the authorities was the destruction of religion. The same was demanded by Marxist dogma, and the nineteenth-century rationalist tradition, and that link between the Church and the pre-revolutionary tsarist regime which seemed indisputable to the fathers of the current regime. For Marxist dogma, religion was the chief expression of "the alienation of man" from that self that occupied the central place in Marxist theory. To the nineteenth-century rationalist tradition, religion seemed incompatible with science. Finally, to the Russian revolutionaries, religion seemed the buttress and sanction of the tsarism that they found hateful. Consequently, the communists considered destroying and combating religion one of the primary goals on the path to creating a new society and a new man.

This fight took on various forms—from disgraceful, bloody, open persecution and terror to painstaking control over the Church and the unspoken governance of it that is characteristic

of our own time. But the goal itself—the destruction of religion—is one that the communist party never renounced, just as it never renounced its understanding of religion as something absolutely incompatible with its own ideology. We cannot of course form an opinion as to the outcome of this struggle, which is far from over. But certain obvious facts regarding it can hardly be doubted.

Firstly, there can be no doubt that, through the systematic efforts of the authorities, religion has been ousted from the public and cultural life of the country. Officially, there is no religion, and its existence as a sort of relic is only acknowledged on the periphery of existence. Several generations have grown up knowing of it only what is touted by generally low-grade, rudimentary anti-religious propaganda. For many millions of people, the religious problem simply does not exist. This is an "asset," so to speak, of the regime's anti-religious policy. But it is equally indisputable that the authorities have failed not only to completely destroy religion, but even to eradicate the tradition of religious quests that is so characteristic of Russia.

In addition to faith as such, to religion proper, the authorities also ran up against another fact that cannot be suppressed or denied. This is Russian culture's organic link with religion, its permeation with religious themes, inspiration, and quests. The traces and evidence of a millennium of ties with Christianity cannot be destroyed. Dostoevsky and Tolstoy cannot be "silenced"; Rublev and Russian ecclesiastical architecture cannot be "denied"; it is impossible to "overlook" the intense

religious quests of vehicles and representatives of nearly every branch of Russian culture. There were attempts, of course: Dostoevsky was not published, churches were dynamited, scholarly attempts were made at proving the atheism of Pushkin, etc. But all these attempts failed to produce the result that the authorities required.

And in recent times it has become clear that today we are seeing a resurgence specifically of religious quests, which for the authorities is more dangerous than the religious ritualism tolerated on the fringes of society. The "qualitative" significance of these quests must not of course be exaggerated. As in other fields, these quests are the affair of a paltry minority. But in matters of spirit and culture nearly everything begins with a minority.

Primacy in the rebirth, or rather the preservation, of the continuity of religious interests and quests must naturally be allotted to their important significance in the greatest works of literature. It is hard to consider it a mere coincidence that the three names that tower high above the literature of the last fifty years are linked in one way or another with religion. These names are Pasternak, Akhmatova, and Solzhenitsyn. Furthermore, it is important to emphasize that the first two, Pasternak and Akhmatova, were formed as poets even before the revolution—and that it was not until the Soviet era that they came to a deliberate and open confession of Christianity. Consequently, their Christianity is a sort of *answer*, personal and profound, to the fifty years of pressure on the part of not only totalitarian but even blatantly anti-religious authorities.

Characteristically, the Christianity of late Pasternak is at once very personal and intimate and also cosmic, global, and historic. Here, one all-absorbing ideology is contraposed to another that is equally universal, equally all-absorbing. "You meant all in my destiny once,"[216] Pasternak says to Christ, and this is his personal statement. But then there is this cosmic statement—from his poem "Christmas Star," after the lines about the magi who are searching for the cave in Bethlehem:

> But, in strange visions of the flow of time,
> All future ages rose up distantly,
> The thoughts, hopes, worlds, of every century ...[217]

The same is found in "Gethsemane":

> 'For, see, the ages like a parable
> March on until they burst aflame and burn,
> And in the name of their dread majesty
> Through voluntary torment I'll go down
> "Into the grave. But on the third day rise;
> And then like rafts that float down-river dumb,
> Like trains of barges, to my judgment seat
> Out of the night the centuries will come!"[218]

The entire novel *Doctor Zhivago* is first and foremost a profound, religious response to the fundamental and fanatical apostasy of the world in which Pasternak was living.

The work of Akhmatova, and of Solzhenitsyn after her, is not directly governed by a religious theme, but it is apparent that, although for each in his own way, it is associated with a

religious perception of life and is a denial of the "godless man" of the new culture.

Let us reemphasize: atheism failed to create an authentic culture, the creation of which remains the work of religion and the religious world perception. Nor were religious sentiments limited to the leading writers. The second environment in which these sentiments manifested is the youth, which has lost faith in the official ideology. To judge by the publications of the underground press, it is increasingly obvious that part of the youth is arriving at the same themes, questions, and quests that were widespread in Russia in the early twentieth century and gave rise to the term "religious renaissance." Thinkers such as Bulgakov and Berdyaev, both of whom passed through Marxism and returned to Christianity to become Christian thinkers, are increasingly attracting the attention and interest of this "questing" youth.

And it is highly characteristic that this attraction is not just to faith, but to a coherent worldview developed in the light of faith, in which history, culture, science, and social agenda all find their place. Effectively, it is this coherent Christian worldview that Russian religious thought has always sought: it was a theme in the works of Khomyakov and Kireyevsky, as well as Soloviev and Fyodorov, right up until the former Marxists Bulgakov, Berdyaev, and Frank. All of them were acutely concerned by what they called the rift between religion and life, and they strove to overcome this rift by returning to the cosmic, historical, and social dimensions of Christianity.

In the well-known letter of the two young Moscow priests Eshliman and Yakunin, one is struck by their profound, organic knowledge of this particular tradition of Russian religious thought, prohibited not only by the godless authorities, but even by the official Church itself.[219] Young people obviously were not reading these books in seminary or at the academy.

The same interests and searches for a coherent approach to real life permeate a work by another priest, Zheludkov, entitled *Why I Too Am a Christian.*[220] It too contains an openness to life, to modernity, to all its agonizing problems—an aspiration to the inner victory of a religion that is bright and joyous, and not of a gloomy, world-renouncing religion.

Apparently it was these inclinations that led to the formation in Leningrad of the "All-Russian Socio-Christian Union," which was decimated in 1967–1968.[221] Openly contraposed here to social but anti-religious ideology was an ideology and a political program that was social but also inspired by Christianity. Religion is no longer perceived or understood as a "private affair," as the domain of intimate, personal convictions, but is contraposed to the totalitarian design and assertions of the official ideology.

Finally, there is yet another source of the rebirth of religious quests and sentiments: Russian culture itself. The new fascination with Old Russian pictorial art; the radiant witness of the churches of Suzdal, Pskov, and Novgorod; the mysterious, towering, purifying world of religious rituals; and on the other hand the profound religious agendas of Dostoevsky and Tolstoy—all this functions, if not yet as a religious conversion,

at least as a call to other agendas, to another frame of consciousness. For Russian culture has never been religiously *neutral*. The attempt of Peter the Great to secularize it was unsuccessful. Via various complex, at times even tragic paths it returned and constantly continues to return to its primordial, latent religious inspiration. And since the ludicrous "prohibition" of the Russian culture of the past has been lifted in all spheres, it will lead to a deepening of consciousness and thought, and to a raising of the same eternal questions, the same eternal themes, that pervade it from beginning to end.

If Russian culture has a future, if it rediscovers its lost coherence, religious inspiration will inevitably be at least one of its foundations. The books of Bulgakov and Berdyaev, which for years have collected dust on the bookstore shelves of Paris, are now being copied by hand and clandestinely distributed. The youth are seeking not only faith, but also a coherent philosophy of life in place of the broken idol of the official ideology. This rebirth of religious quests must be recognized as one of the most significant symptoms of our time.

AT A CROSSROADS

As has repeatedly occurred throughout its long history, once again Russian culture stands at a crossroads. This situation cannot be thought to have resulted merely from the tragic political and social conditions in which Russian culture has had to exist over the past fifty years. For if "politics" to a large extent defines culture, culture in turn bears an enormous share of responsibility for "politics."

Culture is not an autonomous sphere of activity within the national and social organism, one that needs only for that organism to leave it in peace. Culture itself participates in the building, growth, and life of this organism: it determines its fate, and consequently it bears responsibility for that fate.

At the dawn of Russian history, Prince Vladimir's choice of the Byzantine cultural and religious tradition was undoubtedly a political act. Later this cultural tradition in turn determined the development of "politics." Consequently, if we define the sociopolitical aspect of the life of the national organism as "politics," and its intellectual and creative aspect

as "culture," these will undoubtedly constitute two aspects, two expressions, two fused parts of a single organism, a shared destiny—two parts, moreover, which by their interaction determine this historical destiny.

The vehicles and founders of Russian "politics," meaning the focus and nature of all state activity—Prince Vladimir, Ivan the Terrible, Peter the Great, Alexander II, Lenin, and other heads of state—are responsible for the fate of Russia, effectively, on a level with Andrei Rublev, Derzhavin, Pushkin, Blok, and other Russian cultural figures. But here it must be noted that in Russian history "politics" and "culture" very rarely coexisted in harmony, and that they had a more or less identical understanding of the fate of Russia and their shared responsibility for it. For Russia, for her historical development, the rift between "politics" and "culture" and their often tragic conflicts were a more typical phenomenon than perhaps for any other nation. The result was that "politics" and "culture" had different concepts of Russia: before them they saw two different Russias, as it were—and not only different, but opposite. And this rift naturally could not fail to have consequences for both "politics" and "culture." For these two cannot be fully separated: they need each other, and only in cooperation with each other can they truly, fully perform their functions.

The current crossroads of Russian culture, its enslavement and its searches for its soul and its foundation, are naturally the result of a particular "politics." But even the "politics" that predominate in modern Russia are the result of the tragic

past instability of Russian culture, its lack of clarity, and the stumbling blocks that ended in catastrophe.

The problem here is not merely a lack of freedom, which is often cited as the cause and the root of all misfortunes. Restoring freedom as such cannot of itself automatically cause culture to flourish. Without freedom, of course, creating culture is impossible—indeed, the very concept of freedom, its nature, and its substance are defined by culture. It is culture that lends substance to freedom, transforming it from pure potential into a spiritual reality.

All this shows that in a certain very profound sense "politics" is one object of "culture." Culture suggests to politics its "goal," giving it the system of values that politics is called to embody in the life of the people, the nation, and society. A culture that demands only freedom from politics, while rejecting and shunning politics itself, remains inadequate, lifeless, and is ultimately doomed. In its turn, politics that rejects the spiritual oversight of culture inevitably degenerates into tyranny or anarchy, into corruption and mediocrity.

Thus, one of the historical tragedies of Russia, one source of its current crossroads, was the gradually deepening rift between "politics" and "culture." From Byzantium Russia obtained a certain coherent political-cultural design as the foundation of its historical path. This was a design born of an absolute understanding of man and society, of history and culture, and the absolutism of that design was religious. This means that at its foundation there lay a concept of man as a transcendental being—that is, one not limited by the

historical horizon and, consequently, not reducible to the state, to society, or to anything else. Furthermore, by virtue of this concept of man, neither society, nor the state, nor history are recognized as absolute values: they could not be *an end in themselves.* Everything in the world serves something higher— ultimately, God; everything is called to fulfill a certain divine plan, the final embodiment of which lies outside the bounds of history. Consequently, in the world everything is measured and evaluated against this transcendent goal, against this absolute ideal.

One may debate the success or failure of this design's execution in history; one may acknowledge all the historical sins, falls, and mishaps. But one thing is undeniable: this design, this ideal, united "politics" and "culture" into a single organic system of values; it subjected both to a single higher criterion. Neither "politics" nor "culture" in this system of values could become "autonomous," for above both there stood a supreme principle, a supreme goal, that united and transcended them both. And if it is difficult for modern man to acknowledge the indisputable loftiness of this design, as well as the real successes of the politics and culture derived from it, this is hampered by the pride and self-aggrandizement typical of our time.

We are accustomed to treat our past as something dark and inferior, although right now, at the crossroads, many are turning their spiritual gaze toward the past in search of the secret of the lost "coherence." But very early on this coherence began disintegrating—disintegrating specifically because of the gradual rift between "politics" and "culture." It must not be

forgotten that when Stalinism was at its height, by orders from higher up, great autocratic Russian politicians such as Ivan the Terrible or Peter the Great were inordinately exalted—but this occurred because they were seen as the full embodiment of the absolute primacy, the absolute autonomy of "politics," of which Stalin marked the tragic and bloody conclusion. Ivan the Terrible, Peter, and Stalin were all skilled politicians, helmsmen of a mighty global power that instilled and continues to instill fear almost throughout the world. Glory, might, invincibility—with good reason these words are repeated by all politicians in various combinations. At the same time, as time passed it became increasingly clear that the gulf was deepening between the Russia dominated by "politicians" who knew how to create a stratum of mindless workers, obedient servants, party men by vocation and by conviction, and the Russia of "culture."

In its best incarnations, Russian culture never ceased to be "political"—that is to say, it remained aware of its responsibility for the fate of Russia. "Woe to the land where slave and flatterer alone / Are intimates of the royal throne,"[222] said Pushkin, who had desired to be an imperial counselor—but he was disdainfully given the rank of *kammerjunker* and allowed to perish.

And so it was that in one country there appeared two worlds, two Russias, that were mutually hostile and did not understand each other. Blok's "Russia, half-starved, beggarly Russia" had little in common with Suvorov's self-satisfied words, "I am proud to be Russian."[223] And due to this rift,

this failure to understand, from both culture and politics the consciousness of their union and fusion gradually faded away. The Silver Age of Russian culture, its new florescence at the dawn of the current century, simultaneously signified culture's almost total rejection of politics, responsibility, and service. Blok wrote, "In secret the heart begs destruction, / Secretly it begs to sink"[224]—Pushkin could never have written these lines. And when Russia saw the new, final, most terrible triumph of a now wholly soulless politics, culture still continued, shall we say, to debate over culture, to live its own "autonomous" life, to live by the manifestos of poetic schools, awaiting the hour when the crude downshouting of politics would command it to "enter the service of communism." Such is the crossroads of today.

They are right, of course, who first and foremost demand simply freedom, simple freedom: to live, to breathe, to create, to publish. But it is also true that this is not enough for a cultural rebirth. There must be a new encounter between "culture" and "politics" in the deepest sense of the words. To many it is now clear that neither their complete autonomy and independence from each other nor the complete subjection of one to the other is possible.

But what can freely unite them? What makes politics open to culture, while rendering culture a "political power," and by what means? The answer to these questions is sought today by thinkers in both Russia and the West—and upon these answers apparently depends whether the world will take the path that leads to destruction or to salvation.

ON THE PATH TO SYNTHESIS (1)

Our musings on Russian culture are occasioned by a fermentation that has begun in the recesses of Russian consciousness, by quests that, while new, in the past were always inherent in it. Consciousness declares: One *cannot* live like this. And not only liberation and renewal are needed: a new area of focus is also needed, a choice of some common and—to use the language of Pushkin—"important" goal.

This seriousness and this quest permeate the voices of those whom all Russia and all the world are now beginning to heed. Culture and creativity cannot remain what they seemingly became on the threshold of the "years of the holocaust,"[225] when Bryusov wrote:

> Perhaps all in life is but the means
> For brilliant, melodious verse,
> And from thy carefree childhood on
> Seek out combinations of words.[226]

No, too much that is fearful and nearly irreparable has been done to the words themselves for us to simply return to combining them in carefree fashion. The culture itself has been too terribly ravaged for it to shake itself off and go on with "business as usual." Finally, too much has happened to man himself, his life, and his fate for him to wave off the new problems that he now faces.

It may be supposed that a new synthesis and a new coherence essential for the existence of culture will be found specifically in Russia, which has undergone so terrible a trial over the past half a century. The reason for this is first and foremost that it is "synthesis" and "coherence" that effectively were always one of the chief themes of Russian culture, since its history and its historical formation were marked by two events of primary significance. These were, firstly, the abrupt watershed produced in Russian culture itself in the early eighteenth century. Secondly, it is the consciousness of a certain antinomian "associativity" with Western culture, inherent in it almost from the very beginning.

Not one of the great Western cultures—French, German, English—underwent so jarring a reform as that implemented in Russia by Peter the Great. Throughout the West, culture developed organically and gradually; in Russia, by orders from above, without warning it was suddenly transplanted from one spiritual climate into another. This introduced a duality, a dichotomy, into Russian cultural consciousness, and at the same time doomed it to continually seek to overcome its duality. And all that mattered in Russian culture has always

been linked in one way or another with the resolution of this problem.

Without the "cultural revolution" of Peter the Great, in all probability the great Russian literature of the nineteenth century would not exist. But on the other hand, that literature would not have been "great" had it had no mysterious source in folk tradition that was unaffected by the Petrine revolution. It was overcoming this dichotomy, finding a synthesis between "latent," "folk" Russia, on the one hand, and the "new," "cultured" Russia on the other, that created the great literature of Russia—and at the same time it was the first requisite, the first source of "synthesis" as the main theme of Russian culture.

The second source consisted of that particular regard for the West that has always marked Russian culture, which we have mentioned on several occasions. For it, the West was something consummately *its own*—so much *its own* that Pushkin's *Scenes from the Time of Chivalry*[227] or the monologue of the miserly knight may seem to be excerpts from some hitherto unpublished works of Shakespeare, discovered by chance and by some miracle written in Russian. Yet Pushkin never traveled beyond Russia. But at the same time this same West is so *foreign*, so different, that Russian culture does nothing but push it away and denounce it. And the more closely Russian consciousness examined the West, the more the latter stood revealed both as its own, something near and dear to it, and simultaneously as something foreign and hostile. Such is the paradox of Russian culture, and hence the theme of synthesis

it contains: it is *our duty* to rebuild what was broken and fragmented *there*, in the West, so as to restore cultural coherence.

Everything in the West is near and dear—but it all became foreign because it was violated, broken, and sundered. Our mission is to restore to the West its lost coherence and unity, and thereby to restore the West to Russia, and Russia to the West. By rebuilding its own unity, the coherence of its own culture, Russia will lead the way for the West, as well. "It will be, it will be—this truth will shine from the East,"[228] Dostoevsky exclaims ecstatically through one of his monks.

And so the theme of synthesis permeates Russian culture; or, to put it another way, the theme of culture predominates in Russian culture as a theme of *synthesis.* But in the nineteenth century and right up to the revolution of 1917 this theme effectively remained abstract, philosophical musing, almost divorced from reality. For Russian reality was in fact progressing in the opposite direction: from a certain initial synthesis toward division.

With each passing decade the gulf between the composite elements of Russia—the empire, society, the people, the intelligentsia—did not lessen, but rather increased, and even within "culture" itself its inner unity and equilibrium that had existed in Pushkin's time gradually became increasingly compromised. And the theme of synthesis became prophetic, as it were: it was perceived as a mission, as a special vocation of Russia and Russian culture. Synthesis was the focus of the thinking of the Slavophiles, of Khomyakov and

Kireyevsky: Vladimir Soloviev insisted on a synthesis of culture and religion, of East and West, of Russia and humanity; in his "Pushkin speech" Dostoevsky spoke of "global sensitivity;" the poetry of the Symbolists was focused on the final "theurgical" synthesis. Finally, the Russian revolutionaries themselves drew their inspiration specifically from the global perspective, the idea of "global revolution." Consequently, Russian thought and Russian creativity lived by this universal outlook, and the rejection of universality was perceived as infidelity to the auspicious destiny of Russia, as a withdrawal from responsibility into provincialism.

Decades of party dictatorship isolated Russian culture from the world, and this led to an incredible spiritual provincialism. Paradoxically, while asserting their own global significance and vocation, the civil authorities demand a narrow chauvinism from their state-owned culture, in comparison with which the chauvinists and nationalists of the nineteenth century—Pobedonostsev, Danilevsky, the "Pochvenniki,"[229] and so on—practically seem cosmopolitans. Hence the first and primary task facing Russian culture: the need to rediscover its original, native sense of "globalism."

And it must be said that everything that is now breaking through the dead bureaucracy in Russia is marked by this particular sense. And if we disregard isolated manifestations of the same old Slavophile pridefulness or, on the contrary, of immoderate laudation of the West, we may conclude that the main artery of creativity and quests remains what it was before, focused on finding "synthesis."

To be sure, there are deviations from this artery, which present a danger of choosing the wrong path. For example, there is the temptation to further increase the isolation, under the influence of immoderate, pseudo-Slavophilic pridefulness—"She has a special stature of her own"²³⁰—or out of a desire to deny any special "Russian vocation" whatsoever. There is also the idea that all the misfortunes that have befallen Russia effectively came from the West, from Western theories, and consequently we must turn back, back to times of old, to Protopope Avvakum, to our "ancestral way of life," away from global history.

On the other hand, conversely, there is the almost morbid desire to break with what is our own, to abandon forever our "native swamps," to fulfill the ecstatic incantation: "Go off into space, disappear, / My Russia, O Russia, my own!"²³¹

And these stumbling blocks, as we see, conceal antitheses that must be overcome—and this will require considerable effort, considerable labor and resolve.ⁱ

Authentic Russian culture thirsts for a new, free encounter with the West—along with a new, free return to *its own* roots. If Pasternak and Solzhenitsyn were instantly and naturally perceived as "global" phenomena, this was first and foremost because both returned Russian literature to its ancestral, "global" path. Both write of Russia and are focused on her. And both specifically reveal to us the "global" face of Russia,

i But there is no reward without effort, and this is especially true of culture building.

and not the exoticism of isolation. In both Pasternak and Solzhenitsyn we hear the call to synthesis and the witness to it that in the nineteenth century made Russian literature, more than any other, specifically a *global* literature. And in both the particular tragedy of Russia is shown and revealed to be the tragedy of man, the world, and history—the indivisible fate of mankind.

Such is the first conclusion that may be drawn from our musings on the history and foundations of Russian culture. Five or ten years of the iron curtain, of insistent and cruel attempts to compel Russian culture to reject its vocation and turn down the narrow path of a provincial worldview, have produced no fruit, nor could they. And all that is alive in Russian culture inevitably returns to the path of "globalism" on which it was set by Pushkin, Dostoevsky, and Tolstoy. But in our time, more even than a hundred years ago, globalism signifies a search specifically for "synthesis"—and of this we will speak in our final, closing talks on the foundations of Russian culture.

TALK 30
ON THE PATH TO SYNTHESIS (2)

As we conclude our musings on Russian culture, on its complex and often contradictory development in the past, on the crisis and quests of the present, how may we envision its future? What form may be taken by the synthesis to which, consciously or unconsciously, it aspires and seeks?

We have already said that the idea of synthesis, or, to use a Russian word, the idea of "coherence," in a certain sense pervades the entire history of Russian culture, the entirety of its long path. The late Professor Vasily Vasilyevich Zenkovsky, in his excellent *History of Russian Philosophy,*[232] demonstrated that the guideline of this history was the quest of Russian consciousness for *pan-unity*. Coherence, pan-unity, synthesis—such are the themes and ideals that fate itself seemed to assign and bequeath to this enormous country, a country that by its very nature could not wholly identify with either West or East, and which felt itself to be not in Europe alone, nor yet only in Asia.

Involuntarily, this country became caught in the narrow context of an already divided Christian world—and found itself susceptible to the influence of both parts thereof. Out of necessity it had to spend its entire history in pursuit of synthesis and unity. It was precisely due to this intermediate situation, so to speak, that it was always in danger of losing its soul and its vocation, and thereby dissolving into foreign cultures and ideologies. It also faced another prospect: in fear, hatred, and suspicion to shut itself in, to fortify itself against everything "foreign," to withdraw into its own narrow world, into desiccating, barren isolation.

To open a window or, conversely, to board it up tightly, to enter into free commerce and there to seek oneself and one's path; or, conversely, to try to pinpoint and capture what is "one's own," in such a way that no commerce can ever cause it to waver—these are the extremes, these are the constant stumbling blocks with which all Russian history is strewn. Furthermore, these stumbling blocks are not only outward: first and foremost they are stumbling blocks of the soul, of the subconscious. Blok wrote of "both passion and hatred for the homeland,"[233] and indeed, in our past there has been a great deal of near-morbid self-assertion, and of no less morbid self-rejection, of absolute self-confidence and at the same time of bewilderment and doubt.

This is why the path of the development of Russian culture has proven so arduous and complex. It was as though suspended above two gulfs, into which the entire edifice of culture could many times have fallen and vanished without a

trace. The fanatical schismatic, who in an apocalyptic panic sought the refuge and protection of dense, impenetrable forests—and beside him the flippant intellectual, with another, almost equally ardent faith of his own, ecstatically renouncing all his roots in favor of reverently adopting the latest European fad. And so it was almost continually, almost constantly: passionate absolutization and canonization of either "the olden days," the peasant coat and a return to the simple life, the soul of the people, and self-subsistence—or else of Western technical "progress," of Voltaire and Hegel, Marks and Avenarius; an eternal readiness to wholeheartedly and unconditionally accept—but also to wholeheartedly and unconditionally reject. All this constitutes the almost innate ailments of Russian consciousness, and hence Russian culture is first and foremost an inner and creative "transformation"—or, in the language of Freud, a "sublimation"[234] of extremes. And for this same reason Russian culture at its peaks is always *already* a synthesis, *already* the fruit of profound spiritual struggle to overcome and eliminate unwholesome inner perturbation and dichotomy.

If in every conversation, every musing on Russian culture we invariably arrive first and foremost at Pushkin, this is naturally because he forever remains its inner yardstick—a yardstick specifically of coherence, pan-unity, and synthesis. Pushkin stood at the close of the gradual formation, the gradual development of Russian self-identity with its aspiration to coherence, without which Pushkin himself would not have been "possible," so to speak. And it is Pushkin who in his

work arrived at a "synthesis" of Russian cultural consciousness, to which he gave its ultimate meaning and focus. Consequently, Pushkin was the first synthesis and inner yardstick of Russian culture, of its searches for coherence and pan-unity.

If Russian culture had and still has Pushkin, it cannot and morally must not stoop from the level that he established, from his encompassment of all of life. It cannot choose either dense forests and the sacrosanct immobility of "self-subsistence," or the flippant rejection of its native roots, or provincialism in its spiritual outlook, or the East, or the West, or the impasse of self-rejection, or the impasse of self-assertion.

But it is a hard thing to remain at Pushkinian heights: Pushkin set Russia a nearly impossible task. And this is why after him there immediately began the most fateful and at times the most tragic decades in the history of Russian culture. It was, in a sense, a test of Pushkin's behest: it was both a rebellion against him and a quest for other paths—an almost sacrilegious attempt to replace Pushkin's "synthesis" with another.

We repeat: it has long ago been said that Pushkin is "our everything." At the same time, almost immediately after his death the tradition he created began to disintegrate, and Russian culture, abandoning the Pushkinian paradise, went out into the foul weather, into the blizzard and the crossroads. It was as though it had found something lacking in Pushkin's synthesis: its mind and heart demanded a life of risk and danger, to live "however it pleased," outside those all-encompassing but clearly defined bounds that Pushkin set for culture.

The history of the decades that followed was a history of tremendous successes and tremendous falls. On the one hand, whenever creativity peaked, each time it was in fact a return to Pushkin's synthesis, to the path that he defined. In the persons of Gogol, Dostoevsky, and Tolstoy, Russian culture indeed became *global*—and at the same time it was a prophecy of the "synthesis" whose disintegration defines the tragedy of the Europe born of Rome and Christianity. But on the other hand, in terms of society, politics, and ideology, the decades that followed were decades of ever-increasing disintegration, of the approach of "whirlwinds and storms."[235] A governmental, social, ideological Russia increasingly broke ties with its own culture, and consequently with its own soul and vocation, its own path and purpose. It switched to serving "strange gods," and this could only hasten the final catastrophe.

The twentieth century became the age of Russia's disintegration, the age in which it lost its inner, unifying yardstick. The foreign, stillborn "synthesis" adopted from without very quickly unmasked itself as specifically foreign, dead, and forcibly imposed. It treats Russian culture and Russian self-identity solely as a captive—with orders and prohibitions, with barbed wire and all-pervasive fear.

It could be supposed that in this tragic "solitary confinement" a slow death of Russian culture would ensue—a death by suffocation, by loss of the soul, by isolation, by internal division. But such was not the case. Russian culture proved to be alive—and not only in the sense that it continues to

produce talented writers, artists, and thinkers, or that creativity has not been depleted in it, but also in the sense that all that is finest and authentic in this creativity proves as though naturally oriented toward "coherence," toward "synthesis," and inspired by them.

Consequently, in our time we are seeing not just a return to religious faith, but a return to the universal and all-encompassing perspective of Russian religious thought. Not just a return to free literary creativity, but a return to the literary ideal nourished on the great literature of Russia, which melds it with conscience and prophecy, with humanity and freedom. Finally, not just a return to the idea of free science and culture, but also an affirmation of the primacy of a truly pan-human and all-encompassing culture. And the more wooden and inhuman the voice of *official* Russia becomes, the more strongly and humanly will resound the voice of this as yet clandestine Russian culture.

It turns out that fifty years of artificial isolation failed to isolate it. Fifty years of imposition of the official ideology, as it turns out, failed to affect its underlying sources; fifty years of inhumanity did not dehumanize it; and fifty years of crude materialism did not shake the primarily spiritual inspiration of Russian culture. And it should be clear that, when speaking of a new possible "synthesis," this must refer not to some new "ideology," not to a new "coherent worldview" to which one is bound to submit, but first and foremost to a common *inspiration*, a common underlying aspiration of culture, its level and its encompassment of current phenomena. Synthesis

lies not in an ideology or a worldview: synthesis lies in the perception and experience of *culture itself* as free and open exploration, as attention and understanding, as criticism and inspiration of the historic paths of the nation.

Such was the inspiration of Pushkin, his synthesis which he bequeathed to Russian culture. Pushkin imposed nothing upon it, just as he imposed nothing upon Russia itself. But he showed Russian culture its *image,* by which it was able to measure and evaluate itself. Pushkin excluded and prohibited nothing, just as he commanded nothing—but he created an atmosphere of culture by which one could live, and he said that Russia could live only in this atmosphere—and that without it Russia could not survive. And it is this atmosphere and this image that are now being restored to Russia by the creators of her present-day culture.

As he was dying, Blok whispered, "Pushkin, we have learned to honor secret freedom after you … "[236] To this "secret freedom" Russian cultural self-identity is now returning. For it is the "synthesis" within which and by inspiration of which everything once again becomes possible.

 TALK 31
CONCLUSION

In his novel *Cancer Ward* Solzhenitsyn writes the following of one of his characters: "At such moments an image of the whole meaning of existence—his own and of everyone in the world—did not seem to be embodied in the work or activity which occupied them ... and by which they were known to others. The meaning of existence was to preserve unspoiled, undisturbed and undistorted the image of eternity inborn in each person."[237] These wondrous words of the greatest Russian writer of our time may be applied both to culture as a whole and to Russian culture in particular. On the one hand, the concept of culture is a collective and abstract concept. Strictly speaking, culture does not exist: what exists is a given work of literature, music, architecture, sculpture, and so on. Culture is first and foremost a particular embodiment in words, sounds, or paint. But on the other hand it is of course no accident that people speak of culture as a specific phenomenon, meaning something not only abstract, but also very real. But what exactly? Here, perhaps, the aforementioned

words of Solzhenitsyn may be of assistance: "the image of eternity." Eternity, after all, is also something abstract, something not given to us in our direct empirical experience. We know only time, both its flow and simultaneously its fragmentation. But we also know that ultimately time is what fills and conceptualizes it, taking a vacant, empty entity measured in hours and making it alive and filled with life.

The same is true of culture: it is always an embodiment. But an embodiment of what? When the renowned French poet Racine was asked how his work on *Fedra* was progressing, he replied, "It is ready. All that remains is to write it." This meant that, before it was embodied in words, his tragedy was already a reality in the creative consciousness of Racine himself.

Culture is an embodiment of *something,* and it is perhaps that something that may be defined by Solzhenitsyn's term "the image of eternity." Eternity is not a comprehensible and abstract counterweight to time; it is not what is outside or above it—rather, it is the very core of all that exists, from which its light, meaning, beauty, and wisdom shine upon us.[i]

i Eternity is not outside, but inside a man; it is "inborn" in him. And a creator is one who finds and embodies it—in time, words, paint, and sounds. Culture is "the image of eternity" not because it speaks of things outside of and above time, but because it lends a dimension of depth to the temporal, because out of the flow and fragmentation of the temporal it creates something that is no longer subject to this flow and this fragmentation. In speaking of Russian culture we may concentrate our attention and interest on its individual creators—on Pushkin, Dostoevsky, Tolstoy, and Solzhenitsyn. We may cast our inner gaze upon the

Does Russian culture have a common form, a common image of eternity? This question must clearly be answered in the affirmative: yes, it does. And not only does it have this—despite all disruptions, falls, humiliations, and sins, this image, in the words of Solzhenitsyn, remains "unspoiled, undisturbed, and undistorted."

In a certain ultimate sense and at its very core, this "image" is rooted in that perception of the world, of man, and of life that Rus' adopted at the dawn of her history from the not yet completely divided Christian world. This refers not to belief or unbelief, to religious dogmas or interpretations, but specifically to a particular "world perception." Perhaps, while not yet understanding it wholly with the mind, Russian consciousness assimilated a certain inherent positivity of creation, its essential goodness, which typifies the biblical Christian perception of it.

Throughout the history of Russian culture we find in it no *blasphemy* against the world, against man, against life, and no denial of them.[ii] The foundation of Russian culture, despite

churches of Suzdal and Pskov, the beauty and symmetry of Petrograd that Pushkin lauded, and with our inner ears we may hear the sounds passed down to us by Musorgsky or Glinka. But we also can and must see, hear, and perceive that "image of eternity" that is contained in all this and inwardly unites it, making all these creators and all their incarnations ultimately an embodiment of a single, inwardly coherent, albeit complex, culture.

ii It was never scandalized to any great degree by the Manichean, pessimistic tendencies that comparatively early on began to afflict other cultures born of the same Christian source. No, the foundation…

all the reality of evil, deformity, suffering, and grief endured by the people who created it, consists of *light*, not darkness, and of faith in that primordial light that no darkness can fully comprehend.[iii]

We repeat: the essence of Russian culture is its inherently bright and positive intuition, its refusal to consider grief and evil the original source of creation—that is, its refusal to recognize them as a normal, legitimate phenomenon. And even where Russian culture is most open to darkness and sorrow, in it there resounds a certain laudation of some ultimate, transcendent beauty and truth. Everything authentic in Russian culture is foreign to the cynicism and mockery, as well as to the indifferent irony, that are frequently felt in the auras of other cultures.

And this merely underscores the significance of the second dimension of Russian culture: its "humanity," which occasions its openness to suffering and grief and, consequently, to pity, compassion, and "involvement." In it there is no vilification of the world, nor any vilification of man. Evil for it always remains evil—that is, not the norm, but a fall and a distortion, a betrayal and violation of the moral law.

To understand this we need only compare two "terrible worlds"[238]: the world of Dostoevsky and the world of the Czech writer Kafka. For Kafka, evil is impersonal: it is diffused throughout the world as its essence, as its normal state; one cannot rebel or protest against it, for it is the essence of the very

iii And this primordial foundation, this inspiration of Russian culture, may rightly be called "stratospheric."

"system" of the world, so to speak, and the hero of Kafka's *The Trial* perishes without ever learning the identity of his persecutor and destroyer. According to Kafka, there is in fact no such "person": instead there is a pointless, absurd, dark world, and for man there is no escape from its pitiless, pointless wheels.

To a significant degree, the world of Dostoevsky is also terrible. It too is inhabited by monsters and deformed freaks of nature—by Svidrigailovs, Smerdyakovs, and Fyodor Pavlovichs. But never and nowhere in Dostoevsky are this evil and this deformity perceived as the simple truth about the world, as a pitiless, objective sentence passed upon it. For Dostoevsky, evil is always the evil person: it is not an indefinite "something," but always "someone" who has chosen evil, but who did not have to choose it; someone who torments people, but who does not have to torment them. And this "someone" is dark because his darkness stands out against the backdrop of light, and is seen in the context of it.[iv]

This gives rise to the third dimension of Russian culture: it does not give up anyone or anything for lost, does not pass final judgment and sentence upon anyone or anything, never surrenders hope. Salvation is always possible; rebirth is always achievable; a person can always return to his conscience—and for this reason people relate to one another first and foremost through conscience, through compassion, through *uchastie,* or "involvement"[239]—an impulse signified

iv Evil stands out against the backdrop of good, and by good it is weighed and judged.

by a word that is not translatable into any other language. Russian culture is filled with testimonials to evil and suffering, to deformity and often hopeless sorrow. And yet its "image of eternity," its general form and atmosphere perceived as a whole, remain luminous.

Russian culture is the embodiment of that "light Russia" that was contraposed to "oppressive Russia" almost from the very beginning, illumining her from within, cleansing her, striving to permeate her with light and joy. To a significant degree, "oppressive Russia" is history itself, the very experience of Russian reality. The Tatar yoke, the craftiness of the Muscovite princes, Ivan the Terrible, the burdens imposed by the heavy-handed Russian state system, penury, inequality, cruelty—all this is what must be overcome and eliminated, and it is not eliminated because the consciousness of many heirs of the oppressive past is often darkened by a blind gravitation toward this very "oppressiveness."

The "light Russia" is the venerable Sergius of Radonezh, who withdrew into the forest, but inundated all Russia with a luminous vision of "otherness"; it is an undying longing for nobility and truth; it is Pushkin's "mercy for the fallen"; it is all the sorrow over beauty and goodness that never runs dry in the depths of Russian consciousness. And at its core it is specifically that same inspiration that in strange manner unites the Western, Petersburgian Pushkin with what would seem to be a completely different world—the world of Sergius and Seraphim, of *Kassian from the Beautiful Lands* and the *Bishop* of Chekhov.[240]

Russian culture is a remarkable symphony in which sorrowful melodies are ultimately transfigured into a laudation of

goodness, truth, and beauty. From his terrible ordeal Solzhenitsyn took away his words of an "unspoiled, undisturbed, and undistorted … image of eternity." And at the other edge of the world, out of a wholly different but also severe ordeal, the emigrant poet Anatoly Shteiger said:

> We shall not be asked: Did you sin?
> We shall be asked only: Did you love?
> And without raising our heads,
> We shall say bitterly: Yes, alas,
> We loved … Oh, how we loved![241]

All this is mysteriously part of "the image of eternity," inborn in Russian culture and embodied by it, which in spite of all it continues to embody. And as long as it remains true to this image, we may believe that it is destined for life, for a *future*, and ultimately for victory.

As has often happened in the past, Russia today effectively lives and is preserved in her culture. The oppression that weighs upon her no longer even bears the name of Russia. But perhaps this name is only truly merited and purified by all that has been accumulated over the centuries as a counterweight to this oppression, all that has been embodied and continues to be embodied today. And this is so because the eternal foundation of Russian culture, of which we have been speaking in these talks, is more profound and more powerful than culture alone. This foundation is "the image of eternity," which was "inborn" in Russia at the very outset of her history, and to which Russian culture remains faithful.

Acknowledgments

H oly Trinity Seminary Press would like to express special appreciation to Serge Schmemann for granting permission to publish these broadcasts by his father. Much gratitude is also due to Maria Vasilyeva, Andrey Teslya and everyone who contributed to the A. Solzhenitsyn House issue of the original Russian edition (Moscow, 2021). In addition, this project was accomplished with the encouragement and generous support of:

Irina and Dmitrij Plotnikov
RBR Inc.—Olga Koulomzin-Poloukhine, President
Zoya and Miltiadis Leptourgos in memory
 of Maria and Zacharias Leptourgos
Anonymous in memory of Capitolina and Julia.
Olivier Berggruen
St Alexander Nevsky Benevolent Fund
Russian American Cultural Society of Cleveland
St Sebastian Orthodox Press
St Vladimir's Orthodox Theological Seminary
Inna and Alexis Rodzianko
Paul V. and Barbara B. Epanchin
Professor Vera Shevzov (Smith College)

John Kuhn Bleimaier, Esq. in memory
 of Colonel M.M. Okolodkoff
Russian Brotherhood Organization (RBO)
Dr. and Mrs. Vladimir Morosan
The Russian Orthodox Theological Fund
Alexandr Neratoff
Anonymous donors

Notes

In Russian-language works cited, where no translator is named, the information is from the Russian edition, and the translation is that of the translator of the English edition.

Introduction

1 The complete corpus of *Foundations of Russian Culture* was reproduced in the Russian language from the typewritten copy stored in the collection of Vladimir Varshavsky at the Alexander Solzhenitsyn House of Russia Abroad (Vladimir Varshavsky archive, collection 291).

2 The Alexander Solzhenitsyn House of Russia Abroad (HRA), coll. 291. The acquisition, analysis, and preliminary compilation of the archive was carried out by the academic secretary of the House for the Russian Diaspora and one of the authors of this article, Maria Vasilyeva.

3 Radio Liberation (renamed Radio Liberty in May of 1959) began broadcasting in 1953. Vladimir Varshavsky and Protopresbyter Alexander Schmemann were among its first freelance collaborators. Father Alexander began hosting broadcasts in March of 1953. Varshavsky came to Radio Liberation as a "consultant and scriptwriter" in April of 1954 (this information is found, in particular, in the draft of a statement from Vladimir Varshavsky concerning his application for naturalization to the U.S. Ministry of Justice on May 5, 1956. See "Alien registration: Vladimir Varsavsky, № A7976352. Application to file petition for naturalization. United States Department of Justice" (HRA, coll. 291).

4 See Tikhon Troyanov, "«Мне было интересно рядом с ними»: Беседа М.А. Васильевой и Е.Ю. Дорман 12 ноября 2012 г." ["'I Found Their Company Interesting': A Conversation Between Maria Vasilyeva and E.Yu. Dorman on November 12, 2012"], in *Ежегодник Дома русского зарубежья имени Александра Солженицына* [*The Annual Report of the Alexander Solzhenitsyn House of Russia Abroad, 2012*] (Moscow: 2012, 235–240.)

5 We are grateful to Ivan Tolstoy at Radio Liberty for providing this information. In a letter he observed in particular: "Alas, we have no such series. We do not even have a title under which it could be concealed. Moreover, we do not have his recordings from 1970–1971! With one exception—a series of programs on Solzhenitsyn. But they are in a different segment."

6 Alexander Schmemann, *Основы русской культуры: [Беседы на «Радио Свобода»]* ["Foundations of Russian Culture": Talks on Radio Liberty], Maria Vasilyeva and E.Yu. Dorman, columnists, in *Ежегодник Дома русского зарубежья имени Александра Солженицына* [*The Annual Report of the Alexander Solzhenitsyn House of Russia Abroad, 2012*] (Moscow: 2012, 241–290).

7 Alexander Schmemann, *Основы русской культуры: Беседы на «Радио Свобода»* [*Foundations of Russian Culture: Talks on Radio Liberty*], compiled by E.Yu. Dorman, foreword by O.A. Sedakova, revised and annotated by Maria Vasileva, E.Yu. Dorman, and Yu.S. Terentyev (Moscow: Publishing House of PSTGU, 2017).

8 This publication became one of the ten most important books published in Russia in the 2010s, as rated by the almanac of modern Christian literature *Dary* (2020, № 6). In 2019 *Foundations of Russian Culture* was published in Serbian and French translations: Alexander Schmemann, *Osnove ruske kulture*, trans. I. Nedić and J. Nedić (Kragujevac: Kalenić, 2019); Alexander Schmemann, *Les Fondements de la culture russe*, trans. M. Sollogoub (Geneva: Éd. Des Syrtes, 2019).

9 The "fragmentation" of the radio series, as it was later learned, has a dramatic and even criminal history. During one of T.G. Varshavsky's trips abroad, her apartment was robbed. One victim of the break-in was the family archive: in an instant the Varshavsky collection, carefully compiled by the writer's widow, was chaotically scattered.

10 Alexander Schmemann, "О Солженицыне" ["On Solzhenitsyn"], in Alexander Schmemann, *Собрание статей, 1947–1983* [*Collected Articles, 1947–1983*], compiled by E.Yu. Dorman, foreword by A.I. Kyrlezheva (Moscow: Russky Put, 2009), 761.

11 Id., "Духовные судьбы России" ["The Spiritual History of Russia"], in ibid., 670.

12 From this point on [in the introduction by Maria Vasilyeva], quotes from *Foundations of Russian Culture* are given in italics with quotation marks.

13 On April 10, 1970, the Holy Synod of the Russian Orthodox Church granted autocephaly to the Russian Orthodox Greek Catholic Church in America, and Patriarch Alexy I signed the Tomos of Autocephaly. Concerning this, see Alexander Schmemann, "Знаменательная буря" ["A Landmark Storm"], in id., *Collected Articles*, 550–572. See also O.Yu. Vasilyeva, "Православная Церковь в Америке: к вопросу об автокефалии" ["The Orthodox Church in America: On the Question of Autocephaly"], in *Alpha and Omega*, 2006, № 2 (46), 166–173; A.A. Kostryukov, "Дарование автокефалии Православной Церкви в Америке в свете документов церковных архивов" ["The Granting of Autocephaly to the Orthodox Church in America in Light of Documents from the Church Archives"], in the Vestnik of the PSTGU, series 2: History, History of the Russian Orthodox Church, 2016, issue 3 (70), 93–103; A.A. Kostryukov, "Предоставление автокефалии Православной Церкви в Америке и московско-константинопольские отношения" ["The Granting of Autocephaly to the Orthodox Church in America and Relations

between Moscow and Constantinople"], in *Rossiyskaya istoriya*, 2020, № 3, 148–155.

14 Alexander Schmemann, "О Солженицыне" ["On Solzhenitsyn"], *Vestnik of the RSCM*, 1970, № 98, 72–87.

15 Father Alexander served as deputy chairman (1963–1979), then chairman (1979–1983) of the Movement.

16 Alexander Schmemann, *Дневники* [*Diaries*], 1973–1983, compiled and revised by U.S. Schmemann, N.A. Struve, and E.Yu. Dorman; foreword by S.A. Schmemann; annotated by E.Yu. Dorman (Moscow: Russky Put, 2005), 126.

17 Concerning this, see A.S. Kolchin, "«Радио свобода» в 1950–1970-е годы XX века: поиск форм пропаганды в период холодной войны" ["Radio Liberty in the 1950s–1970s of the 20th Century: The Search for Forms of Propaganda in the Era of the Cold War"], *Moscow University Vestnik*, series 10: Journalism, 2010, № 3, 103–116; A.V. Antoshin, "Солженицын и радио 'Свобода' в 1970-е гг.: попытка диалога" ["Solzhenitsyn and Radio Liberty in the 1970s: An Attempt at Dialog"], *Izvestiya UrFU*, series 2: The Humanities, 2019, vol. 21, No. 1 (184), 23–32; "Письма Владимира Варшавского к протоиерею Кириллу Фотиеву (1968–1977)" ["Letters of Vladimir Varshavsky to Archpriest Kirill Fotiev (1968–1977)"], revised and annotated by Maria Vasilyeva, in *Филосовские письма. 2019* [*Philosophical Letters*: 2019], vol. 2, No. 3, 129–150.

18 Regarding this shift in internal politics, in a letter dated June 21, 1976, Victoria Semenova-Mondich, the longest-standing employee at Radio Liberty, wrote the following to acting director Francis Ronalds: "In recent years the entire radio station has looked on as the Russian office has been systematically liquidated. … In New York on various pretexts a wide range of collaborators has been wholly or partially eliminated: Dudin, Adamovich, Petrovskaya, Koryakov, Sanders, Zavalishin. In Munich Rosinsky has been fired and replaced with

Matusevich; Rudin has been ousted and replaced with Fedoseyeva." (quoted from A.V. Antoshin, *А.И. Солженицын и радио «Свобода» в 1970-е гг.* [*A.I. Solzhenitsyn and Radio Liberty in the 1970s*], 26). A year later Vladimir Varshavsky described a similar situation at the Munich office: "Unfortunately, certain new people are indeed attempting to oust the old from 'key' posts. As a rule they disdain the first and second emigrations, believing that they alone know what to do and how to do it. In Munich they have marginalized nearly all the old people— not only full-time employees but even freelancers." (V.S. Varshavsky to Archpriest K. Fotiev, not earlier than February 8, 1976, in *Письма Владимира Варшавского к протоиерею Кириллу Фотиеву (1968– 1977)* [*Letters of Vladimir Varshavsky to Archpriest Kirill Fotiev (1968– 1977)*], 141.)

19 Alexander Solzhenitsyn to Francis Ronalds, October 30, 1976 (quoted from A.V. Antoshin, *А.И. Солженицын и радио «Свобода» в 1970-е гг.* ["Solzhenitsyn and Radio Liberty in the 1970s"], 27–28).

20 Valeryan Alexandrovich Obolensky, prince (1925–1977)—journalist, radio commentator, and translator. In 1956 he was invited to Radio Liberation in Munich, where he headed the department of breaking news. After moving to New York he served as program director at Radio Liberty (until 1973).

21 Ludmila Obolenskaya-Flam to M.A. Vasilyeva, January 9, 2021.

22 Sergey Schmemann, ["О беседах о. Александра Шмемана на Радио «Свобода»" ["Fr. Alexander Schmemann's Talks on Radio Liberty"], in Alexander Schmemann, *Беседы на Радио «Свобода»* ["Talks on Radio Liberty"], in two volumes (Moscow: PSTGU, 2009), 1.6.

23 Alexander Dvorkin, *Моя Америка: Автобиографический роман в двух книгах с прологом и двумя эпилогами* [*My America: An Autobiographical Novel in Two Books with a Prologue and Two Epilogues*]. Foreword by D. Smirnov, O. Nikolaeva, and N. Novgorod (Christian Library: Russia, 2014), 449.

24 Alexander Schmemann, Дневники [*Diaries*] (1973–1983), 126.

25 Ibid., 597.

26 Pyotr Bitsilli, "Трагедия русской культуры" ["The Tragedy of Russian Culture"], *Sovremennye Zapiski*, 1933, № 53, 297–309.

The Cultural Debate in the USSR: A Protest

27 An expression originating from the Futurist manifesto, "Пощечина общественному вкусу" ["A Slap in the Face of Public Taste"], with its call to "throw Pushkin, Dostoevsky, Tolstoy, *et al., et. al*, overboard from the Ship of Modernity" (Vladimir Markov, *Russian Futurism: A History* [Berkeley, CA: University of California Press, 1968], 46).—Trans.

28 Alexander Solzhenitsyn, *В круге первом* [*In the First Circle*] (1955–1958). —Trans.

The Dispute over Culture in the Soviet Union

29 A reference to *Будка* [*The Booth*] by Gleb Uspensky. —Trans.

30 Andrei Alekseyevich Amalrik, *Просуществует ли Советский союз до 1984 года?* [*Will the Soviet Union Last until 1984?*] (Amsterdam: Herzen Foundation, 1970), 4, 5.

31 Boris Pasternak, *Доктор Живаго* [*Doctor Zhivago*] (1957). —Trans.

32 Vladimir Dudintsev, *Не хлебом единым* [*Not by Bread Alone*] (1956). —Trans.

"Culture" in Russian Self-identity

33 This expression has been erroneously ascribed to Dmitry Pisarev. It dates back to a satirical quote in the article by Fyodor Dostoevsky, "Господин Щедрин, или Раскол в нигилистах: Стаья 2-я" ["Mister Shchedrin, or Schism among the Nihilists: Article 2"] (1864), written in

response to the article by Mikhail Saltykov-Shchedrin, "Литературные мелочи" ["Literary Minutiae"] (1864). The polemics were generally directed against the utilitarian approach which contributors to *Russkoe Slovo* magazine (including Pisarev) applied to the role of Pushkin in Russian culture and to art in general. "Boots are better than Pushkin, in any case. Pushkin is a luxury and utter nonsense. … Even Shakespeare himself is a luxury and utter nonsense" (Fyodor Dostoevsky, *Полное собрание сочинений* [*Complete Collected Works*, hereinafter CCW] [30 vols.; Leningrad: Nauka, 1972–1990], 20: 109). In his "observational notebook" from 1864–1865, in his observation "Socialism and Christianity," concerning the authors of the "Young Russia" proclamation, Dostoevsky writes, "They admit this *with pride:* boots are better than Shakespeare, it is shameful to speak of the immortality of the soul, etc., etc." (Dostoevsky, CCW, 19:192–193.) We find similar thinking in the words of *Russkoe Slovo* contributor V.A. Zaitsev: "There is no floor polisher or lavatory cleaner who is not more useful than Shakespeare" (*Russkoe Slovo,* 1864, № 3, quoted from Dostoevsky, CCW, 12:284, 312), and also in the words of Pyotr Kropotkin: "The nihilist was repulsed by the endless talk of beauty, of ideals, of art for art's sake, of aesthetics, and so forth. … He knew that the so-called worship of beauty was frequently just a mask concealing vulgar debauchery. Even then the nihilist molded his merciless criticism of art into a single formula: 'A pair of boots is more important than all the Madonnas and all sophisticated discussions of Shakespeare'" (Pyotr Kropotkin, *Записки революционера* [*Notes of a Revolutionary*] [Moscow: Moskovsky Rabochy, 1988], 284).

34 Leo Tolstoy's tract "Что такое искусство?" ["What Is Art?"], on which the writer labored for fifteen years right up until 1896, was first published in the Moscow magazine *Voprosy Filosofii i Psikhologii* in 1897–1898.

35 The Supreme Censorship Committee was particularly displeased with the words of Vladimir Odoevsky: "The sun of our poetry has set!

Pushkin is dead, dead in the flower of his youth, at the midpoint of his
great course!" (from the necrology in *Literaturnye pribavleniya k 'Russ-
komu Invalidu, № 5* (1837). Contemporaries recall that A.A. Kraevsky, edi-
tor of *Literaturnye pribavleniya k 'Russkomu Invalidu,* was summoned to
M.A. Dondukov-Korsakov, trustee of the Saint Petersburg educational
district, who relayed that S.S. Uvarov, chairman of the Chief Censor-
ship Administration, was "extremely displeased": "What kind of expres-
sions are these?! 'The sun of poetry'!! I ask you, to what is this honor
owed? … What is this 'course'? … Was Pushkin a military commander,
a general, a minister, a man of state?! … Writing poetry is not the same
as … running a great course!" (*Russkaya Starina, № 7* [1880], 536–537;
quoted from V.V. Veresaev, *Пушкин в жизни: Систематический свод
подлинных свидетелств современников* [*Pushkin in Life: A System-
atic Corpus of Authentic Testimonials of His Contemporaries*] [Moscow:
Khudozhestvennaya Literatura, 1987], 615). The censor's reaction to
the necrology devoted to Pushkin is described in the diary of censor
and journalist A.V. Nikitenko: "Grech was reprimanded by Benken-
dorf for his words printed in *Severnaya Pchela*: 'Russia owes Pushkin a
debt of gratitude for his 22 years of service in the field of the language
arts' (№ 24). Kraevsky, editor of *Literaturnye pribavleniya to Russkomu
Invalidu,* also ran into trouble over several lines printed in praise of the
poet. I was ordered to strike a small number of similar lines intended
for the 'Reading Library'" (A.V. Nikitenko, Дневник [*Diary*] [3 vols.;
Leningrad: State Publishing House of Fiction, 1955], 1:196–197).

36 Nikolai Gogol, *Мертвые души* [*Dead Souls*] (1842). —Trans.

37 Fyodor Dostoevsky, *Дневник писателя* [*Diary of a Writer*] (1873–
1881). —Trans.

38 A reference to Smerdyakov's comment in *Братья Карамазовы*
[*The Brothers Karamazov*]: "If it's poetry, it's absolutely rubbish. …
Consider yourself: have you ever met a person who talks in rhyme?
And if we all started talking in rhyme, even at the order of the author-
ities, how much, do you think, should we say? Poetry's of no use"

(Fyodor Dostoevsky, *The Brothers Karamazov* 2.5.2, David Magarshack, trans. [Harmondsworth, Middlesex: Penguin Books, 1982], 260).

39 We have not located the source of this quote. This statement of Paul Valéry was reported in émigré literary circles, and may be found in the article by N.A. Otsup, "The Silver Age of Russian Poetry:" "Paul Valéry called nineteenth-century Russian literature one of the three greatest wonders of human culture" (*Chisla,* book 7/8 [Paris: n.p., 1933], 174). In a letter from Georgy Ivanov to M.M. Karpovich (April 19, 1951): "We are the last dregs of what Paul Valéry defined in his diary: 'There are three wonders of world history: Hellas, the Italian Renaissance, and nineteenth-century Russia'" (quoted from A. Aryev, *Жизнь Георгия Иванова: Документальное повествование* [*The Life of Georgy Ivanov: A Documentary Narrative*] [Saint Petersburg: *Zvezda* magazine, 2009], 78). Valéry's words were often cited by Georgy Adamovich, but when Yu.P. Ivask asked him to clarify the source of the quote, in answer to the question "Where approx[imately] did Valéry speak of three wonders of the world—Greece, the Renaissance, and nineteenth-century Russian literature?" Adamovich answered, "I do not remember and I cannot find it. But he probably said it in some notes of his. These words have since been quoted repeatedly, courtesy of yours truly" (quoted from *Проект «Акмеизм»* [*The Akmeizm Project*], opening chapter, text preparation, and commentary by N.A. Bogomolov. *Novoe Lliteraturnoe Obozrenie,* № 54 [2002], 149, 175).

40 *Geoffrey Chaucer* (approx. 1348–1400)—English poet, "the father of English poetry," the first to begin writing his compositions not in Latin, but in his native tongue. Author of the famous *Canterbury Tales* (approx. 1380–1390), *The Legend of Good Women* (1388), and others.

41 The *Pléiade* (originally the *Brigade*) was a circle of French humanist poets, formed in 1556. The name *La Pléiade* ("The Seven Stars"), borrowed from a circle of poets in ancient Greece headed by Theocritus, indicated the constant number (seven) of its members. The most prominent of these were Pierre de Ronsard (1524–1585) and Joachim du Bellay

(1522–1560). During the French Renaissance, French humanist poetry reached its zenith in the person of the *Pléiade*. Governed by a renunciation of traditional national poetic forms, the *Pléiade* polemicized with a poet from the early French Renaissance, Clément Marot (1496–1544), author of the famous collection *L'Adolescence Clémentine* (1526).

42 The *assemblées* (French, "assembly") were introduced in 1718 by imperial edict of Peter I ("Edict concerning the dignity of a guest who is present at an *assemblée*"), in order to Europeanize the leisure of the Russian nobility. The Petrine *assemblées* became the antecedent of various sorts of secular entertainments—receptions, evening parties, balls, etc. Concerning this see Evgeny Anisimov, *Императорская Россия* [*Imperial Russia*] (Saint Petersburg: Piter, 2008) and Anna Kolesnikova, *Бал в России XVIII–начало XX века* [*The Russian Ball in the 18th–Early 19th Centuries* (Saint Petersburg: Azbuka-klassika, 2005).

43 In his article "Опровержение на критики" ["A Repudiation of Criticism"] (1830), Pushkin noted, "The conversational tongue of the simple people (who do not read foreign books and, thank God, do not express their thoughts in French as we do) is worthy of such extensive study. Alfieri studied the Italian language at a Florentine bazaar; we would do well to occasionally turn our ear to the prosphora bakeries of Moscow. The language they speak is amazingly pure and proper" (Alexander Pushkin, CCW, 4th ed. [10 vols.; Leningrad: Nauka, 1977–1979], 7:122).

44 In the text of the script, "*third*," but there can be no doubt that here the "*second*" culture is meant.—Editor of the Russian Edition.

Paradoxes of Russian Cultural Development: Maximalism

45 Cf. Lk. 10:42. KJV.

46 A reference to the words of Alyosha Karamazov: "I recently read the opinion of a German who had lived in Russia about our schoolboys today. 'Show a Russian schoolboy,' he writes, 'a map of the stars, of which

he had no idea before, and he'll return it to you corrected next day.' No knowledge and utter self-conceit—that's what the German meant to say about the Russian schoolboy'" (Dostoevsky, *The Brothers Karamazov* 4.10.6, 502).

Paradoxes of Russian Cultural Development: Minimalism

47 A reference to the ideologeme "Moscow as the Third Rome," proposed by Elder Filofei (approx. 1465–1542) of the Elizarov Monastery in Pskov and presented in the form of epistles to Great Prince Vasily Ivanovich of Moscow and the royal clerk M.G. Munekhin: "Know thou, O pious king, that all the Christian kingdoms have come together into the one that is yours—that two Romes have fallen, the third stands, and there will be no fourth" ("Epistle of the Elder Filofei to the Great Prince Vasily," in *Памятники литературы Древней Руси* [*Historic Literature of Old Rus'*] [Moscow: Khudozhestvennaya Literatura, 1984], book 6: Late 15th Century to the First Half of the Sixteenth Century, 441).

48 *Heresy of the Judaizers*—a religious movement that existed in the last third of the fifteenth–early sixteenth century in Novgorod, Kiev, and Moscow. Its founder was the Kievan heretic and sorcerer Skhariya (according to the anti-heretical tract by Joseph of Volotsk, "Просветитель" ["The Enlightener"]. The heresy comprised a mixture of Judaism and Christianity: it denied the dogma of the Trinity, the divinity of Jesus Christ, and the redemption; and it preferred the Old Testament to the New, rejected the writings of the Holy Fathers and the veneration of relics and icons, renounced monasticism, etc.).

49 *Nilus of Sora* (in the world, Nikolai Maikov [1433–1508])—founder and leader of non-possessiveness in Russia. Opposed church land ownership at the council of 1503 in Moscow and supported monastery reforms based on the skete way of life and the individual labor of monastics. Developed ideas of "mental prayer"—a particular kind of prayerful contemplation, or hesychasm. The general thinking of Nilus

of Sora is strictly ascetic in focus, appealing primarily to inner, spiritual asceticism, as distinguished from how asceticism was understood by the majority of Russian monasticism at the time.

50 *Maximus the Greek* (in the world, Mikhail Trivolis; approx. 1475–1556)—publicist, writer, and translator. He lived for around ten years on Athos, from where he came to Moscow at the invitation of Great Prince Vasily III Ivanovich in 1518 to translate spiritual books. He actively participated in the disputes between the Josephites and the Non-possessors, taking the side of Nilus of Sora and his elders. He gathered a circle about himself which, aside from theoretical ecclesiastical matters, discussed matters related to the foreign and domestic policy of the great prince. An ascetic by conviction like the other Non-possessors, he spoke out against land ownership by monasteries and the amassing of wealth by churches. At the council of 1525 he was accused of heresy, barred from communion, and sentenced to exile at the Joseph-Volokolamsk Monastery. After being condemned a second time at the council of 1531 he was exiled to the Tver Otroch Dormition Monastery. In 1551 he was retired to the Trinity-Sergius Monastery. He was glorified as a venerable father at the Local Council of 1988.

51 Concerning the closing remark in Alexander Pushkin's tragedy *Борис Гудинов* [*Boris Gudinov*] (1831), see T. Zenger, "Николай I – редактор Пушкина" ["Nicholas I, Editor of Pushkin"], in *Literaturnoe Nasledstvo* (Moscow: Zhurnal'no-gazetnoe obedinenie, 1934), 16–18:513–536; D. Blagoy, *Социология творчества Пушкина: Этюды* [*The Sociology of the Works of Pushkin: The Etudes*], 2nd ed., exp. (Moscow: Mir, 1931); V. Lavretskaya, *Произведения А.С. Пушкина на темы русской истории* [*The Works of Alexander Pushkin on the Topic of Russian History*] (Moscow: State Educational and Pedagogical Publishing House of the RSFSR Ministry of Education, 1962); M.P. Alexeyev, "Ремарка Пушкина «Народ безмолвствует»" ["Pushkin's Remark 'The People are Silent'"], *Russkaya Literatura*, № 2 (1967): 36–58; etc.

52 The renowned words of the preeminent early Old Believer figure Protopope Avvakum (1620–1682), from his composition *Житие протопопа Аввакума, им самим написанное* [*The Life of Protopope Avvakum, Written by Himself*] (1672–1673): "Glory to God! Suffer tortures for the placing of thy fingers, reason not much, but I with thee am ready to die for this and for Christ. If I am a foolish man and one without learning, yet this I know, that all the traditions of the Church, handed down to us by the holy Fathers, are holy and incorrupt. I keep them even unto death, as I received them. I will not falsify the eternal boundaries—that which was laid down before our days, let it so remain to all eternity" (Protopope Avvakum, *The Life of Archpriest Avvakum by Himself*, in *Medieval Russia's Epics, Chronicles, and Tales*, Serge A. Zenkovsky, ed. [New York: Dutton, 1963], 369).

53 Alexander Pushkin, "Критикою у нас большею частию ... " ["Criticism in Our Country for the Most Part ... "], in Pushkin, *CCW*, 7:354.

54 A reference to the article by Pyotr Chaadayev, "Апология сумасшедшего" ["Apology of a Madman"] (1837): "Would the country have allowed itself to be robbed of its past, and the past of Europe to be as though imposed upon it? But this was not the case. Peter the Great found in his native land only a blank sheet of paper: with his powerful hand he wrote upon it the words *Europe* and *The West,* and since that time we have been part of Europe and of the West" (Pyotr Chaadayev, "Apology of a Madman," in Pyotr Chaadayev, *Сочинения* [*Writings*] [Moscow: Pravda, 1989], 143).

55 These words were said not by Dostoevsky, but by literary and theatrical critic and writer Apollon Alexandrovich Grigoryev (1822–1864) in his article "Взгляд на русскую литературу со смерти Пушкина" ["A Look at Russian Literature since the Death of Pushkin"] (1859). "The best that has been said of Pushkin in recent years was said in the

articles of Druzhinin, but even Druzhinin viewed Pushkin only as our aesthetic mentor. But Pushkin is our everything: Pushkin represents everything we have that is *soulful* and *special,* which will remain our *soulful* and *special* possession after all conflicts with outsiders and with other worlds" (Apollon Grigoryev, "A Look at Russian Literature since the Death of Pushkin," in *Writings* [2 vols.; Moscow: Khudozhestvennaya Literatura, 1990], vol. 2: "Articles and Letters," 56–57).

56 One of the central ideas of Fyodor Dostoevsky's "Pushkin Speech" (1880): "Indeed, in the literary traditions of Europe there have been colossal artistic geniuses—Shakespeares, Cervanteses, Schillers—but show me even one of these great geniuses who possessed such as capacity for universal sensitivity as did our Pushkin" (Fyodor Dostoevsky, "Пушкин" ["Pushkin"], in CCW, 26:145).

57 *Semyon Yakovlevich Nadson* (1862–1887)—poet and literary critic. Entered literature in the genre of civil lyricism and as an expresser of the era of "stagnation" in the late nineteenth century. Osip Mandelshtam called "Nadsonism" "an enigma of Russian culture" ("Шум времени" ["The Noise of Time"] [1925]). His first collection of poetry (1885) saw several reprintings in the author's lifetime and was awarded the Pushkin Prize by the Academy of Sciences (1886). After the poet's death his fame reached its apogee, and a vast body of memorial and critical literature about him was produced (N.K. Mikhailovsky, A.M. Skabichevsky, L.E. Obolensky, and others). Nadson's writings became the basis for over fifty romances composed by greats such as Sergei Rachmaninoff, Arthur Rubinstein, Alexander Grechaninov, and others. Doubt was first cast on the significance of Nadson's work by the symbolists, after which the futurists radically reassessed it. Concerning him see S.Yu. Dudakov, *Этюды любви и ненависти* [*Etudes of Love and Hate*] (Moscow: RGGU, 2003) and O.A. Lekmanov, *Русская поэзия в 1913 году* [*Russian Poetry in 1913*] (Moscow: Vostochnaya Kniga, 2014).

58 A quote from the article by Alexander Pushkin, "Мои замечания об русском театре" ["My Notes on Russian Theater"] (1820). Compare: "A significant part of our parterre (that is, its chairs) is too occupied with the fate of Europe and the fatherland, too exhausted with labor, too introspective, too important, too careful in expressing the movements of the soul to take any part whatsoever in the dignity of dramatic art (and Russian dramatic art, at that)" (Alexander Pushkin, CCW 7:8).

59 *K.R.*—Great Prince Konstantin Konstantinovich Romanov (1858–1915), member of the Russian imperial house, adjutant general (1910), general of the infantry (1907), inspector general of military training institutions, president of the Saint Petersburg Imperial Academy of Sciences (1889), poet, translator, and dramaturg. A continuer of classical traditions in poetry, author of several collections of poetry entitled "Стихотворения [1879–1885]" ["Poems [1879–1885]"] (1886), "Новые стихотворения К.Р." ["New Poems of K.R."] (1900), "Третий сборник стихотворений К.Р." ["A Third Collection of the Poems of K.R."] (1900), and "Стихотворения К.Р." ["Poems of K.R."] (1901). Many poems were set to music. The most famous were romances set to the music of Pyotr Tchaikovsky: "Растворил я окно" ["I Opened the Window"], "Я сначала тебя не любила" ["I Did Not Love You at First"], "Вот миновала разлука" ["Cheerless Parting Is Over"], and others.

Paradoxes of Russian Cultural Development: Utopianism

60 This event is dated to 996 and is described in the twelfth-century chronicle, *Повесть временных лет* [*Tale of Bygone Years*]: "6502-6504 (994-996). … For Vladimir was fond of his followers, and consulted them concerning matters of administration, wars, and government. He lived at peace with the neighboring Princes, Boleslav of Poland, Stephen of Hungary, and Udalrich of Bohemia. … The number of bandits increased, and the bishops, calling to his attention the

multiplication of robbers, inquired why he did not punish them. The Prince answered that he feared the sin entailed. They replied that he was appointed of God for the chastisement of malefaction and for the practice of mercy toward the righteous, so that it was entirely fitting for him to punish a robber condignly, but only after due process of law. Vladimir accordingly abolished *wergild* and set out to punish the brigands. The bishops and the elders then suggested that as wars were frequent, the *wergild* might be properly spent for the purchase of arms and horses, to which Vladimir assented. Thus Vladimir lived according to the prescriptions of his father and his grandfather" (*The Russian Primary Chronicle: Laurentian Text*, Samuel Hazard Cross and Olgerd P. Sherbowitz-Wetzor, trans. and eds. [Cambridge, MA: Mediaeval Academy of America, 1953], 122).

61 This refers to the first chapter, "Boris and Gleb, Holy Passion-bearers," from the book by Georgy Fedotov, *Святые Древней Руси* [*Saints of Old Rus'*] (Paris: YMCA-Press, 1931). "The ascetic feat of non-resistance is a national ascetic feat of Russia, an authentic religious discovery of the newly baptized Russian people. … Saints Boris and Gleb created a special, not wholly liturgically defined rank of 'passion-bearers'—the most paradoxical rank of Russian saints. In the majority of cases it is impossible to say that these died voluntarily; we can only say that they did not resist death. This non-resistance apparently imparts to a violent death the sense of going voluntarily to the slaughter, and cleanses the slaughtered victim when infancy does not afford natural conditions of purity" (Georgy Fedotov, *Святые Древней Руси* [*Saints of Old Rus'*] [Paris: YMCA-Press, 1931], 31–32).

62 This refers to the decision of Yaroslav the Wise (approx. 978–1054) to divide his dominion among his numerous sons in order to forestall any possible power struggle among them. After the death of Yaroslav, however, fourteen years of peace among his sons gave way to a period of internal strife among the princes that lasted forty-five

years (1068–1113). During these internal wars many princes occupied the throne of Kiev, and these frequently enlisted the aid of the Cumans (Polovtsy) in fighting their opponents.

63 The final verse in Fyodor Tyutchev's quatrain, "Умом Россию не понять … " ["Not by the Mind Is Russia Understood"] (1866). (*Poems & Political Letters of F. I. Tyutchev*, Jesse Zeldin, trans. [Knoxville, TN: University of Tennessee Press, 1973], 144).

64 *Holy Alliance*—an alliance of European monarchs (Emperor Alexander I of Russia, Emperor Franz I of Austria, and King Frederick William III of Prussia) after the fall of the Napoleonic empire. The "Act of Holy Alliance" was signed on September 26, 1815, in Paris. On November 19, 1815, the Holy Alliance was joined by King Louis XVIII of France, followed subsequently by a number of other European states. The objectives of the Holy Alliance included maintaining inviolate the borders of Europe established in 1815 by the Congress of Vienna, as well as combating dissidence. At the congresses of the Holy Alliance that were periodically convened (the Congress of Aix-la-Chapelle in 1818, the Congress of Troppau in 1820, the Congress of Laibach in 1821, the Congress of Verona in 1822), Metternich and Alexander I played a leading role. On January 19, 1820, Russia, Austria, and Prussia signed a protocol that proclaimed a right to armed intervention on their part in the internal affairs of other states in order to combat revolution. In 1826, however, against the backdrop of the Greek question, relations between Russia and Austria began to deteriorate. By 1830 the Alliance had essentially disbanded.

65 Concerning this, see Nikolai Berdyaev, *Истоки и смысл русского коммунизма* [*The Sources and Meaning of Russian Communism*] (Paris: YMCA-Press, 1955), particularly the chapter on Russian socialism and nihilism: "Among the Russian intelligentsia, before the advent of nihilism, the predominant human type was the one known as the 'idealist of the forties.' It was the continuation of the

type which belonged to the end of the eighteenth and beginning of
the nineteenth centuries, and was connected with mystical masonry.
It was the outcome of the working over by Russian thought of Ger-
man romanticism and idealism. It grew up on the soil provided by cul-
tured Russian gentry. This type of man, a very honourable type, was
prone to the highest aspirations, to appreciation of taste and beauty.
As later on Dostoyevsky loved to observe with irony, it was given to
much day dreaming and had but a feeble capacity for action and put-
ting into practice; there was no little of the Russian laziness to which
the gentry were liable. From this type the 'superfluous people' came.
The type of 'thinking realist' preached by Pisarev produces com-
pletely different traits, which are often engendered in reaction against
the idealist type. The 'thinking realist' was alien from all day dream-
ing and romanticism; he was the foe of all lofty ideas which had no
relation whatever to action and were not put into practice. He was
inclined to be cynical when it came to unmasking illusions, whether
religious, metaphysical or aesthetic. His cult was a cult of work and
labour. He recognized only the natural sciences, and despised the
humanities. He preached the ethic of reasoned egoism, not because
he was more egoistic than the idealist type (on the contrary, the
reverse was the case), but because he desired the merciless exposure
of fraudulent lofty ideas which were made to subserve the basest
interests" (Nicolas Berdyaev, *The Origin of Russian Communism*, R.M.
French, trans. [Ann Arbor, MN: University of Michigan Press, 1960],
54–55).

66 From the closing verse of Mikhail Lermontov's poem "Ангел"
["The Angel"] (1831). (Mikhail Lermontov, *The Demon and Other
Poems*, Eugene Mark Kayden, trans. [Yellow Springs, OH: Antioch Press,
1965], 14).

67 Possibly a literary reference; this phrase is used both by Osip Man-
delstam in О поэзии [*On Poetry*] (1928) and by Vladimir Soloviev in
Судьба Пушкина [*The Fate of Pushkin*] (1897). —Trans.

The "Explosion" of Russian Cultural Identity in the Nineteenth Century (1)

68 See n39.

69 Alexander Pushkin, "Медный садник" ["The Bronze Horseman"] (1833). —Trans.

70 "We do not belong to any one of the great families of the human race, neither to the West nor to the East; we have not the traditions of either. We stand as though outside time; the universal upbringing of the human race was not extended to us" (Pyotr Chaadayev, *Философские письма* [*Philosophical Letters*], in *Writings* [Moscow: Pravda, 1989], 18).

71 In the source, чудо ("wonder" or "miracle"). —Trans.

The "Explosion" of Russian Cultural Identity in the Nineteenth Century (2)

72 The closing lines of Fyodor Dostoevsky's "Pushkin Speech": "Pushkin died at the full development of his abilities and indisputably took some great mystery with him to the grave. And so we now find ourselves working to solve this mystery without him" (Fyodor Dostoevsky, *Пушкин* [*Pushkin*], in CCW 26:149).

73 *Pyotr Dmitrievich Boborykin* (1836–1921—Russian writer, dramaturg, and journalist.

This episode in the history of Russian literature is connected rather with the name of Mikhail Saltykov-Shchedrin. According to A.N. Pypin, his daughter, V.A. Lyatskaya, recorded this conversation between Saltykov and Boborykin: "[Saltykov] came in to see Boborykin, in a cheerful and self-satisfied mood."

"'Well now, how goes your work, Mikhail Evgrafovich?' he inquired, rubbing his hands."

"'Ah, I seem to be writing dully, too little, and poorly.'"

"'Well, now, I'm writing rather differently—energetically, a great deal, and quite well!'" (Mikhail Saltykov-Shchedrin, *Собрание сочинений* [*Collected Writings*] [20 vols.; Moscow: Khudozhestvennaya Literatura, 1965–1977] 19.2:36). In a letter to M.M. Stasyulevich dated September 7/19, Saltykov-Shchedrin himself also wrote, "In the same hotel where I am, Boborykin is also. But it is impossible even to say how much he writes! He himself says frankly: 'I am writing swiftly and quite well'" (ibid., 35).

In the writings of Georgy Adamovich we find a similar account, albeit linked with the name of Ivan Turgenev: "Perhaps the truly poor writer is the one who 'creates' with invariable satisfaction, as Boborykin, lustily slapping his thighs, said in conversation with Turgenev, who was already unwell and retreated from every sort of 'Why?' ('I, you see, on the contrary am writing a great deal and quite well!' I heard this remarkable account from Merezhkovsky)." (Georgy Adamovich, *Комментарии* [*Commentaries*], in *Collected Writings* (12 vols.; Saint Petersburg: Aleteya, 2000], vol. 8, compiled, with afterword and commentary, by O.A. Korostelev, 116.). Ivan Bunin reacted to this passage in a letter to Georgy Adamovich dated November 16, 1947: "How could Merezhkovsky have been with Turgenev in the presence of Boborykin? When? Where? How old was Merezhkovsky at the time? Merezhkovsky made it all up." ("Письма И.А. Бунина к Г.В. Адамовичу" ["The Letters of Ivan Bunin to Georgy Adamovich"], publication of Prof. A. Zveyers, *Noviy Zhurnal*, № 110 (1973): 168.)

74 Lines from Valery Bryusov's "Поэту" ["To a Poet"] (1907).

75 Lines from Alexander Pushkin's sonnet "Поэту" ["To the Poet"] (1830), translated by W. Morrison, and his poem "Пророк" ["The Prophet"] (1826), translated by A.D.P. Briggs (*Alexander Pushkin*, A.D.P. Briggs, ed. [London: J.M. Dent, 1997], 23, 24).

76 A reference to *Метель* [*The Blizzard*] by Alexander Pushkin (1830). —Trans.

77 Alexander Pushkin, *Капитанская дочь* [*The Captain's Daughter*] (1836). —Trans.

The "Explosion" of Russian Cultural Identity in the Nineteenth Century (3)

78 A reference to the words of a character from the story *Гамлет Щигровского уезда* [*Hamlet of Shchigrovsky Province*] (1849), from the *Записки охотника* [*Notes of a Hunter*] cycle: "I too am eroded by reflection, and there is nothing straightforward in me" (Ivan Turgenev, *Collected Writings* [10 vols.; Moscow: Khudozhestvennaya Literatura, 1961], 1: 220).

79 *Alexei Stepanovich Khomyakov* (1804–1860)—poet, philosopher, publicist, theologian, one of the founding fathers of the Slavophile movement. Khomyakov wrote to several of his correspondents, including A.I. Koshelev, A.N. Popov, Yu.F. Samarin, A.O. Smirnova, and A.D. Bludova, concerning the tradition he introduced of wearing the Russian folk costume. "I go everywhere in Russian dress," he wrote to A.I. Koshelev in March of 1856. "When I come I will tell you all about it. It was a terrible scandal, but I withstood it, though they know I had evening dress reserved just in case. When I am asked why I do not don the evening dress prepared for me, I reply, 'So that people do not think that Russia has surrendered me along with the banks of the Pruth River'" (Alexei Khomyakov, *CCW* [8 vols.; Moscow: University Printshop on Strastnoy Boulevard, 1900], 8:152–153). The ideas of Alexei Khomyakov were a topic of lively discussion among the Russian emigration, as reflected in the writings of D.P. Svyatopolk-Mirsky, *Славянофилы (Хомяков. Киреевский)* [*The Slavophiles (Khomyakov, Kireyevsky)*] (1926); E.Yu. Kuzmina-Karavaeva, *А. Хомяков* [*A. Khomyakov*] (1929); Archpriest V. Zenkovsy,

Начало «славянофильства». А.С. Хомяков [*The Beginning of "Slav-ophilia": A.S. Khomyakov*] (1948), and others. The research of Nikolai Berdyaev, including his masterwork *Алексей Степановив Хомяков* [*Alexei Stepanovich Khomyakov*] (Moscow: Put; Association of the A.I. Mamontov Printshop, 1912), contributed significantly to the study of the legacy of Alexei Khomyakov.

Renunciation of Culture in the Name of Pragmatism

80 Ivan Bunin, *Жизнь Арсеньева* [*The Life of Arsenyev*] (1930). — Trans.

81 In the source, *просвещенство* [*prosveshchenstvo*]. The term was coined by Russian philosopher Nikolai Nikolaevich Strakov (1828–1896), a friend and correspondent of Leo Tolstoy, to describe what he saw as the Western European rationalist belief in the omnipotence of human reason. —Trans.

82 Mikhail Lermontov, *Герой нашего времени* [*A Hero of Our Time*] (1839). —Trans.

83 Mk. 8:36.

84 Leo Tolstoy's departure from Yasnaya Polyana ten days before his death at Astapovo Station occurred on the night of November 9 (October 27 old style), 1910.

85 The first line from Alexander Blok's poem "К Музе" ["To the Muse"] (1912). (Alexander Blok, *Selected Poems of Alexander Blok*, Alex Miller, trans. [USSR: Progress Publishers, 1981], 164).

Renunciation of Culture in the Name of Religion

86 Georgy Fedotov repeatedly expressed the idea that the idea of Christian charity, "the common denominator of Russian ethics," lies at the center of the ethical conception of *The Captain's Daughter*. See for example Georgy Fedotov, "Певец империи и свободы" ["The Singer

of Empire and Freedom"], Sovremennye zapiski, № 36 (Paris, 1937): 178–197; idem, "О гуманизме Пушкина" ["On the Humanism of Pushkin"], in Новый град: сборник статей [Novy Grad: Collected Articles] (New York: Chekhov Publishing House, 1952), 268–273; idem, *The Russian Religious Mind: Kievan Christianity, the Tenth to the Thirteenth Centuries* (Cambridge, MA: Harvard University Press, 1946).

87 In the text of the script (erroneously), "having." —Editor of the Russian Edition.

88 In the text of the script, "them," but there can be no doubt that "it" is meant here. —Trans.

89 A reference to the French Catholic historian and literary expert Paul Hazard (1878–1944). In his three-volume work European Thought in the Eighteenth Century: From Montesquieu to Lessing (1946), the first volume is titled Christianity on Trial.

90 Ivan Turgenev, *Живые мощи* [*A Living Relic*] (1874). —Trans.

91 A character in Leo Tolstoy's *Война и мир* [*War and Peace*] (1869). —Trans.

92 Leo Tolstoy, *Анна Каренина* [*Anna Karenina*] (1878). —Trans.

93 Here spiritual "activity" is "Делание"; it is the same word used in the term for prayer of the heart (умно-сердечное делание). —Trans.

94 Nikolai Gogol, *Шинель* [*The Overcoat*] (1842). —Trans.

Renunciation of Culture in the Name of Social Utopia

95 From a letter by Vissarion Belinsky to V.P. Botkin, dated September 8, 1841. "Socialityetter by Vissarion Belinsky to V.P. Botkin, dated September 8, 1841. Foremost in two heavenly existence on earth, when the mass wallows in the mud? Why should I care that the world of ideas in art, religion, and history should be open to me, when I cannot share

this with all those who should be my brothers as men, my neighbors in Christ, but whose ignorance makes them strangers to me and my enemies?"

(Vissarion Belinsky, as quoted in *Toward Another Shore: Russian Thinkers between Necessity and Chance,* Aileen Kelly [New Haven, CT: Yale University Press, 1998], 66. Revised and expanded by current translator).

96 cf. Alexander Pushkin, "Exegi Monumentum," in *Alexander Pushkin, The Queen of Spades and Selected Works,* A.D.P. Briggs, trans. (London: Pushkin Press, 2012), 154. —*Trans.*

97 A reference to the story by Anton Chekhov, *Восклицательный знак* [*The Exclamation Point*] (1885). See Anton Chekhov, *Полное собрание сочинений и писем* [*Complete Collected Works and Letters*] (in 30 vols.; Moscow: Nauka, 1984), 4:266–270.

98 We encounter a similar definition in the article by Georgy Fedotov, "Трагедия интеллигенции"] ["The Tragedy of the Intelligentsia"] (1927): "In simple terms, the Russian intelligentsia is 'idealogical' and 'groundless.' These are its exhaustive definitions. They are not made up, but taken from the language of life: the first, positive definition was overheard from friends, and the second, negative one—from enemies (Strakhov)." (Georgy Fedotov, "The Tragedy of the Intelligentsia," *Novy Grad: Collected Articles* [New York: Chekhov Publishing, 1952], 15. Initially printed in *Versty,* № 2 (Paris, 1927): 145–184.

Tolstoy and Culture

99 Ivan Bunin, *О Чехове* [*On Chekhov*] (New York: Chekhov Publishing, 1955), 85.

100 Here Schmemann mistakenly cites the poem by Alexander Pushkin, "Демон" ["My Demon"] (1823), which runs, "And nought in all nature / To bless he ever wished." (Alexander Pushkin, *Poems by Alexander Pushkin*, Ivan Panin, trans. [Boston, MA: Cupples and Hurd, 1888], 68.)

101 A quote from the novel *The Brothers Karamazov*: "I'd rather remain with my suffering unavenged and my indignation unappeased, even if I were wrong. Besides, too high a price has been placed on harmony. We cannot afford to pay so much for admission. And therefore I hasten to return my ticket of admission. And indeed, if I am an honest man, I'm bound to hand it back as soon as possible. This I am doing. It is not God that I do not accept, Alyosha. I merely most respectfully return him the ticket" (Dostoevsky, *The Brothers Karamazov* 2.5.4, 287).

102 A paraphrasing of the words of Ivan Karamazov: "Anyway, you'd be surprised to learn, I think, that in the final result I refuse to accept this world of God's, and though I know that it exists, I absolutely refuse to admit its existence. Please understand, it is not God that I do not accept, but the world he has created. I do not accept God's world and I refuse to accept it" (Dostoevsky, *The Brothers Karamazov* 2.5.3, 275).

103 *Charles Du Bos* (1882–1939)—French literary expert; author of works on Charles Baudelaire, Marcel Proust, and André Gide; prominent member of the "Catholic renewal" movement; proponent of the works of Anton Chekhov and Leo Tolstoy. Connected professionally and personally with members of the Russian diaspora (Nikolai Berdyaev, Vladimir Veĭdle, Vyacheslav Ivanov, Yuri Felzen, Lev Shestov, Boris de Schloezer, and others). Du Bos's statement regarding Tolstoy was often mentioned in the émigré community. For example, Georgy Adamovich observes: "Regarding *War and Peace* the perceptive French critic Charles du Bos commented: 'If life could write, this is exactly how it would do so.'" (Georgy Adamovich, "Одиночество и свобода" ["Loneliness and Freedom"], in *Collected Writings* [12 vols.; Saint Petersburg: Aleteiya, 2002], vol. 7 [compilation, afterword, and notes by O.A. Korosteleva], 258.) The same phrase is cited by G. Gazdanov in one of the "Дневник писателя" ["Diary of a Writer"] broadcasts (dated October 8/9, 1971) on Radio Svoboda (see G. Gazdanov, "Достоевский

и Пруст" ["Dostoevsky and Proust"] in *Collected Writings* [5 vols.; Moscow: Ellis Lak, 2009], 4:417).

104 Gen. 1:31. —Trans.

105 Here lines from two different poems by Alexander Pushkin are cited: "Пора, мой друг, пора! покоя сердце просит … " ["'Tis Time, My Friend, 'Tis Time! The Heart to Peace Aspires … "] (1834) (*Alexander Pushkin: Selected Works in Two Volumes*, Avril Pyman, trans. [USSR: Progress Publishers, 1922], 57) and "Монастырь на Казбеке" ["The Monastery on Kazbek"] (1829).

106 Quoted with slight discrepancies. The actual text by Ivan Turgenev reads: "And it's not only I, sinner that I am, but many other Chrestians that go walking and wandering through the wide world with nothin' but bast on their feet and seekin' for the truth" (Ivan Turgenev, *Kassian from the Beautiful Lands,* Richard Freeborn, trans. [London: Penguin Classics, 2015], 47–48).

Dostoevsky and Russian Culture

107 Mt. 6:33.

108 Alexander Pushkin, "Пиковая дама" ["The Queen of Spades"] (1833). —Trans.

109 Fyodor Dostoevsky, "Игрок" ["The Gambler"] (1866). —Trans.

110 1Kings14:43 LXX (1 Sam. 14:43).

111 Mikhail Lermontov, *Мцыри* [*The Novice*] (1840). —Trans.

Cultural Identity at "The Beginning of the Century"

112 This may well be a reference to the book by Andrei Bely, *Начало века* [*The Beginning of the Century*] (1933). —Trans.

113 A term from the poem by Alexander Pushkin, "К морю" ["To the Sea"] (1825), властитель дум ("Master of Thoughts") today means a person of great influence among his contemporaries. —Trans.

114 Alexander Blok, *Стихи о Прекрасной Даме* [*Poems about the Beautiful Lady*] (1901–1902). —Trans.

115 An underground religious sect that existed from the 1600s to the late twentieth century. —Trans.

116 Alexander Blok, "Двенадцать" ["The Twelve"] (1918). —Trans.

117 *Sergei Evgenyevich Neldikhin* (real last name: Neldikhen-Auslender, 1891–1942)—primitivist poet, member of Gumilev's third "Poet Workshop" (1920–1922). Author of the poetry collections *Ось* [*The Axis*] (Prague, 1919), *Органное многоголосье* [*Organ Polyphony*] (Prague, 1922), *С девятнадцатой страницы* [*From the Nineteenth Page*] (Moscow, 1929), *Он пришел и сказал* [*He Came and Said*] (Moscow, 1930), *Он пошел дальше* [*He Continued On*] (Moscow, 1930), and others. His book *From the Nineteenth Page* was qualified as "a manifesto of a class enemy in poetry" (*Na Literaturnom Postu*, 1929, № 21/22, 87). Neldikhin was first arrested in 1931, then again in 1941; he perished in the Gulag. Opinions among the poet's contemporaries were conflicting. Georgy Ivanov observed that his poems "are favorably distinguished by their singularity and acumen" (quoted from Yu. Annenkov, *Дневник моих встреч: Цикл трагедий* [*Diary of My Encounters: A Cycle of Tragedies*] [2 vols.; Moscow: Khudozhestvennaya Literatura, 1991], 1:339). His close friend N.A. Otsup recalled: "Of the poets 'nourished by the revolution' we knew Tikhonov. We knew Neldikhen. Where did the fascinating Walt Whitman disappear to in the Russian edition, whom Pyast considered a genius, and whom Gumilev fondly called an apostle of foolishness?" (N. Otsup, *Современники* [*Contemporaries*] [Paris: (n.p.) 1961], 164). V.F. Khodasevich, who left the "Poet Workshop" in part because of Neldikhin, wrote: "The 'self' on behalf of which Neldikhin spoke showed itself to be a choice specimen of a

consummate fool, and a happy, triumphant, thoroughly self-satisfied fool, at that" (V.F. Khodasevich, "Некрополь" ["The Necropolis"], in *Collected Writings* [4 vols.; Moscow: Soglasie, 1997], 4:87). Concerning him see D. Davydov, "Сергей Нельдихен: поэзия и репутация" ["Sergei Neldikhen: His Poetry and Reputation"], in *Органное многоголосие* [*Organ Poliphany*] (Moscow: OGI, 2013), 7–26.

Cultural Identity at "The Beginning of the Century" (2)

118 Alexander Blok, "О подвигах, о доблести, о славе" ["Prowess, Heroic Deeds and Deathless Fame … "] (1908), in *Alexander Blok: Selected Poems*, Alex Miller, trans. (Moscow: Progress Publishers, 1975), 183. —Trans.

119 This refers to the essay "Пленный дух" ["A Captive Spirit"] (1934). "But then, in the zoo, I found out that the Blue Cloak, loved to anguish by all of Russia … was Liubov Dmitrievna's blue cloak" (Marina Tsvetaeva, *A Captive Spirit: Selected Prose,* J. Marin King, ed. and trans. [London: Virago, 1983], 145).

120 Cf. Georgy Adamovich in the essay "Наследство Блока" ["The Legacy of Blok"] (first printed in *Novy Zhurnal,* № 44 [1956]: 73–87): "There were days when, upon reading a new poem by Blok in some journal—those lines on 'the children of Russia'" for example, that appeared in *Apollon*—they felt and knew that they had read something of extreme importance for them, and the impression stayed with them a long time afterward: all other poems, even those that are defined as "brilliant" and "masterful," seemed an idle piece of fancy in comparison" (Georgy Adamovich, *Commentaries*, 177).

121 A slight variation of the final lines of Zinaida Gippius's poem "А. Блоку" ["To A. Blok"]: "I shall not forgive. Your soul is innocent. / I shall not forgive it. Ever" (1918) (as quoted in *Women Writers of Great Britain and Europe: An Encyclopedia*, Katharina M. Wilson, Paul Schlueter, and June Schlueter, eds. [New York and London: Routledge, 2013], 169).

122 In 1911–1912 the Moscow publisher Musaget released the first *Собрание стихотввворений* [*Collected Poems*] of Alexander Blok (three volumes, each with its own title). Later it served as the basis for a four-volume collection of his works (the three volumes of the *Collected Poems* and Театр [*The Theater*]), which was published twice, in 1916 and 1918–1921.

123 Lines from the poem by Alexander Blok, "Верю в Солнце Завета" ["I believe in the Glory"] (1902): "I believe in the Glory, / Distant dawns I behold. / Universal light, shine / From the spring of this world" (Blok, *Selected Poems,* 48).

124 The cycle of poems *Страшный мир* [*This Terrible World*] (1909–1916) was included in the volume *Стихотворения. Книга третья* [*Poems: Book III*] *(1905–1914)* (Moscow: Musaget, 1916).

125 Alexander Blok, "Куликово поле" ["On Kulikovo Field"] (1908), in Blok, *Alexander Blok: Selected Poems,* 236.

126 Alexander Blok, "Ночь, улица, фонарь, аптека" ["A Night, a Street, a Lamp, a Drugstore"] (1912), Dina Belyayeva, trans. No pages. Cited November 18, 2022. Online: https://ruverses.com/alexander-blok/night-street-lamp-drugstore/488/. —Trans.

127 A reference to lines from the poem "Балаганчик" ["The Puppet Booth"] (1905) and the play by the same name (1906) by Alexander Blok.

128 From the poem "Дума" ["Meditation"] by Mikhail Lermontov: "In shame, protesting neither good nor ill, / We rot without a struggle ere we flower" (Lermontov, *The Demon and Other Poems,* 46).

129 Andrei Bely's *Воспоминания о Блоке* [*Recollections of Blok*] first appeared in the Berlin-based magazine *Epopea,* № 1 (1922): 123–273; № 2 (1922): 105–299); № 3 (1922): 125–310); and № 4 (1923): 61–305. Concerning this see Alexander Lavrov, "О Блоке и о других: мемуарная

трилогия и мемуарный жанр у Андрея Белого" ["On Blok and Others: The Memoir Trilogy and Memoir Genre of Andrei Bely"] (Moscow: Novoe Literaturnoe Obozrenie, 2007), 220–265.

130 A reference to the words of the prophet Isaiah: "For, behold, I create new heavens and a new earth; and the former shall not be remembered or come to mind" (Is. 65:17).

Abandonment of the Moral Foundations of Culture

131 Probably a reference to *На рубезе двух столетий* [*At the Border of Two Centuries*] (1930), the first book in the memoir trilogy of Andrei Bely. —Trans.

132 The rift between Alexander Herzen (1812–1870) and Timofey Granovsky (1813–1855) occurred in 1846—the result of serious contradictions in the Westernist circle at the University of Moscow. As an adherent of the liberal trend in Westernism, Granovsky did not share the radical revolutionary democratic and atheist views of Herzen. Herzen's move abroad in 1847 distanced them still further. Herzen devoted a chapter in *Былом и думах* [*My Past and Thoughts*] to their "theoretical rift" (chapter 32). But the ideological schism did not lead to complete spiritual dissociation, and did not stop Herzen from including poignant memories of Granovsky in the same book (chapter 29). Granovsky for his part wrote in one letter to his friend abroad: "I have divested myself of my former romanticism (of 1846), but my romanticism has grown still stronger with regard to my personal attachments. Of this I have no wish to be divested. It is the best, bright, and holy corner of my heart, to which I retreat from all else. ... Among the beliefs that support me personally, one of the chiefest is faith in you and in your friendship." (Timofey Granovsky to Alexander Herzen, July–August, 1849, in *Литературное наследство* [*Literary Legacy*] (Moscow: Publishing House of the USSR Academy of Sciences, 1955), vol. 62: *Герцен и Огарев* [*Herzen and Ogarev*], 2:94.)

133 Nikolai Nekrasov, *Кому на Руси жить хорошо* [*Who Lives Well in Russia?*] (1863–1877). —Trans.

134 Fyodor Dostoevsky, *Униженные и оскорбленные* [*The Insulted and the Injured*] (1861). —Trans.

135 Alexander Pushkin, *Повести покойного Ивана Петровича Белкина* [*Tales of the Late Ivan Petrovich Belkin*] (1831). —Trans.

136 Fyodor Tyutchev, "*Эти бедные селенья … *" ["These Villages so Poor … "] (1855), in *Poems and Political Letters of F.I. Tyutchev,* Jesse Zeldin, trans. (Knoxville, TN: University of Tennessee Press, 1973), 137.

137 A reference to the book by Dmitry Merezhkovsky, *Тайна Трех: Египет и Вавилон* [*The Secret of the Three: Egypt and Babylon*] (1925). —Trans.

138 A reference to the work by German philosopher Friedrich Nietzsche, *Jenseits von Gut und Böse: Vorspiel einer Philosophie der Zukunft* [*Beyond Good and Evil: Prelude to a Philosophy of the Future*] (1886).

139 A paraphrasing of lines from Alexander Blok's poem "Возмездие" ["Retribution"] (1910–1921): "And the black blood of earth, / Veins swelling, holds out to us its promises, / Destroying all boundaries, / Changes unheard of, / Revolts never before seen … "

140 Ivan Bunin, *Деревня* [*The Village*] (1909). —Trans.

141 "The red rooster" signifies fire. Possibly a reference to a phrase in an article by Alexander Blok entitled "Пламень" ["The Flame"] (1913): "In the sixteenth century (for example), blood, the axe, and the red rooster hung over Russia; in the twentieth century 'the boo'" appeared; and in the twenty-first century, perhaps, once again there will be blood, the axe, and the red rooster." (Alexander Blok, "Пламень" ["The Flame"], in Alexander Blok, *Полное собрание сочинений и писем* [*Complete Collected Writings and Letters*] [20 vols.; Moscow: Nauka, 2010], 8:277.) —Trans.

The Initial Reaction to the Revolution

142 In the source, мечтание (Fantasy or Dream). —Trans.

143 An allusion to the work by Friedrich Nietzsche, *Jenseits von Gut und Böse: Vorspiel einer Philosophie der Zukunft* [*Beyond Good and Evil: Prelude to a Philosophy of the Future*] (1886).

144 The story mentioned was widely circulated among the Russian émigré community, most likely courtesy of Georgy Ivanov, who in "Петербургские зимы" ["Petersburg Winters"] (1928) recalled the following: "Blok was already unconscious. He was in constant delirium, raving repeatedly about the same thing: had all copies of 'The Twelve' been destroyed? Did even one remain anywhere? 'Lyuba, look carefully, and burn them—burn them all.' Lyubov Dimitrievna, Blok's wife, patiently repeated that they had all been destroyed; not one remained. For a short time Blok would be calm, and then he would begin again, making his wife swear that she was not deceiving him." (Georgy Ivanov, y repeated that they had *Китайские тени: мемуарная проза* [*Chinese Shadows: Memoirs in Prose*] [Moscow: AST, 2013], 176). Nevertheless, this incident cited from Blok's biography has not been documented, and is disputed in modern literary studies. Concerning fictitious events from the biography of Alexander Blok in Mr. Ivanov's memoirs in prose, see E.V. Ivanova, "Г. Иванов и А. Блок: реальность и вымысел" ["G. Ivanov and A. Blok: Reality and Fiction"], in *Георгий Владимирович Иванов: Исследования и материалы, 1894–1958: II международная научная конференция* [*Georgy Vladimirovich Ivanov: Studies and Materials, 1894–1958: 2nd International Scholarly Conference*], compiled by R.R. Kozhukharov, (editor-in-chief), I.I. Bolychev, and S.R. Fedyakin (Moscow: A.M. Gorky Literary Institute, 2021), 423–435.

145 Maxim Gorky, *Песня о Буревестнике* [*The Song of the Stormy Petrel*] (1901): "Alone, sublime, / The stormy petrel / Soars free above /

Wind-cloven waves / Lashed white with anger." (*Sewanee Review* 44, №
4 [October/December 1936]: 468–471, at 469.)

146 A reference to the play by Alexander Pushkin of the same name:
Пир во время чумы [*A Feast in Time of Plague*] (1830). —Trans.

147 The name of present-day Saint Petersburg during the period of
1914–1924. —Trans.

148 A medieval East Slavic state that Russia, Ukraine, and Belarus all
claim as their ancestor. —Trans.

149 A colloquial name for rural or peasant Russia. —Trans.

150 A peasant paradise, as imagined by Sergei Yesenin, expressed in
his poem "Инония" ["Inonia"] (1918). —Trans.

151 A reference to the essay "Есенин" ["Yesenin"] (1926), which was
later included in the book of memoirs entitled *Некрополь* [*Necropo-
lis*]: "His grief lay in the fact that he didn't know what to call her: he
sang of timbered Rus' and *muzhik* Rusia and socialist Inonia and Asiatic
Rasha, and he even tried to accept the USSR—but his motherland's one
true name never passed his lips: *Russia*." (Vladislav Khodasevich, *The
Necropolis,* Sarah Vitalis, trans. [New York and Chichester, West Sussex:
Columbia University Press, 2019], 214–215.)

The Enslavement of Culture

152 Ibid., 197–198.

153 Ibid. See also R.V. Ivanov-Razumnik, "Россия и Инония" ["Rus-
sia and Inonia"], in *Россия и Инония* [*Russia and Inonia*] (Berlin: Skify,
1920), 5–31.

154 A quote from the poem by Sergei Yesenin, "Инония" ["Inoniía"]
(1918), Don Mager, trans. No pages. Cited November 29, 2022. Online:
https://ruverses.com/sergey-esenin/inoniia.

155 A quote from the poem by Osip Mandelstam, "Сумерки свободы" ["Freedom's Twilight"] (1918), in *The Complete Poetry of Osip Emilevich Mandelstam*, Burton Raffel, and Alla Burago, trans. (Albany, NY: State University of New York Press, 1973), 101.

156 The final stave in the poem by Maximilian Voloshin, "Святая Русь" ["Holy Russia"] (1917), Bernard Meares, trans. No pages. Cited November 29, 2022. Online: https://soviethistory.msu.edu/1917-2/culture-and-revolution/culture-and-revolution-texts/holy-russia.

157 The source of this quote has not been found.—Editor of the Russian-Language Edition.

158 Yury Olesha, *Зависть* [*Envy*] (1927). —Trans.

159 A group of writers formed in Petrograd in 1921. —Trans.

160 "Between bourgeois art, which is wasting away either in repetitions or in silences, and the new art which is as yet unborn, there is being created a transitional art which is more or less organically connected with the Revolution, but which is not at the same time the art of the Revolution. Boris Pilnyak, Vsevolod Ivanov, Nicolai Tikhonov, the 'Serapion Fraternity,' Yessenin and his group of Imagists and, to some extent, Kliuev—all of them were impossible without the Revolution, either as a group, or separately. … None of the 'fellow-travellers' of the Revolution—and Blok was also a 'fellow-traveller,' and the 'fellow-travellers' form at present a very important division of Russian literature—carry the axis within themselves. And therefore we have only a preparatory period for a new literature, only *études*, sketches, essays—but complete mastery with a reliable axis within oneself, is still to come." (Leon Trotsky, *Literature and Revolution,* Rose Strunsky, trans. [Ann Arbor, MI: University of Michigan Press and Toronto: Ambassador Books Ltd, 1960], 57–58).

161 Quoted with slight deviations from the article by Lev Lunts, "Почему мы Серапионовы братья" ["Why We Are the Serapion

Brothers"] (1922): "We do not want utilitarianism. We do not write for purposes of propaganda. Art is as real as life itself. And like life itself it is without purpose or point: it exists because it cannot not exist." (Lev Lunts, "Why We Are the Serapion Brothers," in *Литературные манифесты* [*Literary Manifestos*] [Moscow: Agraf, 2001], 314.)

162 The literary group known as the Serapion Brothers was formed in 1921 under the auspices of a translation studio of Vsemirnaya Literatura publishing. The group included Lev Lunts, N.N. Nikitin, M.L. Slonimsky, I.A. Gruzdev, K.A. Fedin, Vsevolod Ivanov, M.M. Zoshchenko, V.A. Kaverin, E.G. Polonskaya, N.S. Tikhonov, and V.S. Pozner. The group effectively dissolved following the death of its ideologist Lev Lunts (1901–1924), although the meetings and publications of the members continued until 1929. An order of the Politburo of the Central Committee of the All-Union Communist Party (Bolsheviks), or CC VKP(b), "On the Reconstruction of Literary and Artistic Organizations" (dated April 23, 1932), which prohibited the activities of literary groups, sealed the group's fate. Concerning this, see B. Frezinsky, *Судьбы Серапионов (Портреты и сюжеты)* [*The Fate of the Serapions (Portraits and Plotlines)*] (Saint Petersburg: Akademichesky Proekt, 2003) and E. Lemming, *«Серапионовы братья» в зеркалах переписки* [*The Serapion Brothers in the Mirrors of Correspondence*] (Moscow: Agraf, 2004).

163 In the period from 1928–1940, under the supervision of Joseph Stalin, effectively three five-year plans were executed for the development of the national economy. In those same years the party's control tightened over the artistic intelligentsia; 1925 saw an amalgamation of the artistic groups (the All-Russian Association of Proletarian Writers, Kuznitsa, Perevan, Levy Front Iskusstv, and others) into the Federation of Soviet Writers; 1932 saw the creation of a unified writers' organization, the Composers' Union of the USSR, the Union of Soviet Architects, the Republican Unions of Artists, etc., which ensured complete accountability of all spheres of culture to the All-Union Communist Party (Bolsheviks). In 1934, at the First Conference of Soviet Writers,

"socialist realism" was declared the primary artistic method. Yet another stage in fortifying the party rule was a repressive campaign "to overcome Formalism and Naturalism," deployed over 1935–1937.

Creative Resistance (1)

164 The speech "О назначении поэта" ["On the Purpose of the Poet"] for the 84th anniversary of Pushkin's death was commissioned from Alexander Blok by the Writers' Center, where it was delivered on February 11, 1921.

165 Quoted with slight deviations and abbreviations from the essay by Vladislav Khodasevich, "Гумилев и Блок" ["Gumilev and Blok"], from his book of memoirs *Necropolis*, 129–131.

166 Alexander Blok, "Без божества, без вдохновенья" ["Without Divinity, Without Inspiration"] (1921). —Trans.

167 Quoted with deviations from the article by Alexander Blok, "'Без божества, без вдохновенья'. (Цех акмеистов)" ["'Without Divinity, Without Inspiration' (The Acmeist Workshop)"] (1921). Blok actually writes, " … N. Gumilev and several other undoubtedly gifted 'Acmeists' are drowning themselves in the cold swamp of soulless theories and formalism of every kind …." (Alexander Blok, *Собрание сочинений* [*Collected Works*] (8 vols.; Moscow and Leningrad: Russky Put, 1962) 6:183.

168 Quoted with slight discrepancies from the book by Kornei Chukovskii, *Александр Блог как человек и поэт* [*Alexander Blok as Man and Poet*] (Prague: 1924). Translation take from *Alexander Blok as Man and Poet*, Diana Burgin and Katherine O'Connor, trans. and eds. (Ann Arbor, MI: Ardis, 1982), 20.

169 This information is most likely drawn from the book by Konstantin Mochulsky, *Александр Блок* [*Alexander Blok*] (1948), in which the literary expert in turn cites the essay by V.A. Rozhdestvensky,

"Александр Блок" ["Alexander Blok"], first published in *Zvezda*, № 3 (1945): 107–115. Mochulsky cites Rozhdestvensky's recollections erroneously: in his book Rozhdestvensky, finding himself at Blok's grave, "upon one of the wings of the cross ... by the last rays made out with difficulty two lines in pencil." This is followed by the closing lines of Blok's poem "О, я хочу безумно жить ... " ["Oh, I would live life to extremes"] (1914): "He was the child of light and goodness, / He was triumphant liberty" (Blok, *Alexander Blok: Selected Poems,* 192). Rozhdestvensky gives a different account of the story: "One clear summer evening I went into Smolensk Cemetary. ... A white cross, slightly askew, was entirely covered with the names of visitors and with lines of poetry. Among them I found a quote from some poetry of Blok's youth. Gradually recollecting, I recalled the entire poem to memory. And when in place of the romantic, abstract "you" I mentally inserted into it the concept of 'Motherland,' the image of Blok the lyricist lit up for me for the first time with an unprecedented light." This is followed by a citation of the full text of Blok's poem, "Когда я уйду на покой от времен ... " ["When I finally go to my rest from these times"] (1903). See V.A. Rozhdestvensky, "Александр Блок" ["Alexander Blok"], in V.A. Rozhdestvensky, *Страницы жизни. Из литературных воспоминаний* [*Pages of Life: From the Literary Memoirs*] (Moscow and Leningrad: Sovietsky Pisatel, 1962), 218–219. The closing couplet of the poem "Oh, I would live life to extremes" stands as the epigraph to Rozhdestvensky's book (ibid., 195).

170 The date of Sergei Yesenin's death is December 28, 1925.

171 Quoted with slight deviations from the essay by Vladislav Khodasevich, "Есенин" ["Yesenin"] (1926), included in the book *Necropolis* (1939), 215.

172 Lines from the poem by Anna Akhmatova, "А смоленская нынче именинница ... " ["Today Is the Nameday of Our Lady of Smolensk"] (1921), in *Selected Poems of Anna Akhmatova*, Judith Hemschemeyer, trans. (Brookline, MA: Zephyr, 2000), 117.

Creative Resistance (2)

173 A reference to the poem by Alexander Pushkin, "К Н.Я. Плюсковой" ("На лире скромной … " ["To N.Ya. Plyuskovaya" ("On humble lyre")] (1818): "Love and secret freedom / To my heart the simple hymn did whisper, / And my voice untouched by bribes / Was an echo of the Russian people."

174 The LEF creative union (Left Front of the Arts, 1922–1929) was founded in Moscow, with branches in Odessa and other cities of the USSR. The group was headed by Vladimir Mayakovsky; its membership included the writers and art theorists Nikolai Aseyev, Sergei Tretyakov, V.V. Kamensky, Boris Pasternak (who broke with LEF in 1927), Aleksei Kruchyonykh, Osip Brik, Viktor Pertsov, and others, as well as the Constructivist artists Alexander Rodchenko, Varvara Stepanova, filmmaker Sergei Eisenstein, and others. Viktor Shklovsky, a theoretician of the Society for the Study of Poetic Language (OPOYAZ), also had close ties to LEF. The group published the journals *LEF* (1923–1925) and *Novy LEF* (1927–1928). It dissolved due to internal conflicts.

175 The Pereval All-Union Organization of Working and Rural Writers (1923–1932) was created by writer and literary critic Aleksandr Voronsky, under the auspices of the journal *Krasnaya Nov*. The name of the group comes from his article "На перевале" ["In the Pass"] (1923). The group included poets, prose writers, and critics Eduard Bagritsky, Mikhail Barsukov, Denis Gorbov, Ivan Kataev, Andrei Platonov, Mikhail Prishvin, and others. Several members quickly left the group due to ideological differences, including Mikhail Svetlov and Artyom Vesyoly. Concerning the work of Pereval see G.A. Belaya, *Дон Кихоты 20-х годов: «Перевал» и судьба его идей* [*The Don Quixotes of the 1920s: Pereval and the Fate of its Ideas*] (Moscow: Sovetsky Pisatel, 1989).

176 The All-Russian Union of Rustic Writers (VOKP, 1921–1932) was established in Moscow as part of the Surikov literary and musical

circle of people's writers, chaired by the poet G.D. Deyev-Khomyak-ovsky, and had branches in other cities of Russia. It underwent several name-changes, from the All-Russian Union of Rustic Writers (1921–1925) to the Russian Society of Proletarian and Kolkhoz Writers (1931–1932). Its members included E.L. Afonin, P.N. Vasilev, P.I. Zamoisky, Sergei Klychkov, Nikolai Klyuev, and others. In the 1930s many were repressed. Concerning the activities of the VOKP see N.V. Kornienko, *«Нэповская оттепель»: становление института советской литературной критики [The NEP Thaw: The Formation of the Institution of Soviet Literary Criticism]* (Moscow: Gorky Institute of World Literature of the Russian Academy of Sciences, 2010), particularly the chapter entitled "The rural theme in political and literary critical polemics," 183–216; E. Dobrenko, "Становление института советской литературной критики в эпоху культурной революции: 1928–1932" ["The Formation of the Institution of Soviet Literary Criticism in an Era of Cultural Revolution: 1928–1932"], in *История русской литературной критики: советская и постсоветская эпоха [The History of Russian Literary Criticism: The Soviet and Post-Soviet Era]*, E. Dobrenko and G. Tikhanov, eds. (Moscow: Novoe Literaturnoe Obozrenie, 2011), 142–206; and E.A. Papkova, "Как создавалась крестьянская литература" ["How Rural Literature Was Created"], in *Studia Litterarum* 1, № 3–4 (2016): 399–418.

177 The RAPP (Russian Association of Proletarian Writers, 1925–1932) was formed in January of 1925 at the First All-Union Conference of Proletarian Writers. Leopold Averbakh became the secretary general of the RAPP. Its chief activists and ideologists were the writers Dmitry Furmanov, Yuri Libedinsky, Vladimir Kirshon, Alexander Fadeyev, Vladimir Stavsky, and the critic Vladimir Yermilov. Its publication was the journal *Na Literaturnom Postu* (1926–1932), which replaced the journal *Na Postu* (1923–1925). The RAPP became one of the most significant semi-official structures, which waged an unrelenting battle against literary groups of an "anti-Marxist" bent, and ultimately "subjugated" nearly all the literary organizations (LEF,

Kuznitsa, VOKP, and others). The most implacable polemics in those years consisted of RAPP's ideological war against the *poputchiki* and Pereval, ending in the obliteration of the latter. Concerning this see M.M. Golubkov, *История русской литературной критики XX века (1920–1990-е годы)* [*History of Russian Literary Criticism of the 20th Century (1920s—1990s)*] (Moscow: Academia, 2008), 90–116, and G.A. Belaya, *The Don Quixotes of the 1920s* (see especially the chapter entitled "Obliteration," 336–352).

178 *Joseph Leonidovich Averbakh* (1903–1937)—literary critic and notable Komsomol figure. From 1926–1932—secretary general of the RAPP and editor of the journal *Na Literaturnom Postu*. After liquidation of the RAPP in 1932 he participated in organizing the First All-Union Conference of Soviet Writers. Co-editor of the book *Беломорско-Балтийский канал имени Сталина: История строительства, 1931–1934* [*The I.V. Stalin White Sea-Baltic Canal: History of Construction, 1931–1934*] (1934). In April of 1937 he was arrested and accused of Trotskyism. He was sentenced to death and executed by firing squad. Posthumously rehabilitated.

Vladimir Mikhailovich Kirshon (1902–1938)—writer, publicist, dramaturge, poet, and one of the more odious literary functionaries. In 1925 he became one of the RAPP secretaries in Moscow. Author of "industrial-themed" works. In April of 1937, after the arrest of Genrikh Yagoda, he found himself among the disfavored RAPP members of Yagod's circle. That same year he was removed from the Writers Union administration, arrested, and executed by firing squad. Posthumously rehabilitated.

179 One of the primary RAPP rallying cries, at the center of tumultuous discussions among literary figures in the late 1920s and early 1930s. A leading literary critic of the association, Vladimir Yermilov (1904–1965), captured it in his book, *За живого человека в литературе* [*For the Living Man in Literature*] (Moscow: Federatsiya, 1928). Concerning the polemics surrounding the rallying cries of the RAPP, see

T.S. Grits, "Мертвый штамп и живой человек" ["The Dead Stamp and the Living Man"], in *Литература факта: Первый сборник материалов работников ЛЕФа [The Literature of Fact: First Collection of Materials of the Workers of the LEF]* (Moscow: Federatsiya, 1929), 127–130; V. Solsky, *Снимание покровов. Воспоминание о советской литературе и Коммунистической партии в 1920-е годы [The Lifting of the Veils: Recollections of Soviet Literature and the Communist Party in the 1920s]* (Saint Petersburg: Nestor, 2005); E. Dobrenko, "The Formation of the Institution of Soviet Literary Criticism in an Era of Cultural Revolution: 1928–1932"; and O.I. Kiyanskaya and D.M. Feldman, "Типология единства: Литературные сообщества конца XIX–начала XX веков" ["Typology of Unity: Literary Societies in the Late 19th–Early 20th Centuries"], Rossiya XXI, № 3 (2019): 54–83.

180 "Tearing off all masks of every kind" was one of the key rallying cries of the RAPP, taken from an article by Vladimir Lenin, "Лев Толстой как зеркало русской революции" ["Leo Tolstoy as a Mirror of the Russian Revolution"] (1908).

181 In accordance with the order of the Politburo CC VKP(b), "On the Reconstruction of Literary and Artistic Organizations" (dated April 23, 1932), the RAPP was liquidated, and an organizational committee was formed for the creation of a unified Union of Soviet Writers.

182 *Alexander Konstantinovich Voronsky* (1884–1937)—Bolshevik revolutionary, writer, and literary critic; one of the leading Marxist literary theorists. From 1917–1920—member of the All-Russian Central Executive Committee (VTsIK); 1921–1927—editor of the journal *Krasnaya Nov*; 1922–1927—editor of the journal *Prozhektor*. Organizer of the Pereval literary group. In 1923 he joined the "left-wing opposition" in the VKP(b). In 1927 he was removed from his duties at *Krasnaya Nov*, and in March of 1929 he was ejected from the VKP(b), then arrested and exiled to Lipetsk. In 1930 he was brought back from exile and reinstated in the party, but remained suspended from involvement in

modern literary life. Worked as an editor at the Gosizdat state publishing house, preparing an edition of works by nineteenth-century Russian writers. In 1937 he was again arrested and accused of creating a group that masterminded terrorist attacks against the administration of the VKP(b), and in the summer of the same year he was executed by firing squad. Posthumously rehabilitated. Concerning him see E.A. Dinershtein, *А.К. Воронский: В поисках живой воды* [*Alexander Voronsky: In Search of Living Water*] (Moscow: Rosspen, 2001).

183 This theme is the particular subject of Voronsky's article "О художественной правде" ["On Artistic Truth"] (1928). The chief rallying cries of Pereval—sincerity, aesthetic experience of the world, and humanism—were advanced in the program-oriented articles of Alexander Voronsky, which were later included in several collections and a resulting book, *Искусство видеть мир* [*The Art of Seeing the World*] (1928). Concerning the creative program of Pereval see G. Belaya, The Don Quixotes of the 1920s (especially the chapter "The Organic Nature of Creativity as the Criterion of Artistry," 169–178), and N.V. Kornienko, *The NEP Thaw* (especially the chapter "Pro et contra of the literary concept that 'art is life experience' of the Pereval critics," 108–130).

184 Ivan Kataev, *Молоко* [*Milk*] (1930). —Trans.

Creative Resistance (3)

185 Lines from Alexander Pushkin's poem "Полтава" ["Poltava"] (1828). Eubanks, Ivan, trans., in "Poltava by Alexander Pushkin," *Pushkin Review*, vol. 11 (2008): 129+. Cited December 5, 2022. Online: link.gale.com/apps/doc/A259467586/LitRC?u=googlescholar&sid=bookmark-LitRC&xid=ab9c8124

186 Lines from the poem by Vladimir Soloviev, "В тумане утреннем неверными шагами … " ["Through morning mist, with steps uncertain"] (1884). Maria Bloshteyn, trans., in "Philosophy As Ecstatic

Vision: Vladimir Solovyov." No pages. Cited December 5, 2022. Online: https://www.thepostil.com/2017/08.

187 A reference to the Stray Dog cabaret in St Petersburg, a popular haunt among poets, artists, and musicians in the years leading up to the revolution, including Anna Akhmatova. —Trans.

188 Anna Akhmatova, "Поэма без героя" ["A Poem without a Hero"] (begun in 1940, published in 1963). —Trans.

189 A line from the poem by Anna Akhmatova, "Сероглазый король" ["The Gray-eyed King"] (1910), in *Anna Akhmatova: Selected Poems*, Judith Hemschemeyer, trans. (Brookline, MA: Zephyr, 2000), 41.

190 Lines from the poem by Valery Bryusov, "Поэту" ["To the Poet"] (1907).

191 Lines from the poem by Anna Akhmatova, "Памяти 19 июля 1914" ["In Memoriam, July 19, 1914"] (1916), in Akhmatova, *Selected Poems,* 83.

192 Lines from the poem by Anna Akhmatova, "Все расхищено, предано, продано" ["Everything Has Been Plundered, Betrayed, Sold out"] (1921): "Everything has been plundered, betrayed, sold out, / The wing of black death has flashed, / Everything has been devoured by starving anguish, / Why, then, is it so bright?" (Akhmatova, *Anna Akhmatova: Selected Poems*, 113).

193 Anna Akhmatova, "Реквиема" ["Requiem"] (1935–1940). —Trans.

194 Anna Akhmatova, "Poem without a Hero," in Anna Akhmatova, *Requiem and Poem without a Hero*, D.M. Thomas, trans. (London: Elek, 1976), 55.

195 A reference to the article by Marina Tsvetaeva, "Световой ливень. Поэзия вечной мужественности" ["A Downpour of Light: Poetry of Eternal Courage"] (1922), devoted to the work of Boris Pasternak.

196 Lines from the poem by Boris Pasternak, "Быть знаменитым некрасиво" ["It's Unbecoming"] (1956), in Boris Pasternak, *In the Interlude: Poems, 1945–1960,* Henry Kamen, trans. (London, New York, Toronto: Oxford University Press, 1962), 105.

197 Lines from the poem by Boris Pasternak, "Рассвет" ["Daybreak"] (1947), in Pasternak, *In the Interlude,* 75.

The Past and Tradition

198 A line from the poem by Anna Akhmatova, "Чем хуже этот век предшествоваших? Разве … " ["Is this century really worse than those before?"] (1919), A.S. Kline, trans., in "Anna Akhmatova: Selected Poems, Including 'Requiem,'" 78. Accessed December 8, 2022. Online: https://monoskop.org/images/e/e7/Akhmatova_Anna_Selected_Poems_2012.pdf.

199 From the Soviet version of the anthem of the socialist movement, "The Internationale." —Trans.

The West

200 *Vladimir Sergeyevich Pecherin* (1807–1885)—romantic poet, "the first Russian political emigrant" (L. Kamenev), Russian Catholic, author of a collection of memoirs written in Ireland in the 1860s–1870s, which were included in the book *Замогильные записки. Apologia pro vita mea* [*Notes from Beyond the Grave: Apologia Pro Vita Mea*]. In 1836 he left Russia forever (and was stripped of his Russian citizenship by decision of the Senate in 1848). In 1840 he converted to Catholicism in the city of Liège. In 1844 he was sent as a missionary to Great Britain. The last twenty-three years of his life were spent in Dublin. Concerning him see M.O. Gershenzon, *Жизнь В.С. Печерина* [*The Life of V.S. Pecherin*] (Moscow: glued binding edition from the offices of *Kritichesky Obzor* magazine, 1910); N. Pervukhina-Kamyshnikova, *В.С. Печерин.*

Эмигрант на все времена [*V.S. Pecherin: An Emigrant for All Time*] (Moscow: Yazyki Slavyanskoy Kultury, 2006); and E.G. Mestergazi, *B.C. Печерин как персонаж русской культуры* [*V.S. Pecherin as a Figure of Russian Culture*] (Moscow: Sovpadenie, 2013).

201 In 1054 a rift occurred between Constantinople and Rome. Patriarch Michael Cerularius and papal legate Cardinal Humbert anathematized each other. The events of that year determined the division between the Orthodox and Roman Catholic Churches. The schism was based primarily on doctrinal matters pertaining to differing beliefs concerning the mystery of the Holy Trinity, the structure of the Church, and so on.

202 A fairly widespread turn of phrase, found in particular in the work by Vasily Petrov, "Ода 'На взятие Хотина'" ["Ode 'On the Taking of Khoti'"] (1769). —Trans.

203 A quote from Alexander Pushkin's poem "Руслан и Людмила" ["Ruslan and Ludmila"] (1817–1822): "A tale of the times of old! / The deeds of days of other years!" (Alexander Pushkin, *Ruslan and Lyudmila,* Roger Clarke, trans. [London: Hesperus Poetry, 2005], 9.)

204 Alexander Blok, "Россия" ["Russia"] (1908), in Blok, *Alexander Blok: Selected Poems,* 240. —Trans.

205 A reference to the words of the characters of Fyodor Dostoevsky. In the novel *Подросток* [*A Raw Youth*], Versilov says: "To the Russian, Europe is as precious as Russia: every stone in her is cherished and dear. Europe is as much our fatherland as Russia. … Oh, those old stones of foreign lands, those wonders of God's ancient world, those fragments of holy marvels are dear to the Russian, and are even dearer to us than to the inhabitants of those lands themselves!" (Fyodor Dostoevsky, *A Raw Youth*, Constance Garnett, trans., in *The Novels of Fyodor Dostoevsky* [in 7 vols.; New York: The Macmillan Company, 1923], 465.)

In *The Brothers Karamazov,* the words of Ivan Karamazov: "I want to travel in Europe, Alyosha, and I shall be going abroad from here. And yet I know very well that I'm only going to a graveyard, but it's a most precious graveyardryes, indeed! Precious are the dead that lie there. … I know beforehand that I shall fall on the ground and kiss those stones and weep over them." (Dostoevsky, *The Brothers Karamazov* 2.5.3, 269.)

These quotes from Dostoevsky's novels appear in the same order in Nikolai Berdyaev's book *Русская идея* [*The Russian Idea*] (1946), where he talks about the contradictory consciousness of an author who could combine "xenophobia" with "the most amazing words about Western Europe, words which were not equaled by a single Westernizer" (Nicolas Berdyaev, *The Russian Idea,* R.M. French, trans. [New York: The Macmillan Company, 1948], 69).

Technology and Science

206 The memorandum of Andrei Sakharov, "Размышления о прогрессе, мирном сосуществовании и интеллектуальной свободе" ["Progress, Peaceful Coexistence, and Intellectual Freedom"] (1968) was first published in the Amsterdam paper *Parool*, № 6, July 13 (1968), then in the *New York Times*, the émigré publication *Novoe Russkoe Slovo*, and many other periodicals. It was published as a separate pamphlet in Milan, Amsterdam, Zurich, etc., and became a key themes of *Radio Svoboda* broadcasts.

207 Andrei D. Sakharov, *Progress, Coexistence and Intellectual Freedom*, trans. by the *New York Times* (Harmondsworth: Pelican Books, 1982), 54. —Trans.

Social Topics

208 In the source, печалование (intercession or pleading). —Trans.

209 The holy hierarch and wonderworker Phillip, metropolitan of Moscow and all Russia (in the world Fyodor Stepanovich Kolychev, 1507–1569). Fell into disfavor due to his uncompromising stance on the policy of Ivan the Terrible and his condemnation of the brutal *oprichnina* corps. In November of 1586 Metropolitan Phillip was tried by the ecclesiastical court: the bishops defrocked him and exiled him to the Otroch-Dormition Monastery in Tver. He was murdered by Malyuta Skuratov.

210 "Here, O sovereign ruler, we offer a pure and bloodless sacrifice for the salvation of men, while outside the altar Christian blood is being spilled, and men are dying needlessly." (Quoted from A.N. Muravyev, *Жития святых Российской церкви, также иверских и славянских, и местно чтимых подвижников благочестия* [*Lives of the Saints of the Russian Church, and Also of the Iversk and Slavic Saints, and of Locally Venerated Pious Ascetics*], 2nd ed. [Saint Petersburg: Printshop of the Third Department of His Imperial Majesty's Own Chancellery, 1859–1867], 120. Cited in the book by G.P. Fedotov, *Святой Филипп, митрополит Московский* [*Saint Philip, Metropolitan of Moscow*] [Paris: YMCA-Press, 1928].)

211 From the "Order Before the Battle of Poltava" of Peter I (June 27, 1709). See *Письма и бумаги Петра Великого* [*The Letters and Papers of Peter the Great*] (Moscow and Leningrad: Publishing house of the USSR Academy of Sciences, 1950), vol. 9, 1st ed., 226. Originates from an apocryphal speech given by Peter to the troops, published in 1795: "Warriors! Lo, the hour is come that must decide the fate of the fatherland. Think not that you fight for Peter, but for the state entrusted to Peter, for your kinsmen, for the fatherland, for our Orthodox faith and Church. … As for Peter, know that life means naught to him, if only Russia might live in piety, glory, and prosperity." (Quoted from I.I. Golikov, *Деяния Петра Великого, мудрого преобразителя России, собранные из достоверных источников и расположенные по годам* [*The Acts of Peter the Great, the Wise Reformer of Russia, Collected from*

Reliable Sources and Chronologically Arranged] [15 vols.; Moscow: Nikolai Stepanov Printshop, 1839], 11:215.)

212 Possibly a reference to the poem by Mikhail Lermontov, "Как по вольной волюшке … " ["However They Please … "] (1840). —Trans.

213 In particular Konstantin Leontyev wrote concerning the "insignificance" of the Belgian constitution in his *Письма отшельника* [*Letters of a Recluse*] (1879). See Konstantin Leontyev, *Восток, Россия и Славянство: Филосовская и политическая публицистика. Духовная проза (1872–1891)* [*The East, Russia, and Slavdom: Philosophical and Political Journalism. Spiritual Prose (1872–1891)*] (Moscow: Respublika, 1996), 166–175.

214 Amalrik, *Will the Soviet Union Last until 1984?* 10.

215 Ibid., 8.

Religious Themes

216 Pasternak, "Рассвет" ["Daybreak"] (1947), in Pasternak, *In the Interlude,* 73.

217 Boris Pasternak, "Рождественская звезда" ["Christmas Star"] (1947), in Pasternak, *In the Interlude*, 67. —Trans.

218 Boris Pasternak, "Гефсиманский сад" ["Gethsemane"] (1949), in Pasternak, *In the Interlude*, 97. —Trans.

219 A reference to the "Open Letter" sent on November 21, 1965, by representatives of a liberal segment of the clergy, the priests Gleb Yakunin (1934–2014) and Nikolai Eshliman (1929–1985), to Patriarch Alexy I (Simansky). The letter was co-authored by Orthodox theologian and dissident Felix Karelin. Copies of the letter were sent to all the bishops in the country. The document expressed criticism of the decisions of the Bishop's Council of July 18, 1961, and noted numerous

instances of persecutions against the Church and the tightening of state control. On December 15 the "Open Letter" was forwarded without alteration to N.V. Podgorny, chairman of the Presidium of the Supreme Council of the USSR; A.N. Kosygin, chairman of the Ministerial Council of the USSR; and R.A. Rudenko, procurator general of the USSR. The document was also distributed beyond the borders of the Soviet Union without the knowledge of the authors. On May 13, 1966, by decree of His Holiness Patriarch Alexy, both priests were suspended from serving. The letter went unanswered, but it met with a tremendous response among the clergy of the USSR, received global publicity, and was translated into foreign languages. N.A. Struve called the action of Yakunin and Eshliman "one of the most momentous spiritual events of recent years" (N. Struve, *"Историческое событие"* ["A Historical Event"], *Vestnik* (newsletter) of the Russian Student Christian Movement, № 81 [1966]: 1), and in his *"Великопостное письмо"* ["Lenten Letter"] to Patriarch Pimen (1972) Alexander Solzhenitsyn called it a "sacrificial example" (Ibid., № 103 [1972]: 147). Concerning this, see also Alexander Men, *О себе … : Воспоминания, интервью, беседы, письма* [*About Myself … : Memoirs, Interviews, Talks, and Letters*] (Moscow: Zhizn's Bogom, 2007).

220 *Sergei Alekseyevich Zheludkov* (1909–1984)—priest, theological writer, and human rights activist. In 1962–1963, in the form of the clandestine journal *V Puti*, he organized correspondence with a wide circle of clergy and laity regarding the main questions of faith. This correspondence formed the basis for the apologetic work *Почему и я — Христианин* [*Why I Too Am a Christian*] (Frankfort am Main: Posev, 1973).

221 The All-Russian Social-Christian Union for the Liberation of the People (VSKhSON) was an illegal Christian socio-political organization, founded in Leningrad by Leningrad University graduates Igor Ogurtsov, Mikhail Sado, Yevgeny Vagin, Boris Averichkin, and others. Members of the organization saw the rebirth of Russia in the

Christianization of politics, economics, and culture. Yury Andropov, chairman of the KGB, gave a report on the union at a session of the Central Committee of the Communist Party of the Soviet Union. In February of 1967 a number of members and administrators of VSKhSON were arrested on anti-Soviet conspiracy charges; around 100 persons were prosecuted. The trial of the union administrators was closed to the public. Following the main proceedings, VSKhSON leader Ogurtsov was sentenced to fifteen years imprisonment and five years in exile, Sado to thirteen, and Vagin and Averichkin to eight years imprisonment. Following the secondary proceedings, seventeen regular members of the organization were sentenced to terms of up to seven years.

At a Crossroads

222 Alexander Pushkin, "Друзьям" ["To Friends"] (1816).

223 The famous phrase of Alexander Suvorov has no direct source, and is cited in various forms in literature on the general. Cf.: "All things Russian were dear to the heart of Suvorov: he loved his country, and would often repeat, "I am proud to be a Russian!" (D. Bantysh-Kamensky, *Биографии российских генералиссимусов и генерал-фельдмаршалов* [*Biographies of Russian Generalissimos and Field Marshall Generals*] (Saint Petersburg: Printshop of the Third Department of the Ministry of State Property, 1840), part 2, 193.

224 A reference to lines from the poem by Alexander Blok, "Обреченный" ["Doomed"] (1907). Blok's text reads, "If the heart desires destruction, / Begging secretly to sink …."

On the Path to Synthesis (1)

225 A reference to the poem by Alexander Blok, "Those born in eras of stagnation" ["Рожденные в года глухие … "] (1914). Blok's text reads, "Years of the holocaust! Could there be / Tidings in you of hope or madness?"

226 Lines from the poem by Valery Bryusov, "Поэту" ["To the Poet"] (1907).

227 Alexander Pushkin, *Сцены из рыцарских времен* [*Scenes from the Age of Chivalry*] (1837). —Trans.

228 This refers to the words of Father Paissy in *The Brothers Karamazov* 1.2.5: "It will be! It will be! … This star will shine in the East!" (Dostoevksy, *The Brothers Karamazov,* 73–74).

229 *Pochvenniki*—adherents of *Pochvennichestvo*, a Russian literary and social movement of the 1860s, ideologically akin to the Slavophiles, but which acknowledged positive aspects in the Westernist movement. —Trans.

230 A verse from Fyodor Tyutchev's quatrain, "Not by the Mind Is Russia Understood," in *Poems & Political Letters of F. I. Tyutchev,* 144.

231 Lines from the poem by Andrei Bely, "Отчаянье" ["Despair"] (1908). Vladimir Markov and Merrill Sparks, trans. No pages. Cited December 22, 2022. Online: https://ruverses.com/andrei-bely/despair/5841/.

On the Path to Synthesis (2)

232 Vasily Zenkovsky, *История русской философии* [*The History of Russian Philosophy*] (Paris: YMCA-PRESS, 1948). —Trans.

233 Lines from Alexander Blok's poem "Retribution."

234 The term *sublimation* (from the Latin *sublimo*—"I lift up") was introduced by Austrian psychoanalytic Sigmund Freud (1856–1939). The phenomenon is described most notably in his work *Leonardo da Vinci: A Memory of His Childhood* (1910), where the great artist is used as an example to demonstrate the process of the "sublimation" of childhood sexual inclinations into creative achievements. The phenomenon of sublimation was later interpreted variously (by Carl Jung,

Karl Jaspers, Lev Vygotsky, Eric Berne, Max Scheler, and others). In the Russian diaspora the distinguished religious philosopher Boris Vysheslavtsev advanced an original concept of sublimation as spiritual transformation, in his book *Этика преображенного эроса* [*The Ethics of Eros Transformed*] (Paris: YMCA-Press, 1931).

235 Cf. Prov. 1:28–29 LXX —Trans.

236 Lines from the poem by Alexander Blok, "Пушкинскому дому" ["To Pushkin House"] (1921), in Alexander Blok, *Selected Poems of Alexander Blok*, 260.

Conclusion

237 Citation abbreviated. Cf. Alexander Solzhenitsyn, *Cancer Ward,* Nicholas Bethell and David Burg, trans. (Toronto and New York: Bantam Books, 1969), 428. Translation slightly modified by the current translator.

238 See n124. —Trans.

239 Участие—approximately "involvement" or "unindifference." —Trans.

240 Anton Chekhov, *Архиерей* [*The Bishop*] (1902). —Trans.

241 Poem by Anatoly Shteiger, "У нас не спросят: вы грешили?" ["We Shall Not be Asked: Did You Love?"] (1936). Anatoly Sergeyevich Shteiger (1907–1944)—poet, part of the younger generation of the first wave of emigration, one of the most vivid representatives of the Parizhskaya Nota poetic style, author of the poetry volumes *Этот день* [*This Day*] (1928), *Эта жизнь* [*This Life*] (1931), *Неблагодарность* [*Ingratitude*] (1936), and *Дважды два четыре* [*Two Times Two Is Four*] (1950, published posthumously).

Index of Names